Instant Projects

Instant Projects

A Handbook of Demonstrations and Assignments for Photography Classes

By Robert Baker and Barbara London

Edited by Henry Horenstein

Editorial direction:
Henry Horenstein

Project direction:
Lou Desiderio

Authors:
Robert Baker and Barbara London

Art direction and production:
Janis Capone

Managing editor:
Jean Caslin

Editorial and production assistance:
Nancy Benjamin

Photography (demonstrations):
John Sexton

Illustrations:
Tom Briggs/Omnigraphics, Inc.

Picture research:
Lista Duren

Copyeditor:
Alison Fields

Special thanks to:
Eelco Wolf and Wilma Woollard

Polaroid Education Board of Advisers

Robert Baker

Carl Chiarenza
Boston University

A. D. Coleman
New York University

Barbara Crane
Art Institute of Chicago

Henry Horenstein
Rhode Island School of Design

Barbara London

J. Michael Verbois
Brooks Institute

Richard D. Zakia
Rochester Institute of Technology

Library of Congress Catalog Card No. 86-060242

ISBN 0-961-64591-1

Printed in U.S.A.

Polaroid Corporation
575 Technology Square
Cambridge, MA 02139

"Polaroid," "Polacolor," "SX-70," "OneStep," "Time-Zero," and "Sun" are trademarks of Polaroid Corporation.

Cover Photo Credits:

Front Cover (left to right):
Steven Pfefferkorn, Carol Siegel, Paula Brinkman, Carol Siegel, Michael Simon, Lisl Dennis

Back Cover (left to right):
John Sexton, Wanda Levin and Simone Little, Pat Naughton, Ron Jackson, Kaz Tsuchikawa

Contents

Foreword

Over the years, more and more photography instructors have discovered the value of using Polaroid materials as teaching tools. The most obvious advantage—instant feedback—is an invaluable asset for the teacher trying to explain complicated technical points such as exposure or lighting. For years, the most common Polaroid film format for classroom use has been 4 × 5. With this format, a teacher can demonstrate most technical points effectively, and the resulting print is large enough for a class of, say, 15 or 20 students to view easily.

However, today's students are much more familiar with the 35mm than the 4 × 5 format. Some never learn how to use a view camera at all, and those who do often have limited access to the equipment for use on their own time. So, although class demonstrations can be done effectively with a view camera, most students don't get a chance to try out what they've learned with the materials they've learned it on.

The recent introduction of Polaroid 35mm films has changed all that. Now a class lecture can be supplemented by real-time demonstrations and assignments completed by students using their own 35mm cameras. Film can be shot and brought back to class for almost immediate processing and mounting, and the results projected within a single, albeit lengthy, class or over a period of just a few days.

With the Polaroid 35mm instant slide system there is no need for time-consuming darkroom work, and class time can be used to concentrate on creative issues, rather than technical matters. Slide film is not particularly forgiving; one stop or so of over- or underexposure really shows up and, without a printing stage, no amount of contrast change or burning and dodging can obscure the errors. Therefore, such technical problems can be dealt with expediently.

The assignments and demonstrations presented in *Instant Projects* represent the combined efforts of dozens of talented teachers, students, and photographers. Robert Baker, who edited *The New Ansel Adams Photography Series,* wrote Part One, a general collection of demonstrations and assignments developed by Mr. Baker along with Barbara London (Upton), author of *Photography* (Upton and Upton), and Henry Horenstein, author of *Black and White Photography* and *Beyond Basic Photography.* John Sexton provided most of the demonstration photographs, and students from several schools provided the photographs illustrating the assignments. Part Two is a compilation of 37 projects contributed by working photography instructors. The text was written by Ms. London and illustrated with photographs by students of those instructors. All the photographs in *Instant Projects* were made with Polaroid materials.

Instant Projects is not intended as a complete course in photography. Rather, it is an idea book providing teachers with supplementary materials and specific ideas which they can draw on, modify, or use as they wish. We realize that Polaroid materials are just one part of the photographic education process. With this book, we hope that teachers who up to now have used these materials in a limited way will see the value of using them more often.

Instant Projects

Introduction

The material in Part One is divided into nine topics, each representing a single important photographic issue. Each topic is then divided into technical demonstrations for use in class and assignments for students to do on their own time. Demonstrations make key points that can be shown effectively by the instructor with a simple exercise well within a single class period. In each demonstration, the use of Polaroid materials, usually the 4 × 5 format, helps bring home the message in an immediate, clear, and easily remembered way.

The assignments are more creative in their intent, though they draw directly upon the technical information emphasized in the demonstrations. Most suggest the use of 35mm equipment (students are most familiar with this format) and Polapan CT film, Polaroid's continuous-tone 35mm black-and-white slide material. The pages containing the assignments are designed so that the comments addressed to the teacher and the instructions for the students are on separate pages. This way teachers may choose, if they wish, to photocopy the instructions from the book and pass them out directly to their students.

575 TECHNOLOGY SQUARE
CAMBRIDGE, MASSACHUSETTS 02139

Dear Colleague:

Thank you for your interest in *Instant Projects*. We are very interested in learning your reaction to the book so that we can better respond to your needs in future publications.

Please help us in this effort by taking a moment to answer the following questions. Your individual response is highly valued.

Thank your for your time and effort.

Sincerely,

Lou Desiderio
Polaroid Industrial Marketing/Publicity

1a. In which, if any, of the project areas described in *Instant Projects* have you conducted assignments with your students?

1b. In which do you plan to conduct assignments, if any?

Project Areas	1a. Have Conducted Assignments	1b. Plan to Conduct Assignments
a. Lighting	☐	☐
b. Zone System	☐	☐
c. Shutter speed and motion	☐	☐
d. Aperture and depth of field	☐	☐
e. Exposure	☐	☐

2. We are interested in getting your overall reaction to *Instant Projects*. Using the scale below, where 5 means excellent and 1 means poor, or you can use any number in between, please circle the number that reflects your judgment.

	Excellent				Poor
Overall evaluation of *Instant Projects*	5	4	3	2	1

3. Listed below are several statements that could be made about *Instant Projects* and the use of instant photography for educational purposes. Please indicate whether or not you agree with each statement by using a scale of 1 to 5, where 5 means completely agree and 1 means completely disagree, or you can use any number in between. (PLEASE CIRCLE ONLY ONE NUMBER PER STATEMENT)

	Completely Agree	Somewhat Agree	Neither Agree nor Disagree	Somewhat Disagree	Completely Disagree
a. The projects in *Instant Projects* are practical tools for instruction	5	4	3	2	1
b. *Instant Projects* is **not** relevant to my work as an educator	5	4	3	2	1
c. The information was clearly presented	5	4	3	2	1
d. Reading *Instant Projects* is uninteresting	5	4	3	2	1
e. Instant photography is a valuable tool in photographic education	5	4	3	2	1
f. Instant film is **not** too expensive to use for instructional purposes	5	4	3	2	1

4a. What did you like **most** about *Instant Projects?*

4b. What did you like **least** about *Instant Projects?*

5. Please tell us about any areas that were not covered in *Instant Projects* that you are interested in learning more about.

6. We would also welcome additional comments or suggestions you may have for the use of Polaroid products in photographic education.

These final questions are for classification purposes only.

7. Where do you teach photography? (PLEASE CHECK ALL THAT APPLY)

☐ College (4 years)
☐ College (2 years)
☐ Adult Education School
☐ High School
☐ Trade School
☐ Other (SPECIFY) _____

8. How many students do you teach per year? _____ # students/year

Part One of the book is meant to be used in a modular way. It is not intended to be a complete photography curriculum. Rather, we assume that teachers will pick and choose from the various demonstrations and assignments, using only those that fit their needs. In many cases it makes sense to combine two or more related demonstrations or assignments for either economy or ease of presentation.

The photographs that illustrate this section show how the completed demonstrations and assignments might look. The examples for the demonstrations were shot under simulated classroom conditions specifically for that purpose, while those for the assignments were shot during actual photography classes. The teachers and students responsible are credited with each photograph, along with the schools they represent.

A final note: The demonstration recommendations have been made as specific as possible. In all cases, however, we strongly suggest that the teacher set up and test each demonstration before the class begins to determine the exposure and other variables for each particular setup; this will help ensure that all goes smoothly during class time.

DEMONSTRATIONS

A Pinhole Can Form an Image

Aperture and Shutter Speed Affect Exposure

Aperture and Shutter Speed Have a Reciprocal Relationship

Exposure Settings Compensate for Changes in Light Level

Film Speed Affects the Choice of F-Stop and Shutter Speed

ASSIGNMENTS

Expose a Roll of Film Without a Meter

Expose a Roll of Film Indoors

BASIC CAMERA CONTROLS

This topic introduces the camera and shows students how it works. First, Demonstration 1–1 shows them how an image is formed with a simple pinhole camera; with beginning students, the issue of focusing should be discussed. Demonstration 1–2 shows the effects of aperture and shutter speed on exposure; Demonstration 1–3 illustrates the 1-stop reciprocal relationship of aperture and shutter speeds. Demonstration 1–4 relates these camera settings to the subject lighting, and Demonstration 1–5 takes the speed of the film into account.

A Pinhole Can Form an Image

Suggested Materials

4 × 5 camera
tripod
Polaroid Type 52 or Type 57 film
Polaroid 545 film holder
aluminum foil
lensboard
tape
black cardboard
No. 10 needle

A pinhole can be used instead of a lens to form an image, although the light will be dim and the image not perfectly sharp. The pinhole forms the image by blocking out all light except a narrow beam from each point of the subject, and each beam falls on the corresponding area of the film. The image is made up of all the light beams from all the points in the subject. The light reaching the film is dim because the area of the pinhole is so much smaller than the area of a lens, and thus very little light reaches the film. The image is not sharp because the pinhole does not focus the light, but merely allows a narrow beam to pass through it to form the image.

Because a pinhole has no focal length, the distance from pinhole to film is not critical as it is with a lens. (Instead, changing the distance from pinhole to film affects the subject area projected on the film, in much the same way as changing to a lens of a different focal length.) Be sure to point out to beginning students that a pinhole is different from a camera with a lens, which must be focused (see the box "How an Image Is Formed" on page 8).

There are numerous ways of making a pinhole camera, and some, such as building a camera from a plain box, can be quite time consuming. The method described here is simple and effective, and requires a minimum amount of construction.

Step by Step

1 Cover the opening in the lensboard with the aluminum foil. Tape the foil securely around the edges to keep out stray light. At the center of the lensboard hole, pierce the aluminum foil with the No. 10 needle to produce a small hole with clean edges. Push the needle about halfway through.

2 Cut the black cardboard to approximately the size of the lensboard. Tape it to the lensboard along one edge to form a hinge so it can be used to cover the pinhole and thus control exposure time.

3 With the pinhole lensboard in place, set up the camera on a tripod before a well-illuminated subject, preferably an outdoor scene in full daylight. The bellows should be extended so the pinhole is about 6 inches from the ground glass.

4 Using a dark cloth, examine the image on the ground glass if possible. It will be very dim, or possibly invisible, depending on the subject lighting and the size of the pinhole.

5 Make one exposure on Type 52 film. For a daylight subject, try an initial exposure of 2–4 seconds, or make test prints at several exposure times.

6 Process the print. Make another exposure at a shorter time if the print is too light, or at a longer time if it is too dark.

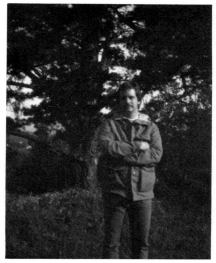 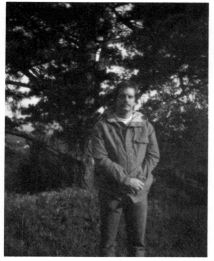 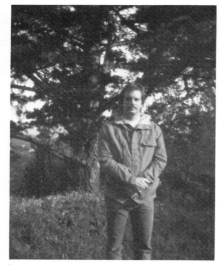

Exposure of 2 seconds 4 seconds 8 seconds

Comments

- The hole can be made with any needle or fine pin. A smaller hole will require a longer exposure, and a larger hole will require a shorter exposure. The size of the hole also affects the image sharpness (see the box "How an Image Is Formed" on page 8).

- To ensure clean edges when piercing the foil, you can place the foil between two thin sheets of cardboard and press the needle through, being careful to hold the needle perpendicular to the cardboard. If the pinhole has rough edges, the image will not be sharp.

- The suggested exposure time of 2–4 seconds is suitable for a typical subject in bright outdoor light with Type 52 film. With a less brightly lit subject, much longer exposures may be required, in part due to reciprocity failure. In this case, it may be practical to switch to a higher speed film, such as Type 57.

- This demonstration can be expanded by making exposures at different bellows extensions to show the effect on angle of view. Moving the pinhole farther away from the film is comparable to changing to a telephoto lens, and moving it closer is like changing to a wide-angle lens. For example, a bellows extension of 12 inches would cut the angle of view in half, and an extension of 3 inches would double it. (Remember that changing the extension will require that you adjust the exposure.)

Aperture and Shutter Speed Affect Exposure

Suggested Materials

4 × 5 camera
normal-focal-length lens
tripod
exposure meter
Polaroid Type 52 film
Polaroid 545 film holder

This demonstration introduces the concept of exposure, showing the effects of aperture and shutter speed. Aperture and shutter speed govern the two factors that determine total exposure: the *intensity* of the light and the amount of *time* the light is allowed to fall on the film, respectively. The aperture increases or reduces the intensity of the light passing through the lens, and the shutter, of course, controls the amount of time. Once students understand the aperture and shutter speed, the reciprocal relationship between them can be explained (see Demonstration 1–3).

This demonstration involves making several exposures at different apertures while keeping the shutter speed constant, then at different shutter speeds while keeping the aperture constant. The darker and lighter prints that result should help students understand what exposure means and how to control it.

How an Image Is Formed

Light rays reflecting off one point in the subject travel in a straight line through the pinhole to one location on the film. The rays that pass through the hole diverge to form a small circle on the film, and thus any point of the image is slightly blurred.

The image is made up of overlapping circles from all the points of the subject. The larger the pinhole the larger the circles, and thus the softer the resulting image.

Changing the distance between the pinhole and the film changes the angle of view. As the distance increases, the angle of view through the pinhole narrows, simulating the effect of using a telephoto lens. Reducing the distance causes an increase in the angle of view, as with a wide-angle lens.

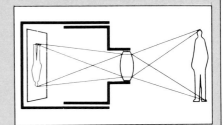

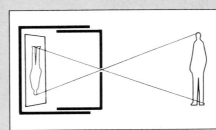

If the pinhole is replaced with a lens, the image of each point is *focused*, and thus is much sharper. Now the distance from the lens to the film becomes critical, and focusing on the subject is an essential part of making a photograph. Because the lens is larger than the pinhole, more light passes through it and the image is much brighter on the ground glass.

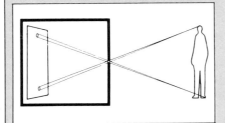

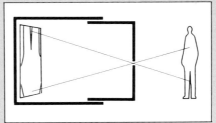

1 Choose a still-life subject indoors, set up the camera, and determine the correct exposure before the class begins. Choose a shutter speed that allows you to use an aperture of f/11.

f/11

¹⁄₁₅ second at f/11

2 Begin the demonstration by showing the class that both aperture and shutter speed control the amount of light that reaches the film. Remove the lens from the camera and open and close the aperture, then operate the shutter at different settings.

f/16 without changing the shutter speed

¹⁄₃₀ second without changing the aperture

3 Using the shutter speed determined in step 1, make exposures at f/11, f/16, and f/8. Process the film and pin the prints to the wall, noting the exposure in the margins.

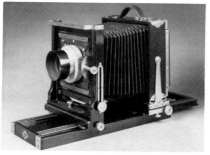

f/8 and the same shutter speed

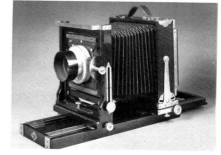

¹⁄₈ second and the same aperture

4 Then make a second series of exposures keeping the aperture at f/11 but changing the shutter speed, first doubling and then halving it. Process these prints, note the exposures, and pin them to the wall for comparison with the first set. It should be clear that the two series of prints are identical. Then discuss how each change of 1 stop or 1 shutter speed doubles or halves the light reaching the film.

Comments

• You can do this demonstration indoors or outdoors, as long as the conditions remain constant. Be sure also that the combination of light intensity and film speed allows you a practical range of apertures and shutter speeds. For an outdoor demonstration, you may want to use a slow film like Type 55.

• With an advanced or accelerated class, you can combine this demonstration with the one that follows to incorporate the concept of the reciprocal f-stop relationship. You can also use it to discuss bracketing exposures, and adapt it to demonstrate basic Zone System concepts (see Topic 6).

Aperture and Shutter Speed Have a Reciprocal Relationship

Suggested Materials

4 × 5 camera
normal-focal-length lens
tripod
exposure meter
Polaroid Type 52 film
Polaroid 545 film holder

This demonstration shows students the reciprocal relationship of aperture and shutter speed. If you close down the lens by 1 stop, you must double the exposure time to keep the exposure constant. If you open up the lens 1 stop, you must cut the exposure time in half for the same result. Doing either one alone—changing exposure by 1 stop or 1 shutter speed—doubles or cuts in half the amount of light reaching the film. It is important to point out to students that they do have choices when making an exposure: that they can choose from more than one combination of f-stop and shutter speed in any given circumstance.

To show this, make five photographs of the same subject in the same light, varying aperture and shutter speed in such a way as to keep the total exposure constant. The five photographs should look the same in overall density.

Step by Step

1 Choose a subject, set up the camera, and determine the correct exposure before the class begins. If possible, use a shutter speed that allows an aperture of f/5.6.

2 Make the first exposure as determined in step 1 (f/5.6 at, say, 1/30 second).

3 Make a second exposure, stopping down to f/8 and doubling the exposure time (in this case, 1/15 second).

4 For the third exposure, stop down to f/11 and again double the exposure time (1/8 second).

5 For the fourth, use f/16 and double the exposure time again (1/4 second).

6 Finally use f/22 and once again double the exposure time (1/2 second).

7 Pin the results up on the wall and compare them, pointing out that with comparable changes in aperture and shutter speed, the total exposure stays the same.

f/5.6 at ⅟₃₀ second

f/8 at ⅟₁₅ second

f/11 at ⅛ second

f/16 at ¼ second

f/22 at ½ second

Comments

- You can do this demonstration indoors or outdoors as long as the light level is constant. If you do it outdoors you may want to use a slow film such as Type 55.

- You may need to vary the recommended f-stops and shutter speeds depending on the lighting conditions and the range of apertures and shutter speeds on the camera used.

- This demonstration (like many of the others) can be adapted as a student assignment, with students using their 35mm cameras and Polaroid Polapan CT or Polachrome CS film. In this case students should use a hand-held light meter or the manual mode on their in-camera meter.

- This demonstration can also lead into the question of how to choose one combination of f-stop and shutter speed over another. (See Topics 2 and 3 on controlling motion and depth of field.)

Exposure Settings Compensate for Changes in Light Level

In previous demonstrations students have seen how to adjust the aperture to offset a change of shutter speed, or adjust the shutter speed to compensate for a change of aperture. You make these adjustments when you want to keep the exposure the same. When the subject lighting changes, however, you need to know how to adjust the exposure settings to compensate. Demonstrating this allows students to see the relationship among all three factors determining how much light reaches the film: shutter speed, aperture, and subject lighting.

To illustrate this point, photograph a student under two different lighting conditions, such as indoors and outdoors, and change f-stop and shutter speed to compensate for the different light levels.

Suggested Materials

4 × 5 camera
normal-focal-length lens
tripod
exposure meter
Polaroid Type 52 film
Polaroid 545 film holder

Step by Step

1 Choose a subject for an informal portrait. With this subject under relatively dim light or at your indoor location, make an overall, or average, exposure reading using a hand-held light meter. Show students the luminance reading, and how to use the meter dial to calculate exposure settings on the camera.

2 Photograph the subject and process the print. Note the exposure in the margin.

Indoors using f/5.6 at ¼ second

3 Increase the light or move outdoors and repeat the process, again noting the exposure in the margin of the print.

Outdoors using f/11 at ¹⁄₆₀ second

4 Compare the two prints. They should look the same in overall exposure. Point out that the portrait in brighter lighting required a smaller aperture and faster shutter speed because of the higher level of illumination.

Comments

- For best results, place the subject in flat light, without harsh shadows, both indoors and outdoors.

- This demonstration can be combined with the next one, which introduces film speed as the fourth and final factor in the exposure equation.

- This is a good time to convey the importance of carefully keeping records of exposure data.

Film Speed Affects the Choice of F-Stop and Shutter Speed

Film speed indicates a film's or paper's sensitivity to light. Film of a certain speed always requires the same quantity of light for normal exposure. Aperture and shutter speed can be adjusted to compensate for different intensities of subject lighting.

To demonstrate this, photograph the same subject under constant light, using two films of different speed. You can calculate the change in exposure required by resetting the meter or by relating the two film speeds arithmetically. Since we are using films with speeds of ISO 400/27° and ISO 3000/36°, the required exposure compensation is the equivalent of about 3 stops, or an 8× change in exposure time ($8 \times 400 = 3200$).

Suggested Materials

4 × 5 camera
normal-focal-length lens
tripod
exposure meter
Polaroid Type 52 film
Polaroid Type 57 film
Polaroid 545 film holder

Step by Step

1 Ask a student to pose, or set up a still life indoors. Determine an average exposure for a film speed of ISO 400/27°.

2 Make the exposure with Type 52 film, and process the film. Note the f-stop and shutter speed used in the margins of the print.

3 Using a speed of ISO 3000/36°, repeat the meter reading and adjust the aperture and shutter speed as indicated.

4 Make a second photograph with Type 57 film. Process it and note the exposure in the margin.

5 Compare the two prints. Because the faster film requires less exposure, a smaller aperture and/or faster shutter speed must be used for this photograph. Note that the exposure difference was about 3 stops. Show students how the film speeds can determine this difference numerically.

Using Polaroid Type 52 film at settings of f/5.6 at 1/60 second

With faster film, Polaroid Type 57, using f/16 at 1/60 second

Comments

- Fast film is best in low light because it requires relatively little exposure. (Fast film has other effects, which are discussed in the following topics.)

- A side effect of fast films is that they have larger grain, which should be visible with a magnifier in the examples.

Expose a Roll of Film Without a Meter

To the Instructor

This assignment teaches students how to make an exposure without depending on light meters or the camera's built-in metering system. After completing the assignment they should better understand the concept of exposure, and particularly the relationship of lighting, aperture, shutter speed, and film speed. The meter is the means by which these different elements are taken into account. This assignment can also help students develop more visual sensitivity to existing lighting conditions, instead of relying entirely on their meters.

Although most people have meters or automatic cameras at their disposal, there is a practical benefit to being able to estimate exposure without a meter. With a nonautomatic camera and a rapidly moving subject, a photographer may not have time to refer to a light meter. In addition, a meter or its battery might fail, and, of course, some cameras have no metering system (for example, many medium- and large-format models).

Students can use several guidelines to estimate exposure without a meter. The 1/ASA rule (see the box on page 17) is valuable because it is so easy to remember, and thus always available in an emergency. The tip sheet packed with some films is another readily available guide to estimating exposure.

Students whose cameras cannot be operated manually will not be able to use them for this assignment. They should be provided with a manual camera by the school, if available, or asked to work with another student, sharing a single camera.

Suggested Materials

35mm camera
Polaroid 35mm instant slide
 system
Polaroid Polapan CT film

Laura Davis

Paula Brinkman

Instructor: John Craig, University of Connecticut, Storrs, CT

1 How did your f-stop and shutter speed change with different light conditions? What did you do to compensate for increases and decreases in light levels?

2 Was it more difficult to estimate exposure under certain lighting conditions than others? Bright light? Back- or side-lighting?

3 Did you notice any difference in the lighting either very early or late in the day, compared with midday?

Holly Lorinser

The 1/ASA Rule

The 1/ASA rule states that a shutter speed equal to 1/ASA can be used with the following apertures:

f/22 on bright sand or snow
f/16 for bright sunny conditions
f/11 for "cloudy bright" conditions
f/8 for overcast
f/5.6 for heavy overcast or
 open shade

For example, with Polaroid Polapan CT (ISO 125/22°) film, use 1/125 second at f/16 for bright sunny conditions. Conditions that do not match those listed will require you to estimate the exposure, using those given as a starting point.

Robin Kaminski

Paula Brinkman

James White

ASSIGNMENT 1-1 Expose a Roll of Film Without a Meter

For this assignment you will expose a roll of film, estimating the exposure instead of depending on a light meter or your automatic camera. The meter takes into account all of the exposure factors—lighting on the subject, film speed, aperture, and shutter speed—to ensure that the right amount of light reaches the film. Although a meter may be built into your camera, you should remember that it can be used separately. You can usually make the exposure choices yourself, either overriding the meter or not referring to it at all.

It is useful to know how to estimate exposure in order to develop greater sensitivity to lighting conditions. Try to be aware of such issues as where the light is coming from, how strong it is, and how reflective your subject is. The exposure guideline used in this assignment can also be very useful in emergency situations. The 1/ASA rule is easy to remember and can provide a basis for estimating if your meter fails or its battery dies or if you don't have time for a careful reading.

To do this assignment, you must have a camera that allows you to set the shutter speed and aperture yourself. With some automatic cameras you can simply remove the batteries to disable the meter, but other automatic cameras require the batteries to operate the shutter. If your camera has a manual setting, you can use it for this assignment, but be sure to estimate the exposure yourself, without referring to any meter reading.

Step by Step

1 Remove the battery from your camera if the camera will work without it. If the camera needs a battery to work, use the manual mode and ignore any exposure information that appears in the viewfinder.

2 Shoot one roll of 36 exposures outdoors, under different lighting conditions and at different times of day. Evaluate the lighting by eye, and use the 1/ASA rule to determine exposure.

3 Write down the time of day and the f-stop and shutter speed you select. Note whether the sun is out or behind clouds, and whether the subject is lit from the front, side, or back, or from overhead.

Expose a Roll of Film Indoors

Suggested Materials

35mm camera
tripod
Polaroid 35mm instant slide
 system
Polaroid Polapan CT film

To the Instructor

For this assignment students should photograph four subjects indoors, both live and still life, with and without a tripod. In addition, they should bracket, making several exposures of each subject.

This assignment shows students the problems of photographing under low light, as well as some ways to handle those problems. Because low light usually requires long exposure times, students will have to contend with camera or subject motion during the exposure. Another problem they may encounter is the tendency to underexpose; it is difficult to meter accurately in low light for several reasons, including meter inaccuracy at low levels and high-contrast lighting conditions caused when light sources are in the picture area.

Because light indoors tends to be not only low but directional, it is important for students to become aware of the available light and to make the best possible use of it. They may need to move their subjects to take advantage of available window light or other room light.

To handle the problems of low-light photography, students are introduced to an important piece of equipment—the tripod—and an important technique—bracketing. The use of flash and other artificial lighting is discussed in Topic 8.

This assignment can lead naturally to the subject of pushing film—an additional aid when photographing in low light.

Instructor: Kenda North, University of California, Riverside, CA

Helen Breeden

Points of Discussion

1 Is there a visible difference in sharpness between the photographs that were made with the camera hand-held and those made using a tripod?

2 For those images that were blurred, was the problem caused by camera movement or subject movement?

3 What do the results tell you about the slowest shutter speed you can use with the camera hand-held and still obtain a sharp image?

4 How are your exposures? Did you tend to overexpose, underexpose, or were your meter readings accurate? If you did over- or underexpose, can you explain why?

5 Was bracketing helpful? Under what other circumstances might you use this technique?

6 Did you find that you could improve the direction of light or the intensity of light by moving your subject? If so, how did it help the appearance of the photograph?

Denise Sanchez

Lia Devine

Alyssa Shepard

Mark Heidrich

Instructor: Kenda North, University of California, Riverside, CA

ASSIGNMENT 1–2 Expose a Roll of Film Indoors

Low-light photography presents a number of problems and challenges. When there is not much light available, it can be especially difficult to expose film accurately. Meters are often not very accurate at minimum light levels. Indoor lighting ranges from the flat and even conditions provided by the fluorescent lights frequently found in schools and offices to the often localized, contrasty nature of lighting in a home, where the light sources themselves may be in the picture area. The latter condition is the most difficult because it creates dark shadows that may require long exposures and bright highlights that might lack detail due to overexposure.

The lighting will vary depending on where your subject is. By a window the light may be quite strong, whereas in the corner of the same room it may be dark. Consequently, this assignment requires you to consider the way the room is lighted, and to move the subject to use the available light to best advantage.

The best way to take readings from a subject indoors is to hold the meter close to the subject. Be sure that your meter is not reading a light source, such as a lamp or window, but only the subject itself.

An important technique to help ensure good exposure is bracketing. Bracketing involves making several exposures—the initial one at the setting indicated by your meter, and subsequent ones at higher and lower exposure settings. For example, if your meter indicates f/4 and 1/30, you might make additional exposures at f/2.8 at 1/30 second and f/2 at 1/30 second (more exposure), and at f/5.6 at 1/30 second and f/8 at 1/30 second (less exposure).

Step by Step

1 Choose an indoor still life or portrait subject. Make a meter reading, and photograph the subject with the camera hand-held. Note the exposure you use.

2 Put the camera on the tripod and photograph the same subject, using a cable release to trip the shutter.

3 Bracket the exposures as follows: at the exposure setting indicated by the meter, with 1 stop more exposure, with 2 stops more, with 1 stop less than the original exposure, and with 2 stops less. You thus have a range of two exposures above and two below the indicated normal setting.

4 Look carefully at the available light. Find another location where the light is different and move your subject there. Then repeat steps 1–3. Be sure to keep records of your locations and procedures.

DEMONSTRATIONS

**Several Factors Affect the
Representation of Motion**

**Camera Motion Affects Image
Sharpness**

ASSIGNMENTS

**Stopping Motion in a
Photograph**

Motion as a Creative Element

SHUTTER SPEED AND MOTION

This topic familiarizes students with the way that shutter speed relates to motion, whether subject motion or motion of the camera. Demonstration 2–1 covers three of the essential factors controlling image blurring caused by motion: shutter speed, speed of motion, and direction of motion. These three factors have been grouped together both to show how they relate to one another and for convenience, so that only one setup of a moving subject is necessary.

Ultimately what counts is the movement of the image on the film. The effect of such factors as changing lenses or moving closer to or farther from the subject can best be understood by considering their effect at the image plane. Demonstration 2–2 relates movement of the camera to image sharpness.

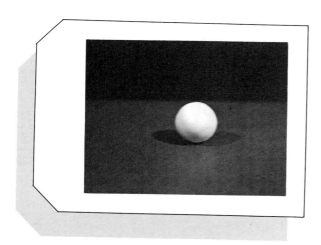

Several Factors Affect the Representation of Motion

Suggested Materials

4 × 5 camera
normal-focal-length lens
tripod
exposure meter
Polaroid Type 52 film
Polaroid 545 film holder
board or cardboard for ramp
yellow tennis ball

An image may be blurred because of movement of the subject or movement of the camera, and several factors determine how sharply a subject is rendered on film. First is shutter speed. The faster the shutter speed, the less blurring that can occur. Second is the speed of motion, which affects how much blurring occurs. Third is the direction of motion. A subject moving across the field of view will appear to be going faster than one moving toward or away from the camera at the same speed, and thus will be more blurred in the image. The important factor in all cases is the motion of the image on the film, rather than the actual speed of the subject.

You can demonstrate these effects by making comparison photographs of a moving subject. The subject we suggest is a ball that rolls down a short ramp and across a tabletop. This subject is easy to set up, and it will provide repeatable speed if you simply start the ball rolling from the same point on the ramp each time. Position the camera to photograph the ball as it passes a marked position on the table. For best results, choose a bright-colored ball, like a yellow tennis ball, and use a dark tabletop and background.

Step by Step

1　Set up the ramp at one end of a large table by simply propping up one end of the board on a small box or several books. Mark a point about halfway up the ramp from which to start the ball, and mark another point on the table where you will photograph the ball as it passes.

2　Position the camera to photograph the ball as it passes the mark. Place the camera fairly close to the path of the ball, and be certain that the ball will pass directly across the field of view.

3　Make a meter reading and determine the exposure. For the first photograph, use a shutter speed of 1/8 second .

4　With the camera ready, start the ball from the mark on the ramp, and photograph it as it passes the mark on the table. Process the print and pin it to the wall, noting the shutter speed in the margin.

5　Repeat this process using shutter speeds of 1/2 second, 1/60 second, and a faster speed, if possible, adjusting the aperture as needed to maintain constant exposure. Process the photographs, label them, and pin them up for comparison.

6　To demonstrate the effect of a change in the speed of motion, make another photograph, this time starting the ball from the top of the ramp so it moves faster, and again using a shutter speed of 1/8 second. Process the photograph and pin it up for comparison with the first example.

7　To demonstrate the effect of a change in the direction of motion, move the camera to the end of the table so the ball will be rolling toward

With the ball started halfway up the ramp:

½ second

⅛ second

1/60 second

1/125 second

With the ball started at the top of the ramp:

⅛ second

With the ball moving toward the camera:

⅛ second

it. The distance from the camera to the point where the ball will be photographed should be about the same as in the preceding steps. Use a shutter speed of 1/8 second and start

the ball from the original mark halfway up the ramp. Photograph the ball using the same shutter speeds as in step 5 as it passes the fixed point on the

table. Process and compare the photograph with the first example, noting the difference in blurring of the ball.

Comments

- A rolling ball is an ideal subject because it is simple and its speed of motion is easily repeatable, but other subjects can be used: an electric train, a pendulum, or a student walking at a constant speed in front of the camera. Or, if your class can be moved outdoors: traffic on a street, a track and field runner, or water in a fountain. Outdoors you may need to use the slower Type 55 P/N film (ISO 50/18°).

- Since the rolling ball is an artificial subject, you might want to follow up this demonstra-

tion with an assignment for students to photograph a moving subject found in their own environment (see Assignments 2–1 and 2–2).

- With more complex subjects, some parts will be moving faster than others, and thus will produce different amounts of image blur. Examples might include a person swinging his or her arms while walking (the arms may be moving considerably faster than the body itself), the spokes of a bicycle wheel, or even wind-blown foliage in a landscape that appears to be stationary.

Camera Motion Affects Image Sharpness

Suggested Materials

35mm camera, manually adjustable, with 50mm lens
tripod
Polaroid 35mm instant slide system
Polaroid Polapan CT film, one 36-exposure roll
stationary subject; a wall with blackboard

The camera may move during the exposure time for various reasons that depend on the circumstances (for example, how solid the photographer's footing is, or what lens he or she is using) and the photographer (some have steadier hands than others). Apart from its occasional creative uses, movement of the camera during exposure is undesirable since it interferes with obtaining sharp images. An effective way to demonstrate this is to use a shutter speed that is too slow.

This demonstration, unlike the preceding ones, has direct student involvement. This allows students to see that some people can hold a camera steadier than others.

Step by Step

1 Begin by making four to six exposures of the stationary subject at different shutter speeds, with the camera hand-held. The suggested shutter speed sequence is 1/2, 1/8, 1/30, 1/125, and 1/500 second, or whatever range the circumstances permit. Adjust the aperture as necessary to maintain constant total exposure.

2 Then have the students each make one exposure of the wall and blackboard from a fixed distance. Make a mark on the floor in front of the target where the students are to stand, and write each student's name on the blackboard before each exposure so it will be visible in the photograph. Have

them all use the same shutter speed, 1/15 second. With a small class, you might have them each make two exposures, at 1/8 second and 1/60 second, for example.

Both photographs were shot at 1/15 second: the one on the left, with the camera hand held, and the one on the right, with the camera on a tripod.

Stanley Rowin

3 Save a frame or two at the end of the roll and photograph the same subject with the camera on a tripod for comparison.

4 Process the roll, mount the slides, and compare them by projection. Be careful when you project the slides because the differences in image sharpness will sometimes be slight. Begin by showing the sequence you exposed with the camera hand-held, and then proceed to viewing and comparing student slides. The final slides, made with the camera on a tripod, should be noticeably sharper than any of the hand-held exposures.

Factors Affecting the Representation of Motion

One element that is sometimes overlooked plays a vital role in determining the range of shutter speeds available: the film speed. If students try to photograph a fast-moving subject with a slow film, they will find that the highest shutter speeds are probably not available to them, even outdoors under bright conditions. News and sports photographers, for example, almost always use films of ISO 400/27° or faster, whether indoors or out. (Film speed also has an effect on the range of apertures available, as we'll see in Topic 3.)

Other important factors include the distance of the subject from the camera and the lens focal length; both affect the speed at which the image moves across the film plane.

Low-light levels aggravate the problems of arresting motion, and often flash is necessary to avoid the very slow shutter speeds that make it difficult to get a sharp image.

To review: Once the film speed has been determined, the factors affecting the rendering of a moving subject are
• the speed of the subject
• its distance from the camera
• its direction of motion
• lens focal length
• shutter speed

Comments

• The first step shows that the faster the shutter speed, the sharper the image. The second step demonstrates that each person's ability to hand-hold a camera steadily varies.

• The use of Polaroid 35mm film is ideal for several reasons. First, it allows students to participate in this demonstration by making an exposure themselves. Second, projecting the images gives higher magnification and thus makes blurring due to motion more apparent.

• While viewing the students' exposures, discuss the fact that people differ in their ability to get sharp images with a hand-held camera. Encourage students to press the shutter release smoothly, rather than stabbing it.

• There are numerous ways you can suggest to steady the camera, including bracing it against a stationary object, supporting it on a ledge or table, using beanbags or other stabilizers, and finally, of course, using a tripod. You may want to have students try out these techniques as part of an assignment.

Stopping Motion in a Photograph

Suggested Materials

35mm camera
Polaroid 35mm instant slide system
Polaroid Polapan CT film

To the Instructor

In most photographs the image is in sharp focus, so the goal becomes to arrest any motion of the camera or subject. This assignment helps students determine what shutter speed to use to secure a sharp image. This is also a good time to explain the many factors involved in stopping motion, including several not demonstrated here, such as lens focal length and distance to the subject.

Students will expose one roll of 35mm film of a single moving subject. By using different shutter speeds, they must determine how fast a speed was required to stop the movement of their subject. They should also write a description of their subject and a list of the factors that affected the minimum speed necessary to stop the movement.

Chris Clark
Instructor: Susan Hacker, Webster University, Webster Groves, MO

Points of Discussion

1 What are the important factors that determine the shutter speed required to stop motion?

2 For the subject you chose, what were the specific issues affecting the choice of shutter speed to stop motion?

Instructor: Elaine O'Neil, School of the Museum of Fine Arts, Boston, MA

Katherine Lyle f16 at ⅛ second

Katherine Lyle f5.6 at 1/60 second

Pat Naughton
Instructor: Susan Hacker, Webster University, Webster Groves, MO

ASSIGNMENT 2–1 Stopping Motion in a Photograph

In most photographs you want sharp images, and thus to be able to stop any motion of the subject or the camera. In addition to the shutter speed, important factors affecting the sharpness of the image include the speed at which your subject is moving and the direction of its movement in relation to the camera. The distance to the subject is another important consideration; a distant airplane can be traveling at hundreds of miles per hour, yet can appear to be almost stationary in the sky. The focal length of your lens is yet another factor; when you try to hand-hold a long telephoto lens, small motions of the hand that cannot be seen with a normal lens are magnified and become obvious.

In this assignment, choose a moving subject and expose a roll of film at different shutter speeds to determine what speed is required to stop the motion on film. Be sure to make notes on the subject you choose and the shutter speed you use.

Step by Step

1 Choose subjects that move at a fairly constant speed, so you can make several exposures of each subject while trying different shutter speeds.

2 Expose half of a 36-exposure roll of Polapan CT film, making six different exposures of three different moving subjects. A range of shutter speeds up to your camera's fastest can be used. Make notes on the shutter speed used for each exposure, and also record the circumstances that affect the shutter speed needed to stop motion.

3 Use the second half of the roll to shoot a variety of subjects in motion, attempting both to stop action and to create motion.

4 Process and mount the slides. Project them, and choose the one that shows motion effectively stopped to show and discuss in class. Also look at the different visual effects of the other speeds. Choose one or more other slides to show and discuss in class.

ASSIGNMENT 2–2

Motion as a Creative Element

Suggested Materials

35mm camera
Polaroid 35mm instant slide system
Polaroid Polapan CT film

To the Instructor

This assignment touches on both technical and creative matters relating to shutter speed and the representation of motion. It combines the main issues that affect motion—shutter speed, subject movement, and camera movement—helping students to understand these factors by using them creatively.

Students will expose one or more rolls of film of a single subject, trying several different approaches to representing motion, whether camera or subject motion. For example, they might choose a very fast or a deliberately slow shutter speed. Another technique they can try is panning, following the subject with the camera at a medium-range shutter speed that blurs the background while keeping the subject sharp. When they have finished, students should choose four photographs that work together to make a series that uses motion expressively.

Julie Reed
Instructor: Tom Lamb, Colorado Mountain College, Leadville, CO

1 How do you determine what shutter speed to use for photographing a moving subject?

2 Which techniques were most effective in representing your subject and why?

3 What difference does camera movement make in the image compared with subject movement?

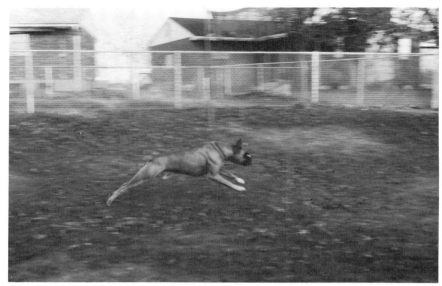

David Meyer
Instructor: Susan Hacker, Webster University, Webster Groves, MO

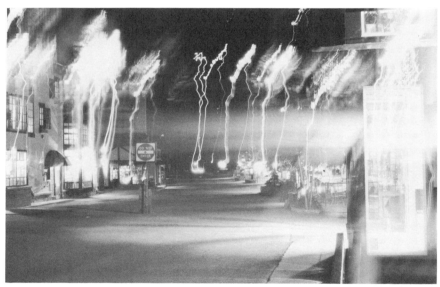

Julie Reed
Instructor: Tom Lamb, Colorado Mountain College, Leadville, CO

ASSIGNMENT 2–2 Motion as a Creative Element

Movement of the subject or camera is an important expressive element in a photograph. Your assignment is to shoot one or more rolls of film of one subject, trying different techniques for depicting motion. The result should be a series of photographs, each of which is visually different, and each of which communicates something different about the subject.

The approaches you can try include having the subject move or moving the camera. In both cases the effects depend in large part on the shutter speed you select. Another useful technique is panning. Use a moderate shutter speed and move the camera to follow a moving subject, so the subject is relatively stationary in the frame while the background becomes a blur. Try about 1/30 second for panning a typical subject—a person running past you, for example.

Here are some suggested subjects in motion: a ballet dancer, a wrestler, a diver, a horse, a motorcycle, car wheels, a tennis ball, wind-blown branches, or waves. Try photographing different directions and speeds of movement. You might even try a subject at rest, using camera movement and different shutter speeds.

Motion can appear very different depending on the technique used. The effect of panning does not look like random camera motion, yet both involve movement of the camera. Be prepared to discuss how different techniques communicate different things and why you think the techniques you chose represent the subject effectively.

Although this assignment requires you to try a variety of techniques, you may find that making a series of photographs using only one is most representative of the subject. For example, if your subject is a ballet dancer, your favorite photographs might show him or her exclusively in blurred motion using a variety of slow shutter speeds.

Step by Step

1 Choose a suitable subject to photograph.

2 Shoot one or more rolls of film, trying a variety of techniques to represent motion with that subject. These can include slow or fast shutter speed, panning, or other camera movement. Try to use these techniques creatively, in ways that best communicate the nature of your subject. Remember that the speed and direction of subject movement are factors in determining how the motion is represented on film.

3 Record data carefully, so you can remember how you achieved the results you did.

4 Choose your four most successful photographs to show in class. Be prepared to discuss the effect of each technique on what the photograph expresses about your subject.

DEMONSTRATIONS

Aperture Affects Depth of Field

Distance to Subject Affects Depth of Field

Focal Length Affects Depth of Field

Depth of Field Extends Farther Behind the Plane of Focus than in Front

ASSIGNMENTS

Using Depth of Field

Shutter Speed vs. Aperture

Prefocusing and the Depth-of-Field Scale

APERTURE AND DEPTH OF FIELD

This topic introduces the concept of depth of field: the area that appears in focus in front of and behind the object focused on. The most common control of depth of field, the aperture, is illustrated in Demonstration 3–1. Demonstrations 3–2 and 3–3 show the effect of subject distance and focal length on depth of field. Finally, Demonstration 3–4 shows the nature of the depth-of-field region, which extends farther behind the plane of focus than in front of it. As in previous topics, the demonstrations may be combined so that more than one is done in a single class session.

Aperture Affects Depth of Field

Depth of field is a difficult concept to explain to students, perhaps because our eyes automatically adjust to see everything in focus, whereas a lens records some areas sharply and other areas as blurs. Closing down the lens aperture makes more of the subject area appear sharply focused, although, of course, the plane on which you actually focus yields the maximum sharpness (see the box "Depth of Field that Goes on Forever" on page 43).

For this demonstration, you must have a prominent foreground and background. A simple way to arrange this is to use three students seated at different distances from the camera. Focus on the middle student, and photograph them at a large aperture and at a small aperture to show how the depth of field changes. The same arrangement of students can be used for the next two demonstrations.

Suggested Materials

4 × 5 camera
normal-focal-length lens
tripod
exposure meter
Polaroid Type 52 film
Polaroid 545 film holder
tape measure

Step by Step

1 Ask three students to act as models for your demonstration, and place them in chairs that are 4, 6, and 10 feet from the camera. Focus the camera on the student who is 6 feet away.

2 Make a photograph with the aperture wide open.

3 Make a second photograph with the lens stopped down 3 stops. Be sure that everything else, except the shutter speed which must be slowed up to compensate for less light, remains constant.

4 Make a third photograph with the aperture stopped down an additional 2–3 stops.

5 Process the prints and record the aperture used in the margin of each. Pin them to the wall for a comparison of the depth of field at three different apertures.

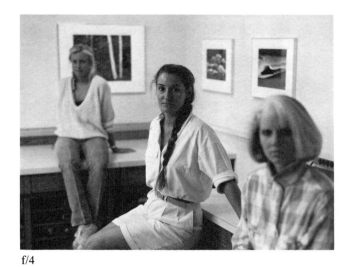

f/4

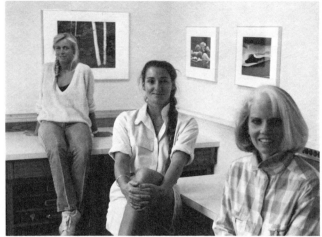

f/11

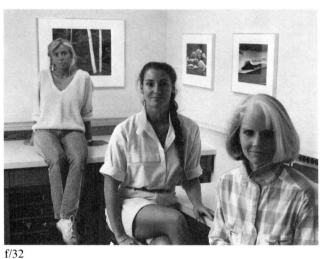

f/32

Comments

- Here are some alternative subject possibilities: a tabletop setup, a row of gravestones, a row of trees, or the side of a building.

- The subject must be stationary during these photographs. If you use students, having them seated should help keep them at least partly immobile. You should also be sure that only the aperture changes between the photographs. The focus setting and the positions of the camera and the students should remain the same.

- You may wish to point out here the effect on the shutter speed of stopping down the lens

(the smaller the aperture, the slower the shutter speed required), although this will be considered later (see Assignment 3–2).

- Discuss the visual effects that make use of shallow depth of field. Sometimes a great deal of depth of field only distracts from the main subject, and selective focus can be more effective.

- This demonstration makes use of the one-third principle, which is explained in Demonstration 3–4.

Distance to Subject Affects Depth of Field

Suggested Materials

4 × 5 camera
normal-focal-length lens
tripod
exposure meter
Polaroid Type 52 film
Polaroid 545 film holder
tape measure

All other things being equal, focus is more critical with nearby subjects than with distant ones since depth of field is limited when the lens is focused close up. In the extreme case, macrophotography, the depth of field is measured in inches or fractions of an inch. To demonstrate the relationship between subject distance and depth of field, you can continue working with the same subject as in the previous demonstration (perhaps in the same class session), or arrange a similar subject. This time you will be changing only the camera-to-subject distance.

Step by Step

1 Set up, or continue with, the same subject as in the previous demonstration. Be sure to preserve the distance relationships with your subjects 4, 6, and 10 feet from the camera.

2 Make one photograph, focusing on your subject 6 feet away, with the lens at its widest aperture.

3 Move the camera back to double the original distance from the subject; that is, the camera should be 8, 12, and 20 feet from the subject. Focus on the same subject as in step 2 (this time 12 feet away), and make a second exposure at the same aperture.

4 Move the camera forward to half the original distance from the subjects, so they are now at 2, 3, and 5 feet. Make another photograph refocusing on the middle subject (3 feet away), but not changing the aperture.

5 Process the prints and compare them. Although the subjects may become rather small in the second photograph, it should be clear that the depth of field is much greater than in the first one. The photograph at the closest distance will have the shallowest depth of field.

6 Now move the camera very close to one student. Focus on his or her eyes and make an exposure at the widest aperture.

7 Process the last photograph and discuss the depth of field. It should be evident that when the eyes are in focus, the ears and nose are not, and the background is completely out of focus. When the lens is focused close up to the subject, the depth of field is severely reduced.

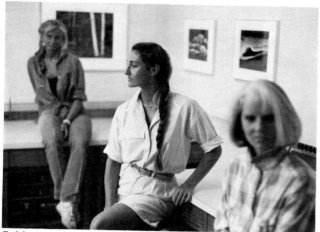

Subjects 6, 8, and 12 feet away from the camera

Subjects 12, 16, and 24 feet away

Subjects 3, 4, and 6 feet away

Close up

Comments

- You may wish to discuss and illustrate the depth of field problems with macrophotography and microphotography; in both cases the depth of field is so slight that subjects must be effectively in one plane to be rendered sharp.

Focal Length Affects Depth of Field

Lens focal length is an important factor affecting depth of field. A short-focal-length lens yields more depth of field at a given aperture and subject distance than does a longer lens (see Topic 4). This should be a familiar concept to students who have single-lens-reflex cameras with accessory lenses. Nearly everyone, for example, has seen published photographs made with a long lens in which the subject is in focus and the foreground and background are out of focus. The effect can be demonstrated with the same subject as in the last two demonstrations, photographing with two lenses of different focal lengths.

Suggested Materials

4 × 5 camera
wide-angle lens (90mm) and
 telephoto lens (210mm)
tripod
exposure meter
Polaroid Type 52 film
Polaroid 545 film holder
tape measure

Step by Step

1 Set up the same subject as in the previous demonstrations, or continue with the same students if these demonstrations are combined in a single class session. Be sure the three students will fit in the frame (and fill the frame) with the 210mm lens.

2 Using the 210mm lens, focus on the middle student and make a photograph at f/5.6.

Telephoto (210 mm) lens

3 Do not move the camera. Change to the 90mm lens and focus on the same subject. Make another photograph, again using f/5.6.

4 Process and compare the photographs. It will be obvious that there is more depth of field with the 90mm lens than with the 210mm lens.

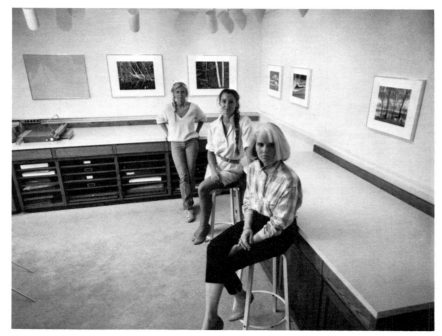

Wide-angle (90 mm) lens

Comments

- If you do not have wide-angle and telephoto lenses for the view camera, you can adapt this demonstration to Polapan CT film and project the results. The advantage of the 4 × 5 format is that students can see each image as it is made, and then all the results can be viewed side by side for comparison.

- Since focal length has not been discussed yet as a separate topic, mention to students that changing focal length has other effects that will be covered later (see Topic 4).

Depth of Field Extends Farther Behind the Plane of Focus than in Front

The rule of thumb regarding depth of field is to focus one-third of the way between the closest object you want sharp and the most distant. Although it is not always exact, this is a useful guideline. It indicates that the depth of field region extends farther behind the plane in sharp focus than in front of it. This can best be demonstrated using a subject that recedes at an angle from the camera, so the near and far limits of depth of field are easy to see in relation to the focus plane.

Suggested Materials

4 × 5 camera
normal-focal-length lens
tripod
exposure meter
Polaroid Type 52 film
Polaroid 545 film holder
tape measure

Step by Step

1 Choose a subject, such as a wall, table, or even the floor, where an 8–10 foot expanse can be seen at an angle receding from the camera. The surface should have texture or other detail that will clearly show whether it is in focus or not. Attach a tape measure that extends toward and away from the camera.

2 Focus on a specific mark near the midpoint of the tape measure, about 6 feet from the camera. Make a photograph with the lens wide open.

3 Process the photograph and determine where the near and far limits of depth of field are on the tape measure. Compare the distance from the plane of focus to the near depth-of-field limit with the distance from the plane of focus to the far limit.

The image is sharper behind the plane of focus than in front of it.

Depth of Field that Goes on Forever

A principle known as the hyperfocal distance rule provides the greatest depth of field possible when the subject extends to infinity. The hyperfocal distance is the distance to the nearest object in focus at a given aperture when a lens is focused at infinity. If the lens is focused at the hyperfocal distance, the depth of field will extend from one-half that distance to infinity. This principle can be applied using the depth-of-field scale. Focus the lens at infinity. Since the near limit of depth of field at the aperture you are using is the hyperfocal distance, if you focus at that distance, the depth of field will extend from half that distance to infinity. Or, easier yet, set

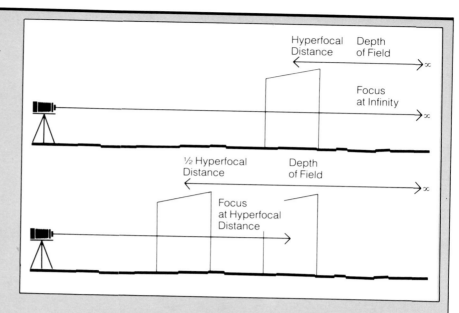

the infinity symbol opposite the mark indicating the far limit of depth of field for the aperture you are using.

Comments

- Other possible subjects include: a row of students, a row of trees, or a sidewalk with cracks.

- Students should be aware of the depth-of-field scale engraved on most lenses. Use this device to discuss with them the relationship of depth of field to aperture, subject distance, and focal length, as well as to illustrate the hyperfocal distance principle.

- The one-third principle is a rough guideline at best. In all critical cases students should refer to the depth-of-field scale or make test exposures with Polaroid film.

Using Depth of Field

Suggested Materials

35mm camera
Polaroid 35mm instant slide system
Polaroid Polapan CT film

Sandy Stergiou

Instructor: Lorie Novak, University of Massachusetts, Boston, MA

To the Instructor

This assignment asks students to use depth-of-field controls in a planned and thoughtful way. They should try to visualize how they want the picture to look, concentrating on image sharpness, and then apply the principles they have learned from the demonstrations to make it happen. In particular, they should consider how aperture, subject distance, and focal length affect depth of field. The one-third principle should be helpful here.

There are two important aids the students should know about. First, the depth-of-field preview button on most single-lens reflex cameras allows you to see the approximate range of focus at each aperture. (However, it can be difficult to judge depth of field from the often dim viewfinder image.) Second, as mentioned earlier, the depth-of-field scale on the lens barrel indicates the range of focus for whatever aperture is chosen.

Students will expose at least one roll of film, making use of the depth-of-field controls. They should be willing to experiment, perhaps photographing one subject in several ways. They should choose four photographs in which depth of field is used effectively for discussion in class. Some possibilities might include: the subject in focus with the background out of focus, the subject in focus and both the foreground and background out of focus, or all parts of the image sharp. If hyperfocal distance has been discussed, you may wish to incorporate it in this assignment.

John Coates

Points of Discussion

1 How can the required depth of field be reduced or increased by changing viewpoint? (One example would be using a less or more steep angle to photograph a table-top.)

2 In what different ways can depth of field be used to emphasize certain parts of the subject?

3 How do the depth-of-field scale and the preview button help in determining focus?

Mary A. Szoc
Instructor: Neal Rantoul, Northeastern University, Boston, MA

Kaz Tsuchikawa
Instructor: Elaine O'Neil, School of the Museum of Fine Arts, Boston, MA

ASSIGNMENT 3–1　Using Depth of Field

In this assignment you will be working with several different subjects in which depth of field is an important consideration. As you view each subject, try to anticipate how much depth of field you want and which controls you can use to get it. This is part of an important concept in photography, often called *visualization*: being able to anticipate how the image will look and to apply controls to modify it as desired. In this case, as you have seen, the primary controls are aperture, distance to subject, and lens focal length. Remember to focus about one-third of the way into the picture area, if you want maximum depth of field, or to refer to the depth-of-field scale on the lens barrel.

Make several exposures of each subject, exploring different alternatives. Expose at least one roll of film, and choose four photographs showing different approaches for class discussion.

Step by Step

1　Choose a suitable subject, one that has some depth to it. Examine the subject closely and try to visualize different ways you might handle focus and depth of field.

2　Make several photographs of the subject, using focus and depth of field in different ways.

3　Repeat this process with 2–3 subjects.

4　Choose your four most successful images to discuss in class. Be prepared to explain how depth of field works effectively in each.

Shutter Speed vs. Aperture

Suggested Materials

35mm camera
Polaroid 35mm instant slide system
Polaroid Polapan CT film

To the Instructor

By now, students have seen the factors that affect the choices of shutter speed and aperture separately. Of course, the two are related since they both affect exposure, and choosing one has an effect on the other. If a fast shutter speed is essential because of subject motion, then a larger aperture will be required, with accompanying loss of depth of field; if a small aperture is chosen to gain depth of field, a longer exposure time will be required to compensate.

For this assignment students photograph a moving subject in a way that requires them to take into consideration both motion and depth of field. Because they will be using a medium-speed film (Polaroid Polapan CT, ISO 125/22°), they may find it a challenge to satisfy both requirements, depending on the subject they choose. The assignment should help them see the tradeoff between aperture and shutter speed in practical terms.

Points of Discussion

1 Why does the interrelationship of aperture and shutter speed sometimes make it impossible to have both great depth of field and the ability to stop motion on film?

2 Would changing to a high-speed film help with this problem? Why?

3 How would a tripod help?

Pat Naughton

Instructor: Susan Hacker, Webster University, Webster Groves, MO

Marc L'Ecuyer

ASSIGNMENT 3–2 Shutter Speed vs. Aperture

Sometimes when photographing you will be faced with the need to compromise. You may have to give up some depth of field to use a shutter speed fast enough to arrest motion. Or you may find you have to support the camera for a long exposure because you need a small aperture for great depth of field. The relationship between depth of field and motion-stopping often involves a tradeoff. Choose a fast shutter speed to capture motion and you have to open up the aperture; choose a small aperture to get depth of field and you'll need a longer exposure.

For indoor events, such as dance or theater, you may not be able to "freeze" moving subjects, even with a fast film. Sports photographers often use electronic flash at indoor events, where they can be close enough to the subjects for the flash to act as the primary light source. Electronic flash is also used frequently for indoor events such as weddings (see Topic 8).

For this assignment, however, you will work with a medium-speed film and with available light, not flash. Your assignment is to choose a moving subject that also requires some depth of field, and to photograph it using different f-stop and shutter speed combinations to see how this interrelationship affects the final results. Some subject possibilities include: children playing, horses at the track, or swimmers in a pool.

Step by Step

1 Choose a moving subject that has important foreground and background areas.

2 Make several exposures using different aperture/shutter speed combinations. Try to include both large and small apertures, and fast and slow shutter speeds.

3 Repeat with at least two other subjects, exposing a minimum of one roll of film.

4 Process and mount the transparencies. Choose four to six of them to bring to class that illustrate the aperture/shutter speed tradeoff.

Prefocusing and the Depth-of-Field Scale

Suggested Materials

35mm camera
Polaroid 35mm instant slide
 system
Polaroid Polapan CT film

To the Instructor

This assignment introduces students to the idea that focus can be set in advance, which leaves them free to concentrate on the actions and expressions of their subjects. One reason for this assignment is to emphasize that there is a region of focus, not a single point. The technique, known as *zone focusing*, allows the photographer to preset the focus, knowing that a zone within the subject area will then be sharply focused. The focus is usually set for a fixed object, such as a signpost or a doorway, and the depth-of-field scale shows the range of the focus zone. Then, to photograph a moving subject passing through this region, no additional focusing is necessary.

Students will zone focus for a region about 7 feet from the camera, and photograph people passing through this area without focusing again. Students should expose at least one roll of film and choose their four best examples to bring to class for projection and discussion.

Kaz Tsuchikawa
Instructor: Elaine O'Neil, School of the Museum of Fine Arts, Boston, MA

1 Under what conditions might it be useful to be able to focus in advance?

2 What are some of the problems and tradeoffs that occur with this method?

Gary Neff
Instructor: Neal Rantoul, Northeastern University, Boston, MA

Mark S. Bouzane
Instructor: Elaine O'Neil, School of the Museum of Fine Arts, Boston, MA

Paula Brinkman
Instructor: John Craig, University of Connecticut, Storrs, CT

ASSIGNMENT 3–3 Prefocusing and the Depth-of-Field Scale

Focusing on a subject also sharpens an area in front of and behind the subject. This depth-of-field region is sometimes referred to as the *zone of focus*, and a technique called *zone focusing* can be helpful when you need to be able to shoot quickly. (Do not confuse this with the Zone System, described in Topic 6, which applies to exposure.)

To zone focus, you set the focus for a certain distance and then check the depth-of-field scale to see what region will be in focus at the aperture you are using. You might set the focus at a fixed distance—say, 7 feet—and then photograph your subjects when they are approximately that distance away. For example, you might prefocus on a doorway, so that when people passed through the door they would be in focus. You can prefocus on any other fixed object: a signpost, the corner of a building, or a location on a street.

For this assignment you'll expose at least one roll of Polapan CT film, using zone focusing under several different conditions. Keep in mind that the purpose of prefocusing is to leave you free to concentrate on the action in front of your camera so you can release the shutter at the optimum moment.

Step by Step

1 With a normal-focal-length lens, set the focus at an intermediate distance such as 7 feet and then check the depth-of-field scale to see what region will be in focus. For example, with a 50mm lens focused at 7 feet, f/8 yields depth of field from 6–9 feet.

2 Shoot several exposures of people as they pass through the zone of focus. Do not change aperture or focus. Because you do not have to focus each time, concentrate on the actions and expressions of your subjects.

3 Use the same technique at a different location. Altogether you should expose at least one roll of film.

4 Process and mount the slides, and choose the four best ones to bring to class for discussion.

DEMONSTRATIONS

**Lens Focal Length Affects
 Angle of View**

**Distance to Subject Affects
 Perspective**

The Wide-Angle Effect

The Telephoto Effect

ASSIGNMENT

Using Interchangeable Lenses

For students with several lenses, this topic introduces the concept of focal length and how it affects their photographs. The most obvious effect, the angle of view, is presented in Demonstration 4–1, followed by Demonstration 4–2 on the often-misunderstood concept of perspective. Demonstrations 4–3 and 4–4 discuss the wide-angle effect and the telephoto effect, respectively.

LENS FOCAL LENGTH

Lens Focal Length Affects Angle of View

Suggested Materials

4 × 5 camera
wide-angle (90mm) and
 telephoto (210mm or longer)
 lenses
tripod
exposure meter
Polaroid Type 52 film
Polaroid 545 film holder

Lens focal length affects how much of the subject is included within the image frame. Short-focal-length lenses include a broad subject area, making each part of the subject appear smaller; they are thus called *wide-angle* lenses. Longer lenses, called *telephoto* lenses, include less of the subject area and make each part look larger.

There are two important principles of focal length to communicate to students. Changing focal length changes the size of each part of the subject as it is rendered in the image; and if the camera position and subject remain constant, changing to a different focal length is comparable to a change in cropping, that is, the perspective remains the same and only the position of the borders imposed on the subject changes.

To illustrate these concepts, photograph a scene with lenses of different focal lengths. Be sure that the subject is fixed and the camera position remains the same.

Step by Step

1 Choose a student to sit as a portrait subject. Position him or her against a background that is varied and filled with detail; avoid plain backgrounds such as a blank wall or seamless paper or it will be difficult to see the angle of view.

2 With the telephoto lens in place, set up the camera on a tripod to make a portrait of the subject's head.

Subject photographed through telephoto lens

Same subject — wide-angle lens

3 Without moving the camera, make another exposure using the wide-angle lens.

4 Process the prints as they are made, and pin them to the wall. Now compare the images. Note that the size of the image (for example, the face) decreases as you change to a shorter-focal-length lens. Also note that changing focal length affects the angle of view as shown by the amount of background area included in each image, and, thus, is comparable to a change in cropping. It does not alter the image in any other way; the relationship of the person to the background (and foreground, if there is any) remains the same in both photographs.

Comments

- You can expand on these principles to point out that doubling the lens focal length doubles the size of the image of any object. The practical effect of this helps you make lens changes. If you know you want to reduce the image size of your subject by half, for example, you need a lens of half the focal length.

- The change in angle of view is comparable to what happens with a pinhole, where changing the distance from pinhole to film changes the angle of view. If the pinhole is close to the film, there is a wide angle of view, comparable to that with a wide-angle lens. If the pinhole is farther from the lens, the angle of view is narrower.

Distance to Subject Affects Perspective

Suggested Materials

4 × 5 camera
wide-angle (90mm) and telephoto (210mm or longer) lenses
tripod
exposure meter
Polaroid Type 52 film
Polaroid 545 film holder

People often confuse the effect of changing lenses with the effect of changing the camera-to-subject distance. As we saw in the previous demonstration, changing focal length without moving the camera is comparable to changing the cropping of a photograph. The true *perspective*—the relationship between near and distant objects within the image—does not change unless the camera is moved.

This is a familiar phenomenon, and one that we take for granted in the visual world. If we hold up our hand in front of our eyes, the hand appears larger—that is, occupies more of our field of vision—than a person standing 10 feet away. The distance from our eyes causes the hand to appear larger than the person. The situation is similar with a camera. If two identical objects are different distances from the camera, the closer one appears larger—or, at least, occupies a larger area in the field of view. This is the basis of perspective effects (for example, the fact that receding parallel lines appear to converge). In practice, however, the visual effects related to distance are often confused with those related to focal length, and all are commonly grouped together under the heading of perspective.

To show the effect of subject distance on perspective, have two students sit to be photographed, with one closer to the camera than the other. Photograph them with both a wide-angle lens and a telephoto lens, at two different distances, so you can compare the effects.

Step by Step

1 Have two students take seats, about 3 feet apart.

2 Set up the camera 7 feet from the nearer student (10 feet from the farther one).

3 With the telephoto lens attached, focus a third of the way between the students and stop down sufficiently to render both sharply. Photograph the students.

4 Without moving the camera, change to the wide-angle lens. Focus and stop down as before, and make a second photograph.

5 Put the telephoto lens back on, then move back so the camera is 15 feet from the close student. Adjust this distance if necessary so the subject area covered is comparable to that covered by the wide-angle lens in step 4. Photograph the students with the telephoto lens, then with the wide-angle lens.

Students positioned 7 and 10 feet away from the camera, photographed with a telephoto lens

Same subjects, at the same distance away, photographed through a wide-angle lens

Same subjects, at 15 and 18 feet away, photographed through a tele-photo lens

6　Process and compare the photographs. The two photographs made at 7 feet have the same perspective; that is, the relationship between the closer person and the more distant one is unchanged. The closer person appears noticeably larger than the distant one in both images. Only the subject area (the cropping) changes when the lens is changed. When the camera is moved to include more of the subject, the perspective changes. Compare the two photographs made with the telephoto lens. In the one made at 15 feet, the size difference between the two subjects should be much less noticeable than in the one made at 7 feet.

Comments

- Point out that this situation represents the choices available when you want to get more of the subject into the picture. Move back with the same lens or remain where you are and change to a wide-angle lens. The two choices have quite different effects.

- The actual focal lengths used for this demonstration are not important, but the longer lens should be at least twice the focal length of the wide-angle lens. Whatever the actual focal lengths, try to choose camera positions so that the lenses cover about the same background area in steps 4 and 5.

- Type 57 film is recommended because its high speed should permit you to keep the lenses well stopped down, eliminating depth-of-field problems that might occur with the telephoto lens. Outdoors, or in a very bright classroom, it may be possible to use Type 52.

The Wide-Angle Effect

Several qualities characterize photographs made with wide-angle lenses, so we can often recognize them immediately. They usually appear to have more space and depth, a more "three-dimensional" feeling. In addition, they have more depth of field. Sometimes shapes within the image are distorted because the wide-angle lens invites us to move very close to our subject; the extreme case is the fisheye lens.

Since distortion of shape is one important characteristic of wide-angle photographs, this demonstration illustrates the effect. Again, we'll use a portrait situation. For comparison, make a photograph with a normal lens. (If you haven't introduced students to the term *normal lens,* this is a good time to do it; see the box "Lenses: Some Terminology" on page 61.)

Suggested Materials

4 × 5 camera
wide-angle (90mm or shorter) and normal (150mm) lenses
tripod
exposure meter
Polaroid Type 52 film
Polaroid 545 film holder

Step by Step

1 Choose a portrait subject. Set up the view camera and photograph the subject using the normal lens so that his or her head fills the frame.

2 Change to a wide-angle lens and move in very close, so that the head again fills the frame. Make another photograph.

3 Process and compare the photographs. Although they "cover" approximately the same subject area, there will be a marked difference in the person's features. The photograph made with the wide-angle lens will show distortion of features such as the nose or ears. As discussed previously, this is an effect of the distance from the camera to the subject, not actually of the focal length itself.

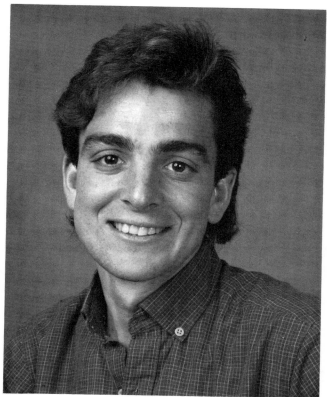

Subject photographed through a normal lens

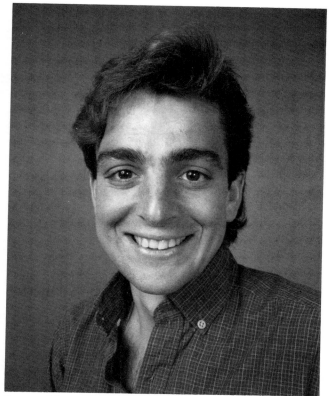

Same subject through a wide-angle lens close up

Comments

- Use a view camera lens shorter than 90mm, if available, for this demonstration. It will make the distortion more pronounced.

- If you wish, you can show the class how a 90mm lens can be a wide-angle lens for the view camera and at the same time a telephoto lens for a 35mm camera. Take one of the Type 52 prints made with the lens and trace an actual size 35mm frame on it. You can simply trace the outline of a 35mm negative carrier from an enlarger, for example, or the cutout area of a slide mount. Show how, with the surrounding area eliminated, the image in the 35mm frame is "telephoto" in its angle of view, or cropping.

- This demonstration and the next one can also be done using a 35mm camera and Pola-pan CT, but several advantages of 4 × 5 are lost: the entire roll must be exposed before processing, and you no longer have the ability to compare the images side by side. However, 35mm may be preferable with a very large class, since projected slides are easily seen by a group. The 35mm camera is also more familiar to students.

The Telephoto Effect

As with the wide-angle lens, photographs made with a long-focal-length lens have recognizable visual characteristics. The spaces often seem flat or compressed, and the borders may feel "tight." The image of an object is magnified, and the depth of field is shallow. Some of these characteristics are due to the focal length itself and some, such as the apparent flatness, are actually due to subject distance, but all are part of the "telephoto effect."

This demonstration involves making a photograph of a distant scene. It is thus important to take the class outside, or at least photograph a scene through a window. Photograph the subject with a telephoto lens and with a normal lens. Comparing the two will show an apparent compression of space.

Suggested Materials

4 × 5 camera
normal (150mm) and telephoto lenses (240mm or longer, if available)
tripod
exposure meter
Polaroid Type 52 film
Polaroid 545 film holder

Step by Step

1 Find a distant subject that recedes from the camera or that includes elements at different distances. You want to be able to see the relationships of shapes at different distances when you use the telephoto lens.

2 Photograph the subject from the same position with the telephoto lens and with the normal lens.

3 Process and compare the photographs. The visual effect of the image made with the telephoto lens should be apparent: a flattening of the subject and tight borders.

4 Crop the photograph made with the normal lens to show the same area covered by the telephoto. In terms of perspective and apparent flatness, the two will be identical, differing only in size.

Through a normal lens

Same subject through a telephoto lens

Lenses: Some Terminology

Focal length. The focal length is an indication of a lens's angle of view, whether it is *wide-angle* or *telephoto*. Actually, focal length is a measure of the distance from the optical center of a lens to the film plane when the lens is focused at infinity. For any given subject and distance, a long-focal-length lens will yield a larger image than a shorter lens. Image size is proportional to focal length. If you double the focal length, you will double the size of the image.

F-number. An f-number is a measurement of how large the lens opening (or aperture) is. The larger the f-number, the smaller the aperture and the less light that will pass through the lens. The aperture is measured as a fraction of its focal length. For an f/4 lens, the aperture is 1/4 the focal length—25mm for a 100mm lens, 1½ inches for a 6-inch lens, and so on.

Normal lens. A normal lens gives approximately the view seen by the human eye. The usual standard for a normal lens is that its focal length is approximately equal to the diagonal of the film. Thus for 4 × 5 film, the normal lens is 6–7 inches (150mm is usually used). For 35mm cameras, this guide indicates that about 43mm is normal, although 50–55mm is the accepted standard. For 2¼ × 2¼, 80mm is the normal lens.

Using Inter-changeable Lenses

Suggested Materials

35mm camera
Polaroid 35mm instant slide system
Polaroid Polapan CT film

Edward Kinney
Instructor: Richard Zakia, Rochester Institute of Technology, Rochester, NY

To the Instructor

In this assignment students are asked to make photographs using wide-angle and telephoto lenses creatively, in ways that make important contributions to the final images. There are a number of purely practical reasons for choosing a wide-angle or tele-photo lens. You might choose a wide-angle lens to photograph an interior when you can't move back to encompass the space. Or you might choose it for more subjective reasons, such as giving a sense of depth to an image. Students should be prepared to discuss why the choice of lens works to enhance each photograph.

Students will expose at least one roll of film, with the aim of making a series of six photographs in which the choice of lens is a significant part of the image. For students who do not have interchangeable lenses, you might suggest a session of team shooting, with students sharing cameras and lenses.

Points of Discussion

1 Did one type of lens— wide-angle or telephoto—lend itself better to your style of photography? Why?

2 Did you find other differences between various lenses, such as differences in exposure, contrast, or sharpness?

Bob Kownacki
Instructor: Elaine O'Neil, School of the Museum of Fine Arts, Boston, MA

ASSIGNMENT 4–1 Using Interchangeable Lenses

The visual effects produced by wide-angle and telephoto lenses can be used creatively in making your photographs. The compression that occurs with telephoto lenses, for example, can suggest such qualities as crowding, flatness, or great distance. Similarly, with wide-angle lenses, the appearance of depth can lend a quality of immediacy or intimacy to a photograph or suggest open space. There are also differences in depth of field. Wide-angle lenses have more depth of field than the longer lenses. Some loss of sharpness may occur with a telephoto lens because it magnifies any movement caused by hand-holding the camera; possible solutions include using fast shutter speeds with long lenses or a tripod or other means of bracing the camera.

In this assignment you will expose a roll of film using lenses of different focal lengths to explore the image possibilities. In each case, think carefully about the lens you are using and how it contributes to the photograph you want to make. Experiment with as wide a variety of subject types as possible to see the effects you can create under different circumstances.

If you do not have access to the three basic types of lens (normal, wide-angle, and telephoto), try to borrow them, or arrange to shoot with a friend. If you use a zoom lens, be sure to record the exact focal-length setting used for each photograph.

Step by Step

1 Choose a subject that you are interested in photographing, and decide what focal-length lens will work best for the subject. Be sure to consider carefully the effect on the final image.

2 Photograph the subject with that lens and record the focal length, aperture, and shutter speed you use.

3 Repeat this process until you have shot at least one roll of film on several different subjects.

4 Process and mount your six best photographs to bring to class. In each case, be prepared to explain why you chose the lens you did.

DEMONSTRATIONS

Middle Gray
Subjects That Are Not Average
Subject Contrast
Reciprocity Failure

ASSIGNMENTS

Exposing for Shadow Detail
**Photographing Dark and Light
 Subjects**
Backlighting
Photographing in Dim Light

EXPOSURE

Most beginning photographers rely on camera automation to take care of exposure. For more sophisticated control of the photographic process, exposure must be understood fully. A major problem is that subjective considerations arise: how do you *want* the image to look? This is why learning to control exposure is so important. By controlling exposure, rather than allowing the camera to control it, you gain the ability to alter your images for expressive reasons. This topic, and Topic 6, look at exposure in depth. The first important concept, introduced in Demonstration 5–1, is middle gray, a basic reference point in exposure. This is followed by Demonstration 5–2 on metering subjects that are not middle gray, and then Demonstration 5–3 on subject contrast. Finally, Demonstration 5–4 presents the exception to the rule, reciprocity failure.

Middle Gray

Suggested Materials

4 × 5 camera
normal-focal-length lens
tripod
averaging reflected-light meter
 (not a spot meter)
Polaroid Type 52 film
Polaroid 545 film holder
large sheets of white and black
 matte construction paper
18% gray card

An exposure meter cannot distinguish an all-white subject from an all-black subject or a subject of average values. The meter is calibrated on the assumption that the subject is average—made up of roughly equal light and dark areas.

An 18% reflectance gray card is the standard reference value in photography; it represents an average subject. A reading made from an 18% gray card should give the same exposure as an average reflected-light reading from a subject made up of equal light and dark areas. (A gray-card reflected-light reading will also give the same exposure as an incident-light reading.) In this demonstration, students are shown that different parts of a subject can give very different meter readings and that the gray card gives a reading equal to the average.

Step by Step

1 Pin the sheets of construction paper to the wall so they overlap slightly, and light them uniformly.

2 Make meter readings of the white paper and the black paper separately, and write them on a blackboard. Discuss with students that you can get very different exposure readings from a single subject, depending on whether the readings are made from dark or light areas.

3 Move the meter back and make a reading that averages the white and black sheet together (that is, hold the meter so it reads equally from the white and the black sheet). This corresponds to making a single reading of an average subject. Record the indicated exposure on the blackboard as the average reading.

4 Pin the gray card to the wall in the center of the line where the white and black papers overlap. Make a reading from the gray card, and record it on the blackboard. It should match the average reading of step 3.

5 Photograph the target at each of the three different exposure readings. Process each one, write the exposure in the margin, and pin them to the wall for comparison.

Results using meter reading — f/8 at ⅛ second — from the black construction paper

Results using meter reading — f/8 at 1/125 second — from the white construction paper

Results using meter reading — f/8 at 1/30 second — from the 18% gray card

Comments

- As you do this demonstration, relate the target to real life. The white and black papers represent light and dark areas of any subject. Students should realize that they can be misled by the meter and give the wrong exposure if they make meter readings from only the dark or only the light parts of a subject, or from a subject that is not average.

- Note that the average reading and the gray card reading were the same, and both gave correct exposure settings for a normal rendering of the subject.

- In the other two exposures, the area in which the reading was taken rendered as approximately middle gray in the final print.

This is because the meter gives exposure settings based on the assumption that whatever area was read was an average value, and should be an average middle gray in the final print.

- Be careful with lighting. You can avoid glare if you place one floodlamp on either side of the target, at a 45° angle to it.

- If possible, have students make readings with their own meters to help them see the difference in reflectance values.

Subjects That Are Not Average

Suggested Materials

4 × 5 camera
normal-focal-length lens
tripod
reflected-light meter
Polaroid Type 52 film
Polaroid 545 film holder
large sheets of white and black
 construction paper
18% gray card

Demonstration 5–1 should have made students aware that an average meter reading must be taken from an average subject or a middle-gray value to be accurate. For a reading from a predominantly light (high-key) or predominantly dark (low-key) subject, some compensation is required.

Using the same targets as in the previous demonstration, make the reading from the black sheet and then show students how to compensate to render it as a black. Then repeat the process for the white paper.

Step by Step

1 Set up the same targets and lighting as in the previous demonstration.

2 Make a meter reading from the black paper. Photograph the target at this exposure. Process the photograph and pin it to the wall. This will yield a middle-gray value.

3 Reduce the exposure by 2 stops and make a second photograph. Process it and compare with the first. Also compare the rendering of the black paper in this photograph with the black area in the target.

Results using meter reading — f/8 at ⅛ second — from the black construction paper

Results using meter reading from the black card minus 2 stops — for example, f/16 at ⅛ second or f/8 at ¹⁄₃₀ second

4 Make a reading from the white paper and photograph the target at this exposure. Process the photograph and pin it to the wall. Again, this will be approximately middle gray.

5 Increase the exposure 2 stops (it will be the same as, or very close to, the exposure of step 3). Make another photograph and process it. Compare the rendering of the white target with the original and with the photographs made at other exposures.

Results using meter reading — f/8 at 1/125 second — from the white construction paper

Results using meter reading from the white card plus 2 stops — for example, f/8 at 1/30 second, f/4 at 1/125 second, or f/16 at 1/8 second

Comments

• Once again, it is important to relate this demonstration to real-world situations. While making readings from the black paper, for example, you can discuss situations that involve predominantly dark (low-key) subjects: a dark interior, dark fabrics or clothing, or a shadowy woods. The white paper can be compared with bright (high-key) subjects.

Subject Contrast

Demonstrations 5–1 and 5–2 showed students how meters measure light reflected from subjects. Since the lighting was uniform, the contrast of the target was determined by the difference in reflectance of the white and black papers. Many real subjects are not under uniform lighting, but are, for example, partly in shade and partly in direct sunlight. In these situations, the contrast can increase dramatically. Other subjects may be under uniform lighting but may not include a full range of reflectances from white to black; such subjects are of very low contrast.

In this demonstration you'll introduce students to the term *contrast* and show them how to evaluate it using their exposure meters. You should also discuss the subjective effects of contrast. Since two different lighting situations are called for, you may wish to take the class outdoors to photograph in sunlight and open shade.

Suggested Materials

4 × 5 camera
normal-focal-length lens
tripod
reflected-light meter or spot
 meter
Polaroid Type 52 film
Polaroid 545 film holder
18% gray card

Step by Step

1 Arrange a portrait subject under very directional lighting, such as light from a single lamp or in direct sunlight.

2 Use a reflected-light meter (ideally a spot meter) to make readings from dark and light areas of the subject. Be sure to include important elements like the side of the face, hair, and clothing. Have the subject hold the gray card under direct lighting and make a reading from it. Record the readings on a blackboard or in a notebook, if outdoors.

Subject in high-contrast light

3 Make a photograph using the gray-card exposure reading. Process the image.

4 Change the lighting to a broad, flat illumination such as indirect indoor lighting. If outdoors, move the subject to a location of open shade.

5 Make readings of the same areas, including the gray card, and record them.

6 Photograph the subject again using the new gray-card reading. Process the image and compare it with the first photograph.

Same subject in low-contrast light

Comments

- As part of the discussion, show students the relationship between the exposure readings and the contrast of the photographs. In particular, the range in stops from the lightest to the darkest part of the subject should be noted.

- Studio photographers often evaluate the "lighting ratio" of a subject. You can do this by measuring the reflected light from the fully illuminated side of the face and the shadowed side, and expressing them in a ratio (or you can use an incident-light meter). For example, if the meter indicates a 1-stop difference between the highlighted and shadowed sides of the face, the ratio is 2:1. This method is somewhat specialized, and not generally as useful as the reflected-light measurement system already discussed or the Zone System presented in Topic 6.

Reciprocity Failure

Long exposure times are not unusual, especially when using large-format cameras. Most of the time we take for granted the reciprocal relationship between exposure time and aperture. Doubling one and halving the other results in no net change of exposure. But students should be aware that this relationship does not hold true at exposures longer than about one second.

To demonstrate this, arrange a subject that you can photograph at several long exposure times. If you then double the exposure time for each stop the lens is closed down, it should become clear that the exposures are not equivalent in their effect on the film.

Suggested Materials

4 × 5 camera
normal-focal-length lens
tripod
Polaroid Type 52 or Type 55 P/N film
Polaroid 545 film holder

Step by Step

1 Choose a portrait or still-life subject under normal room light or other low-level illumination. Arrange the light level so that a 5-second exposure at a moderate aperture is possible. Any means that achieves this long exposure time is all right, including making a close-up photograph that involves long bellows extension, or even placing neutral density filters over the lens. Polaroid Type 55 P/N film is recommended, discarding the negative and using only the print, because it is slower than Type 52.

2 Make three photographs using the following exposures:

5 seconds, at a relatively large aperture
10 seconds, stopped down 1 stop
20 seconds, stopped down 2 stops

3 Process the prints and pin them up for comparison.

Subject exposed at f/16 for 5 seconds Subject exposed at f/22 for 10 seconds Subject exposed at f/32 for 20 seconds

Comments

- The three photographs, although given exposures that normally we would consider equivalent, will be noticeably different. The one exposed for 20 seconds will be darker than the one exposed for 5 seconds. You may also get an increase in contrast.

Exposing for Shadow Detail

Suggested Materials

35mm camera
Polaroid 35mm instant slide system
Polaroid Polapan CT film

W. Dean
Instructor: Tom Lamb, Colorado Mountain College, Leadville, CO

To the Instructor

The demonstrations in this section should help students understand why determining exposure is a complex matter involving judgment, not just automatic measurement. When exposing negative materials, by far the most serious error made is *underexposure*, since it causes detail to be irrevocably lost in shadow areas. The opposite problem, overexposure, is less critical because detail is usually preserved (unless the overexposure is severe) and can be restored in printing by burning-in or using other printing controls.

In this assignment students are given a guideline to help them avoid underexposure. Measure any large and important shadow areas, and be sure a reading taken from them is no more than 2 stops below the overall exposure indicated for that scene. This will ensure that these areas are dark but contain detail in the negative. (Of course, you can use this reading from an important shadow area itself to determine exposure by stopping down 2 stops.)

The assignment is for students to photograph a subject that has large and important areas of shadow. In addition to the average reading or reading from a gray card used to determine the exposure, they are to meter the important shadow area and be sure it is not more than 2 stops below the overall exposure. (Note that, although Polapan CT film is used for this assignment, the principle of exposing for shadow detail applies primarily to negative films. With Polapan CT film, 1½ stops below the overall reading should give optimum results.)

Points of Discussion

1 What were the readings from the gray card and from the important shadow area? How contrasty was your subject, as indicated by these readings? How does subject contrast affect your readings?

2 Did your shadow-area reading require an adjustment in the exposure given?

3 Were you successful in preserving the detail in the shadow areas of the final photograph?

Glenn Suchon

Michael Pereira

Instructor: Alma Davenport, Southeastern Massachusetts University, North Dartmouth, MA

ASSIGNMENT 5–1 Exposing for Shadow Detail

The simplest way to make an exposure reading is to aim a reflected-light meter in the direction of the subject and use whatever exposure it indicates. By their very nature, metering systems built into cameras must work in this fashion, although various methods (such as *center weighting*) are used to help ensure that they base the exposure on important subject areas. However, such methods overlook an important aspect of exposure: the *contrast* of the subject.

With a low-contrast, or flat, subject, an average exposure reading will probably be entirely adequate. But as the contrast increases, the range of brightnesses in the subject begins to approach the limits of the film's ability to record them. At the extremes, some detail may be lost in the bright and dark areas of the subject. It is a characteristic of photographic processes that detail lost in the dark areas cannot be recovered by any processing methods. Detail in the high values that appears to be lost can often be preserved or restored by various processing and printing techniques.

Hence, in broad terms, it is usually better to overexpose than to underexpose. Certainly overexposure won't improve your negatives, but neither is it likely to have the disastrous consequences of underexposure, where detail in dark areas can be hopelessly lost. The best image quality of all, of course, occurs when a negative is neither overexposed nor underexposed, but given just the right exposure to preserve detail in the shadows.

To ensure that shadow detail will be maintained in your negatives, it is helpful to make separate readings of important low-value areas. For this assignment you will make a minimum of two readings for each subject. One should be an average reading, or reading from a gray card, to give you an overall indication of exposure; this is the reading you use to set your camera. The other reading is made from one or more important low-value areas. In general, important shadow-value readings should not be more than 2 stops below the indicated normal exposure to preserve detail.

For example, if your average (gray-card) reading indicates 1/60 second at f/11 and the shadow-value reading indicates 1/60 second at f/5.6, you can expect detail in the shadow areas. But if your meter indicates 1/60 second at f/4 for the shadows, you could expect some loss of detail. In this case it would be best to open up 1 stop from the indicated exposure. By setting 1/60 second at f/8 as the camera exposure, you would be compensating so that the shadow area was now 2 stops below the exposure given.

Step by Step

1 Choose a subject with large and important dark areas—areas that appear significantly darker than a gray card to the eye.

2 Make an overall reading or a reading from a gray card, and use this reading to set the exposure on your camera.

3 Make a separate reading from the important shadow area. Either read it with a spot meter or walk up to it and make a reading of just that area with a broad-angle meter.

4 Record the two readings and compare them. If they are more than 2 stops apart, adjust your camera exposure so it is 2 stops from the shadow-value reading. Make a photograph at this setting.

5 Repeat this process with at least three other subjects of different contrast.

6 Process the film. Bring four examples to class for discussion.

Photographing Dark and Light Subjects

Suggested Materials

35mm camera
Polaroid 35mm instant slide
 system
Polaroid Polapan CT film

To the Instructor

As students gain experience making exposure readings and measuring contrast, you can introduce the situations that represent exceptions to the rules. Among these are the mostly light and mostly dark subjects. Photographing either one requires understanding how exposure works and how to make adjustments to compensate for subjects that do not average out to middle gray in value.

For this assignment students are asked to find examples of both kinds of subject and photograph them, both at normal exposure and compensating for the nature of the subject. Discuss the matter of how to compensate in class. With the Polapan CT film, it is probably best to suggest that they open up 1½–2 stops from the indicated reading for bright subjects, and stop down 1½–2 stops for dark subjects.

Ryder T. Windham
Instructor: Alma Davenport, Southeastern Massachusetts University, North Dartmouth, MA

1 What happens at normal exposure when you don't compensate for the light or dark nature of the subject?

2 How well are your subjects represented when you do adjust exposure? Was the adjustment you made too much, too little, or was it just right?

Paula Gendron
Instructor: Alma Davenport, Southeastern Massachusetts University, North Dartmouth, MA

Susan Leary
Instructor: Alma Davenport, Southeastern Massachusetts University, North Dartmouth, MA

Jan and Pete Jagoda
Instructor: Jim Stone, Breckenridge Summer Workshops, Breckenridge, CO

ASSIGNMENT 5–2 Photographing Dark and Light Subjects

The methods you have used for exposure determination—a gray card reading and checking for the low-value exposure—are adequate for most situations. In some cases, however, subjects do not have average values, but are made up of nearly all dark areas or all light areas. With these subjects you will not have the usual problem of contrast to contend with—they are inherently low-contrast subjects. But it is important to compensate in exposure to render them appropriately.

With a subject made up of all light areas or all dark areas, the meter will indicate exposure that will render the subject middle gray. For a light subject this will be insufficient exposure, and you will have to compensate by opening up the aperture or using a longer exposure time. For a dark subject, the meter will indicate too much exposure, and you will have to stop down the aperture or use a shorter exposure time. With most conventional black-and-white films you might compensate by 2 stops; with the Polapan CT film used for this assignment, 1½ stops should be right for most subjects.

Step by Step

1 Choose a subject that is predominantly light—for example, a snow scene, white fabric, or white wall of a building.

2 Make an average exposure reading and record the settings. Make a photograph at this setting.

3 Adjust the exposure by opening up the lens 1½–2 stops, and make another photograph.

4 Now choose a predominantly dark subject, such as a very dark fabric or a dark interior. Again, record the average exposure reading and photograph the subject.

5 For the dark subject, compensate by stopping down the lens 1½–2 stops. Make a photograph at this adjusted setting.

6 Process and mount the slides.

Backlighting

Suggested Materials

35mm camera
Polaroid 35mm instant slide
 system
Polaroid Polapan CT film

Lisa Almeida

To the Instructor

Another exception to the norm in exposure is a backlit scene, in which an average meter reading is likely to cause underexposure of the most important parts of the subject. Making separate readings of the main subject is the best way to compensate. However, it is difficult to make accurate meter readings in this situation without a spot meter, since a general-purpose meter may be influenced by the strong light from behind the subject.

In this assignment students will photograph a backlit subject. They should make a separate reading of the main subject, if feasible, or estimate exposure compensation for the existing conditions. (Note: this is a good time to introduce the concept of bracketing exposures.)

Charles Dunham

Instructor: Alma Davenport, Southeastern Massachusetts University, North Dartmouth, MA

Points of Discussion

1 Why is it difficult to make an accurate meter reading with a backlit subject?

2 What are some ways in which backlighting can be used creatively?

Instructor: Alma Davenport, Southeastern Massachusetts University, North Dartmouth, MA

Krystal Tolley

Instructor: Elaine O'Neil, School of the Museum of Fine Arts, Boston, MA

Valery Daniels

ASSIGNMENT 5–3 Backlighting

Light coming from behind your subject can produce some interesting visual effects, such as a halo of brightly lit hair around a portrait subject's face. However, backlighting is also likely to cause difficulty with exposure, since the light source may shine directly into the meter. A similar situation occurs when a subject is photographed against a very light background: the bright background will influence an average meter reading. Compensation is required to avoid severely underexposing the main subject.

For this assignment you will make several photographs of backlit subjects or subjects that appear against a bright background. Photograph these subjects both with an overall average meter reading and compensating for the light conditions.

Step by Step

1 Find a subject that is backlit or positioned against a very light background, for example, a portrait subject against the sky or indoors against a window.

2 Make an average scene reading with your meter, and photograph the subject at that exposure.

3 Then move closer and make a separate meter reading from your subject, trying to exclude the effect of the bright background or backlighting. Use this reading to make a second photograph of this subject. (If it is not feasible to make a reading of the subject excluding the background, give 1½–2 stops more exposure than your average reading indicated.)

4 Repeat this process with three other subjects. Process and bring to class both exposures of all four subjects.

ASSIGNMENT 5–4

Photographing in Dim Light

Suggested Materials

35mm camera
Polaroid 35mm instant slide system
Polaroid Polapan CT film

Carolyn Chun

To the Instructor

Photographing at night or in weak illumination raises special problems. The contrast is often high, and you must make meter readings with care to avoid loss of detail in dark values. It is difficult to make accurate meter readings in low light, partly because meters tend to be less accurate at very low levels. In addition, the long exposure times raise the problem of how to obtain sharp images and often require the use of a tripod.

This assignment will give students practical experience with the problems of low-light photography by photographing several subjects in dim lighting, using different techniques to ensure good exposure and sharp images. This is another situation where bracketing exposures is useful.

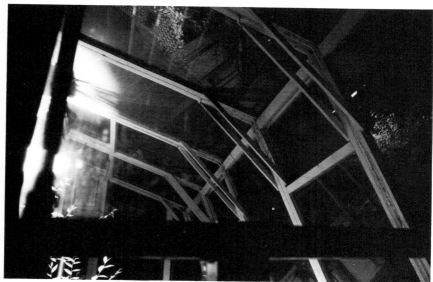

Linda Curran

Instructor: Kenda North, University of California, Riverside, CA

Points of Discussion

1 How can fast lenses, fast films, a tripod or other support, or flash be helpful when you are photographing in dim lighting?

2 How did you handle exposure to ensure good shadow detail?

Instructor: Kenda North, University of California, Riverside, CA

Walt Zamojski

Tina Verder

ASSIGNMENT 5—4 Photographing in Dim Light

You have already seen some of the problems that can occur with exposure measurement. Photographing at night or in low-level illumination raises some new problems. Measuring exposure accurately is often difficult. Your meter is likely to be less accurate in very weak light or may not register at all. If you do get a reading, it may be from high values and light sources and thus indicate less exposure than is actually needed. The contrast may be quite high and loss of shadow detail is likely. In addition, exposure times will be long, even with a fast film, so you must contend with the problem of maintaining image sharpness and perhaps also with reciprocity failure.

Step by Step

1 Choose a subject in low light—for example, urban street scenes at night, landscapes at dawn or dusk, or an interior under weak lighting.

2 Make careful exposure readings. If the subject is contrasty—for example, a street scene or interior containing bright lights—be sure to allow extra exposure for the shadow areas, if possible.

3 Photograph the subject, bracketing the exposures if this is feasible with your subject.

4 Repeat with several subjects using an entire roll of film. After processing, choose four photographs to bring to class.

DEMONSTRATIONS

The Scale of Zones
Determining the Texture Range
Placing a Value on One Zone

ASSIGNMENTS

Expose for Shadow Detail
**Zone System Exposure—Light
 and Dark Subjects**
**Zone System Exposure—
 Backlighting**

THE ZONE SYSTEM

The Zone System is a framework for relating what you see in the subject to what you get in the negative and to what you can reproduce in print. It allows you to make readings from different parts of the subject and evaluate them in terms of the scale of gray values of the final print. The ability to do this makes it possible to visualize the final print, and thus make exposure and processing decisions to achieve the desired final effect. Most of the key concepts of the Zone System have already been presented in a more basic form in the previous sections on exposure.

The Scale of Zones

Suggested Materials

4 × 5 camera
normal-focal-length lens
tripod
reflected-light meter
Polaroid Type 52 film
Polaroid 545 film holder
single-value subject, such as a white or dark wall, or a gray card

The Zone System uses a scale of gray values that ranges from solid black to pure white, spanning all the possible values in a photograph. The scale is anchored in the middle, where Zone V is defined as middle gray, comparable to an 18% gray card. A meter reading from any uniform surface used to determine exposure will lead to a middle-gray value in the print for that area. Since middle gray is defined as Zone V, this exposure is called "Zone V exposure" for that surface.

Stopping down 1 stop (by changing either aperture or shutter speed) from Zone V exposure gives Zone IV exposure for that surface, and stopping down another stop gives Zone III exposure. The print values that result are darker than middle gray: Zone IV is a dark gray, and Zone III is nearly black, but with detail. Zone II is black with a trace of texture, and Zone I approaches solid black. Similarly, opening up 1 stop from Zone V exposure gives Zone VI exposure; opening up another stop gives Zone VII exposure, and so forth. The print values that result are light gray (Zone VI) and near-white, with detail (Zone VII). Zone VIII is white with slight texture and Zone IX is bright white. (See the box "Scale of Zones for Conventional Films" on page 93.)

Using Polaroid film is the most convincing and instructive way to demonstrate this powerful but abstract concept. One reason is that the Polaroid print demonstrates the relationship between the subject value and the print value directly, so you don't need to discuss the intervening negative values until later. The scale of Polaroid films, however, is somewhat shorter than the scale of conventional prints, so the visual appearance of each zone and the amount of detail and texture it reveals is somewhat different.

Step by Step

1 Set up the camera in front of the target, making sure that the wall or surface is evenly illuminated.

2 Make a meter reading from the wall and record it on the blackboard or in a notebook. Choose an f-stop and shutter speed combination that will allow you to increase and decrease exposure by 3 stops on either side of the normal exposure.

3 Make one exposure at the indicated exposure and process it (it should match the tone of a gray card). Label it "Zone V exposure" and pin it to the wall.

4 Stop down by 1 f-stop or reduce the shutter speed by half and make another exposure. Process the print, label it "Zone IV exposure," and pin it to the wall.

5 Repeat this process with two more exposures, to obtain prints representing Zones III and II.

A gray scale

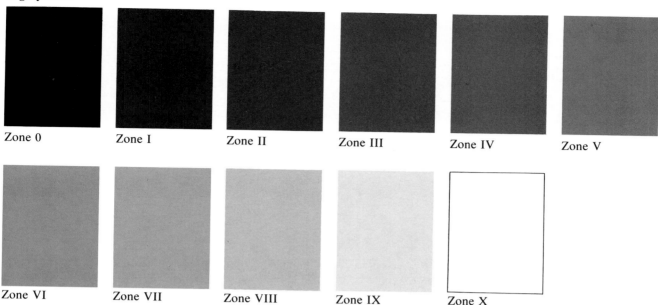

Zone 0 Zone I Zone II Zone III Zone IV Zone V

Zone VI Zone VII Zone VIII Zone IX Zone X

6 Then open up by 1 f-stop from the original (Zone V) exposure, or double the shutter speed, and make a Zone VI exposure, then a Zone VII and Zone VIII exposure.

7 Arrange the prints into a scale from darkest to lightest for discussion. The central principle is that the middle gray is defined as Zone V exposure, and each 1-stop change is defined as a one-*zone* difference in exposure.

Example

If your original meter reading is 1/30 second at f/5.6, here is a sequence you might use to make the exposure scale:

Zone V	1/30 second at f/5.6
Zone IV	1/30 second at f/8
Zone III	1/30 second at f/11
Zone II	1/30 second at f/16
Zone VI	1/30 second at f/4
Zone VII	1/15 second at f/4
Zone VIII	1/8 second at f/4
Zone IX	1/4 second at f/4

Comments

- Although you have not covered the entire scale possible with conventional films, you should have a good representation of black to white with Polaroid Type 52 film. Point out to students that conventional films have a longer scale.

- Emphasize that the target used represents any single-value area of any subject. The great power of the Zone System lies in the ability it gives you to visualize a subject area as a particular gray value in the print and then expose and process to achieve the intended value.

Determining the Texture Range

This demonstration is similar to Demonstration 6–1, but it makes a second essential point. There is a range of zones in which texture and detail are recorded. The Zone System gives the photographer an opportunity to control where texture is preserved and where it is lost. Making a scale of zones using a textured target will help students understand that texture is visible only within a certain exposure range.

Suggested Materials

4 × 5 camera
normal-focal-length lens
tripod
reflected-light meter
Polaroid Type 52 film
Polaroid 545 film holder
uniform-value target with texture, such as a cement wall, painted wood, or tweed fabric

Step by Step

1 Set up the camera in front of the target, making sure that the wall or surface is evenly illuminated. If necessary, position the light source so that light skims across the surface of the subject to show moderate texture.

2 Make a meter reading from the target and record it on the blackboard or in a notebook. Choose an f-stop and shutter speed combination that will allow you to increase and decrease exposure by 3–4 stops on either side of the normal exposure.

3 Make one exposure at the indicated settings and process it. Label it "Zone V exposure" and pin it to the wall.

4 Stopping down 1 stop at a time, make Zone IV, III, II, and I exposures (see earlier example). Process each one, label it, and pin it to the wall.

5 Then open up from the original (Zone V) exposure in 1-stop intervals to expose at Zone VI, VII, VIII, and IX.

6 Arrange the prints in a scale from darkest to lightest. Examine them to see where texture is present and where it is lost. From this you can arrive at the texture range of the film, which should be from about Zone III to Zone VII.

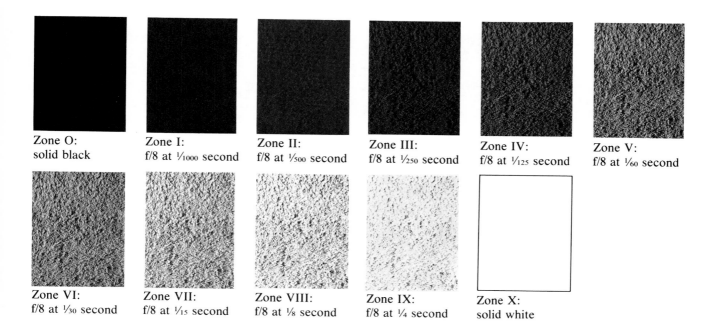

Zone O:
solid black

Zone I:
f/8 at 1/1000 second

Zone II:
f/8 at 1/500 second

Zone III:
f/8 at 1/250 second

Zone IV:
f/8 at 1/125 second

Zone V:
f/8 at 1/60 second

Zone VI:
f/8 at 1/30 second

Zone VII:
f/8 at 1/15 second

Zone VIII:
f/8 at 1/8 second

Zone IX:
f/8 at 1/4 second

Zone X:
solid white

Comments

- The texture scale determined in this demonstration applies only to Polaroid Type 52 film. Conventional black-and-white processes would probably have a longer scale. Conventional color transparencies have a range similar to Type 52.

- Remind students that the most important factor in determining exposure is maintaining detail and texture in the shadow areas, or low zones (see Demonstration 6–3).

Placing a Value on One Zone

To help students make the transition from the single-value surfaces used in the last two demonstrations to subjects in the real world, you can demonstrate photographing a full-scale subject using the Zone System. Often the most useful way to apply the Zone System is to make a meter reading from an important shadow area where texture must be preserved, and place that value on Zone III. Then you can read other subject areas and easily determine the zones in which they fall. Zone III placement ensures that detail will be preserved in the important shadow area and often provides a good literal rendering of a "normal" subject.

Suggested Materials

4 × 5 camera
normal-focal-length lens
tripod
reflected-light meter
Polaroid Type 52 film
Polaroid 545 film holder
18% gray card

Step by Step

1 Choose a full-scale subject—one with large areas of a single value that will be easy to meter accurately and that will show clearly in the prints. Include a gray card in the subject for reference.

2 Make a reading, if possible with a spot meter, from an important low-value area. This should be a dark surface where you want to preserve texture or detail.

3 Make readings from two or three other subject values, including the gray card, and record all readings on a blackboard.

4 Make one exposure using the aperture and shutter speed indicated in step 2 for the low-value area.

5 Stop down 2 stops to place that value on Zone III and make a second exposure.

6 Examine the print to see how the important shadow area was recorded. Then look also at the other areas where you made meter readings. Show students where they fall on the zone scale, and how they appear in the print.

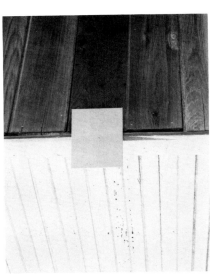

Exposure made with reading from shadow area — f/8 at 1/250 second

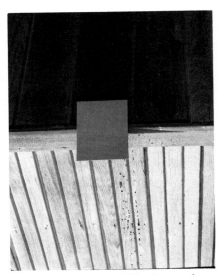

Same subject exposed for 2 stops less — f/16 at 1/250 second — thus placing the shadow area in Zone III

Scale of Zones for Conventional Films*

Zone 0	Solid black, the maximum black the paper can produce.
Zone I	First perceptible tonality above pure black, but still no texture or detail.
Zone II	Very deep tonality with slight texture or substance.
Zone III	Dark surfaces with substance and detail.
Zone IV	Average dark foliage, dark stone, shadows in landscapes; normal shadow value for Caucasian skin portraits in sunlight.
Zone V	Middle gray; clear north sky; dark skin; gray stone; average weathered wood.
Zone VI	Average Caucasian skin value in sunlight, diffuse skylight, or artificial light. Light stone, shadows on snow in sunlit landscapes.
Zone VII	Very light skin; light gray objects; average snow with acute side lighting.
Zone VIII	Whites with texture and delicate values; textured snow; highlights on Caucasian skin.
Zone IX	Whites without texture, nearly pure white; snow in flat sunlight.
Zone X	Pure white of the paper base; light sources and specular glare in the image. (Zone X is not always distinguishable from Zone IX.)

*With thanks to Ansel Adams

Comments

- Placing an important shadow area on Zone III ensures that detail will be preserved there. Some subjects do not have an area that is appropriate for Zone III, however, and students should be aware of alternatives; they may encounter a subject where the important dark area is more appropriately rendered on Zone IV, for example. This is where visualization comes in. If they can visualize the result of their placement, they can decide whether the intended exposure is appropriate.

- High values should be checked to see where they fall. If they are too high on the scale, an adjustment in exposure (or processing/printing, with conventional materials) may be needed.

- The procedure described here—basing the exposure placement on Zone III—is actually appropriate for negative films. With processes that yield a positive image directly, like transparencies or most Polaroid films, it is better to place an important high value on Zone VII or VIII since, with these films, the high values are where the lowest densities occur.

Expose for Shadow Detail

Suggested Materials

35mm camera
Polaroid 35mm instant slide
 system
Polaroid Polapan CT film

Sitthichai Phongmekhin
Instructor: Elaine O'Neil, School of
the Museum of Fine Arts, Boston,
MA

To the Instructor

This assignment follows up on the point made in Demonstration 6–3: Careful placement of values on the scale of zones ensures good shadow detail. It is important for students to see for themselves the difference between good detail and empty, dark shadows—the difference between shadows exposed on Zone III and those on Zones II or I. Although transparency films require careful placement of *high* values, they are nevertheless very useful in teaching the placement concept for the more usual situation, in which low values must be carefully exposed on a negative film.

For this assignment students will expose at least one roll of Polaroid Polapan CT film, using subjects containing large and important shadow areas. Each subject is exposed at different zone placements, to show the effect of each zone exposure on the shadow detail.

Shadow Zone I

Instructor: Richard D. Zakia, Rochester Institute of Technology, Rochester, NY

Shadow Zone II

Shadow Zone III

1 Why is exposing for the shadows so important?

2 How would you expect black-and-white negative film to differ from Polaroid Polapan CT film in tonal scale and shadow detail?

Stormi Grey
Instructor: Kenda North, University of California at Riverside, Riverside, CA

ASSIGNMENT 6-1 Expose for Shadow Detail

The discussion so far on exposure and the Zone System should have made one point clear. Exposure controls shadow detail. If you give enough exposure to the film, you will have adequate detail in the low values of your print; if you give too little exposure, your print will have thin, weak shadows lacking in detail. Nothing you do in the way of subsequent processing or printing steps can restore detail if it is lost through underexposure, which is why so much emphasis is placed on exposing for low values. With high values (whites and light areas), some processing and printing controls can help if detail is lost because they are too high on the scale. Thus high values can be controlled by both exposure and processing, while low values are controlled by exposure alone.

For this assignment you will photograph several subjects that have important low-value areas, bracketing exposures to see the results. Although you will be using Polaroid Polapan CT slide film to eliminate darkroom processing, low-value placement is actually most important when exposing negatives rather than transparencies.

Step by Step

1 Choose a subject that has large and important low-value areas. These may be areas in shadow or areas that are lower in reflectance than the gray card. They must be large enough to be read accurately with your meter and large enough so that the absence of detail will be clearly visible.

2 Make a meter reading from a low-value area where you want to preserve detail. Place that reading on Zone III. (To do this, stop down 2 stops from the meter-indicated exposure when you read that area; the meter reading itself is Zone V exposure, stopping down 1 stop is Zone IV exposure, and stopping down 2 stops is Zone III exposure.)

3 Photograph the subject at the Zone III exposure. Then make additional exposures, using Zone II, Zone I, and Zone IV placements of the same area.

4 Repeat this process with at least three other subjects. Process the film, and bring the four exposures of your best two subjects to class for discussion.

Zone System Exposure— Light and Dark Subjects

Suggested Materials

35mm camera
Polaroid 35mm instant slide system
Polaroid Polapan CT film

Linda Curran
Instructor: Kenda North, University of California at Riverside, Riverside, CA

To the Instructor

One of the great benefits of using the Zone System is the ability to compensate for nontypical subjects. In Topic 5 we discussed compensating for mostly light or mostly dark subjects, but the Zone System provides a working method that helps ensure appropriate exposure for nearly all subjects, including light and dark ones. The objective is to learn to visualize the finished image while looking at the subject, and then make exposure and processing decisions to achieve that image. With a subject made up of predominantly light values, you would visualize this and place the light readings on an appropriate high zone, perhaps Zone VII.

For this assignment, have your students choose two examples each of light and dark subjects. They should try to visualize the finished image for each example and place their meter readings on an appropriate zone to secure the image they visualize. Depending on how advanced your class is, you may want to have them first make an average reading of the overall subject area and expose at this reading for comparison, before exposing according to the zone placement.

Points of Discussion

1 Why can't you just take a meter reading and use the indicated exposure for light and dark subjects?

2 Were you able to visualize the final image? Did this help you make your exposure placement decision?

3 Was contrast a problem? If so, why?

Edward Kinney
Instructor: Richard D. Zakia, Rochester Institute of Technology, Rochester, NY

ASSIGNMENT 6–2 Zone System Exposure—Light and Dark Subjects

Your class discussions and assignments so far should have shown you how to determine exposure for normal subjects rendered more or less literally. There are times, however, when your subject is not average in range or when you wish to achieve a nonliteral rendering. An example of a nonaverage subject is a landscape of brilliant snow or sand that does not have an average distribution of light and dark values, but instead has mostly light values. With such a subject, a meter reading used directly to determine exposure will result in snow that appears middle gray, probably not the effect you want.

The Zone System allows you to handle such subjects easily and precisely. The process is as follows. First, look carefully at the subject and try to visualize the result you want (you should do this with all subjects anyway). Then make a meter reading from an important single-value surface of your subject, such as the snow in our

example. If you have visualized a rendering of the subject, you should have a good idea of what zone to place the reading on, and this will determine your exposure. With snow, for example, you might place the reading on Zone VII or VIII (see the box "Scale of Zones for Conventional Films" on page 93). The zone you choose may differ depending on the film used or your visualized image. With Polaroid Polapan CT film it is probably best not to place an important high value above Zone VI–VI½.

For this assignment you are asked to find examples of both high-key and low-key subjects. Make every attempt to visualize the result before making your exposure decision. Much of your skill as a photographer depends on your ability to relate the world in front of you to the different ways to render it photographically. Learning to visualize can help considerably.

Step by Step

1 Choose a subject that is mostly dark or mostly light. Be sure that nearly all of the subject is dark or light, even if you have to set up a subject.

2 Study the subject closely. How will it look in a photograph? How do you want it to look? Try to visualize the image you want. Then decide in what zones the important subject values should be.

3 Make a meter reading of the important high or low value and place it on the appropriate zone. If you wish to preserve detail, the range of zones you can choose from with Polaroid Polapan CT film is about III½ or IV to VI or VI½.

4 Photograph the subject at the exposure indicated for your zone placement. Be sure to record the exposure information: the meter reading, where the reading was taken, and what zone it was placed on or fell on.

5 Repeat with several different subjects. Altogether you should photograph at least two low-key and two high-key subjects.

Zone System Exposure— Backlighting

Suggested Materials

35mm camera
Polaroid 35mm instant slide system
Polaroid Polapan CT film

Laura Brown

To the Instructor

Another situation that calls for special judgment in exposure is backlighting, where the background is much brighter than the subject, or where the light source itself is behind the subject. Using the Zone System, you can meter the foreground subject separately and place the reading on Zone III or IV to preserve full detail (or on Zone II or lower to get a silhouette). If the scene includes a light background that must be recorded with texture or detail, the photographer must then determine where its brightness falls on the zone scale.

For this assignment students are to find several examples of backlit subjects and make the zone placements appropriate for their visualized images. You may wish to relate this to Assignment 5–3, where backlighting was discussed without reference to the Zone System.

Jeff Miller

Instructor: Sean Wilkinson, The University of Dayton, Dayton, OH

1 How did you choose to place the foreground, and why?

2 Where did the background brightness fall, and how does this look in the final image?

3 Are you visualizing your photographs accurately?

Tim Boone

Tim Boone
Instructor: Sean Wilkinson, The University of Dayton, Dayton, OH

Robert Rodriquez
Instructor: Kenda North, University of California, Riverside, CA

ASSIGNMENT 6–3 Zone System Exposure—Backlighting

A very light background or a light source behind the subject can cause exposure difficulties. Using a meter built into the camera, or making an average reading of the whole scene, you will probably underexpose the foreground subject. You can guess at an exposure correction, of course, but using the Zone System guarantees more accuracy.

Suppose, for example, that you are making a portrait of a person seated indoors in front of a large window. If you make an overall meter reading, the bright outdoor light will dominate the reading, causing the person to be underexposed. With the Zone System, you would make a separate reading of the person—the face or clothing or other important value large enough for an accurate reading—being careful to exclude light from behind the subject. You would then place this reading on any zone you wished. To preserve detail you would probably choose Zone III, although with a portrait you might prefer Zone IV or V. To produce a silhouette, you could choose a lower zone.

If the background is bright and you wish to record detail in it, as with the scene through the window, you will have to make a separate reading from the background and see where it falls

on the zone scale. If it falls on Zone IX, you know that it will not have detail and you should compensate, if possible, by adjusting your exposure. You may find, however, that changing exposure to record detail in the background will cause your main subject to be underexposed. With a negative film, you might then decide to expose for the main subject and try to secure detail in the background using printing controls (that is, burning in the Zone IX area). With transparency films, no such controls are available. You must decide on the best compromise. If keeping detail in your main subject is most important, you might have to abandon detail in the background (or you might be able to increase the illumination on your subject so the overall contrast is reduced).

For this assignment, find at least two situations involving backlighting or a very bright background. Try to visualize how the subject may appear, and then make meter readings and place the values appropriately on the scale of zones for your visualized image. Use other frames to experiment with different exposures, but be sure to keep careful notes about what you do.

Step by Step

1 Find or arrange a person in front of a very bright background or with the main light source behind him or her.

2 Look at the subject carefully, and visualize the different ways you might render him or her.

3 Make an overall meter reading of the scene and write it down.

4 Make a separate reading of an important plane or value of your main subject—the face, perhaps, or a piece of clothing. Be sure that light from behind the subject does not affect your meter reading. Place this reading on the appropriate zone and determine the camera exposure settings.

5 Make a reading of the background and see where it falls on the zone scale. Will there be detail in the background?

6 Make the photograph. Then repeat the process using at least one other subject.

DEMONSTRATIONS

**Filters Lighten Their Own
 Color**
The Polarizer

ASSIGNMENT

Using Filters

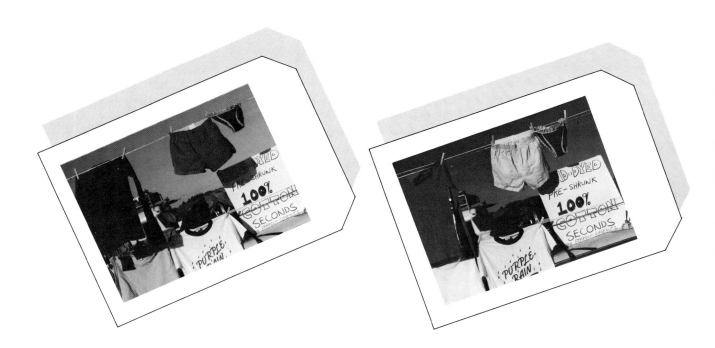

FILTERS

The use of filters with black-and-white film provides an important control of image tonalities. However, since the effect of a filter cannot be seen until the film is processed and printed, students can only guess at the final result. A demonstration of filter effects with Polaroid black-and-white film permits direct comparison of various filtered renderings with an unfiltered print and with the subject itself.

This topic begins with Demonstration 7–1 on the general use of filters, and is followed by Demonstration 7–2 on the polarizer. There is one assignment with several parts, which may be given separately if desired.

Filters Lighten Their Own Color

Color filters are useful for controlling contrast with black-and-white films. The underlying principle is that filters tend to lighten their own color and darken complementary colors, as recorded on panchromatic film (see the box "Frequently Used Filters" on page 107). This demonstration shows students the effects of various filters and the use of filter factors to correct the exposure.

Suggested Materials

4 × 5 camera
normal-focal-length lens
tripod
exposure meter
Polaroid Type 52 film
Polaroid 545 film holder
color chart, such as Kodak or
 Macbeth Color Checker
 charts
several color filters (yellow,
 red, blue)

Step by Step

1 Find a natural subject that has several colors, such as a landscape with blue sky, white clouds, and green foliage. (In a city you might be able to find a good combination of foliage, buildings, billboards, and sky.) Have a student hold the color chart so it appears at one edge of the image. (If the demonstration is done indoors, choose a subject with strong contrasting colors—for example, a group of students wearing different colors. In this case, note the effects of filters on skin tones.)

2 Set up the view camera. Make a photograph with no filter, process the print, and hold it up alongside the subject for direct comparison.

3 Photograph the subject with one of the filters that has a high factor (for example, the red). First make an exposure without using the factor, and then make a second photograph exposing correctly. Process each as it is made, and discuss the use of the factor.

4 Continue photographing with each of the filters, using the appropriate filter factor. As each image is processed, compare it with the subject and with previous exposures. Point out to students that each filter lightens its own color and darkens complementary colors.

Comments

- The filter factor can require a long exposure time, resulting in problems with camera or subject movement or reciprocity failure.

- The color chart is a useful reference for comparing filter effects, but filter effects with real subjects have greater practical value.

- This demonstration illustrates the effects of filters only with panchromatic film. With an advanced class, you might also want to discuss the effects of different filters with orthochromatic and blue-sensitive materials.

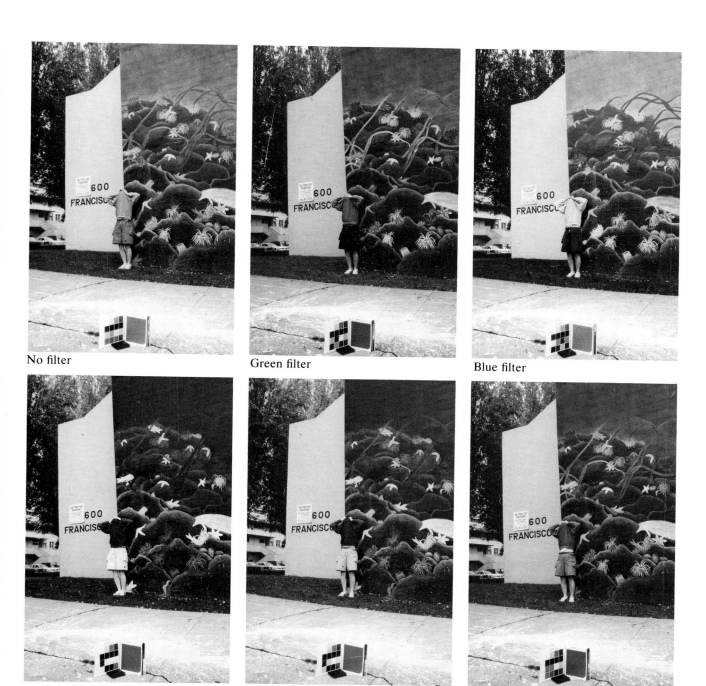

No filter

Green filter

Blue filter

Red filter

Orange filter

Yellow filter

Photographer: William Douglas Grubaugh
Instructor: Jack Fulton, San Francisco Art Institute, San Francisco, CA

The Polarizer

A polarizing filter removes glare from shiny surfaces such as water, glass, and polished materials. It also darkens some regions of blue sky and is the only means of darkening sky with color films. With a view or single-lens-reflex camera, the effect may be viewed through the lens with the polarizer attached. Otherwise, you can hold the polarizer up to the eye and rotate it to see its effect, then place it over the lens at the desired angle.

Suggested Materials

4 × 5 camera
normal-focal-length lens
tripod
exposure meter
Polaroid Type 52 film
Polaroid 545 film holder
polarizer
18% gray card

Step by Step

1 Choose a shiny, non-metallic subject, such as glass, water, or wet pavement. The subject should be under direct lighting so glare is visible. To test the effect of the polarizer, view the subject through the polarizer while rotating it.

No filter

2 Include a gray card with the subject, and photograph it normally, without the polarizer.

3 Attach the polarizer and rotate it for maximum effect. Using a filter factor of 2.5, photograph the subject again. Process and compare the photographs.

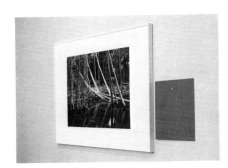

Polarizing filter

Frequently Used Filters

Type of Filter	Effect of Filter	Filter Factor
No. 6 light yellow	Darkens blue sky slightly so clouds are more visible.	1.5 (about ⅔ stop)
No. 8 yellow	Darkens blue sky so clouds stand out, lightens foliage slightly, produces a "natural" rendering.	2 (1 stop)
No. 15 deep yellow	Produces dark blue skies, penetrates distant haze.	2.5 (slightly more than 1 stop)
No. 11 yellow-green	Darkens blue sky slightly while maintaining natural skin tones; lightens foliage and improves its texture in sunlight.	4 (2 stops)
No. 25 red	Dramatically darkens blue skies.	8 (3 stops)
No. 47 blue	Increases the effect of distant haze, lightens blue sky.	3 (1½ stops)
No. 58 green	Lightens foliage.	3 (1½ stops)

Comments

- For maximum polarization effect, the filter must be used at an angle (approximately 30°) to the plane of the subject. However, sometimes it's best not to use the polarizer at the angle of maximum polarization. When photographing a body of water, for example, removing all glare may eliminate the sense that water is present.

- Regardless of the degree of polarization, the factor of 2.5 remains the same, since it is based on the nonpolarized light reflected from the subject.

- The strongest polarization occurs when sheets of polarizer are placed in front of the light sources and a polarizing filter, rotated 90° from the orientation of the sheets, is placed over the lens. This technique is called *cross polarization,* and it can eliminate almost all glare from shiny surfaces.

Using Filters

Suggested Materials

35mm camera
Polaroid 35mm instant slide
 system
Polaroid Polapan CT film
several color filters (red,
 yellow, green, blue, and
 polarizing)

To the Instructor

The ability to predict the effects of filters requires considerable practice. The process of visualizing a finished image while viewing the subject can be applied with filters as well as with exposure. There is nothing comparable to the Zone System to help photographers anticipate the effects of filters, however, and only experience makes successful prediction of results possible. After students have seen some examples of photographs made with filters, they should be able to begin anticipating the effects. To help this process along, suggest that they use a few basic filters at first, adding more only as they need them. Also encourage them to experiment with filters often, whenever they have a few extra frames after photographing a subject.

In this assignment students will expose a full roll of Polaroid Polapan CT film with various filters, including a polarizer, in several situations. First they have a choice of some standard subjects, and then they are asked to look for one or more additional subjects that would be enhanced by a filter.

Points of Discussion

1 What are the effects of the various filters? Can you see the darkening of complementary colors, as well as the lightening of the filter's color?

2 Did you use the filter factor correctly?

3 Were you able to anticipate the filter's effects?

Photographer: Eric Feathers
Instructor: Jack Fulton, San Francisco Art Institute, San Francisco, CA

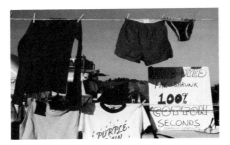
Green filter

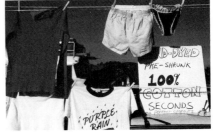
Red filter

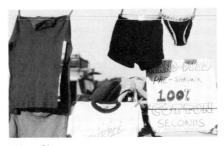
Blue filter

Polarizing filter

ASSIGNMENT 7–1 Using Filters

You should understand from the class demonstration that filters lighten their own color and darken complementary colors. Thus a yellow filter will darken a blue sky while the clouds remain white, so the clouds stand out against the sky. And a red filter will lighten a red apple seen against green leaves. You may not need filters very often, but the principles are worth learning, since at times they can be extremely valuable.

It can be difficult to anticipate the effect of using a filter. Sometimes a filter will benefit one part of a photograph but have a detrimental effect on another. For example, using a yellow or red filter to darken a blue sky will also darken areas illuminated by the sky—that is, the shadows. This should not be a problem if the filter factor is adequate. Remember that you can multiply the factor directly by the exposure time to get a new exposure time, or you can convert it to f-stops and open up the aperture by the indicated amount. A factor of 2 equals 1 stop, 4 equals 2 stops, 8 equals 3 stops, and so on.

In this assignment you have a choice of several standard subjects to photograph with the filters listed. The specified colors should ensure that the results are clearly visible. This is a good way to get to know what filters can do. Then you will choose one or more other subjects that would be improved by a filter and photograph them with and without the filter. Use one roll of Polaroid Polapan CT film for the assignment, and bring four examples, shot with and without filters, to class.

Step by Step

1 Choose one or two subjects to photograph that will clearly show the effect of the filters you use. Some examples, with filters to use, are a landscape with blue sky and clouds (yellow, green, red filters, polarizer); a red apple, an orange, and green leaves (red, yellow, green filters); a portrait subject with green shirt, light-blue jeans (green, blue filters).

2 Photograph the subject using Polaroid Polapan CT film with no filter, then using each of the filters (and others, if you wish). Don't forget the filter factors. Keep careful notes so that you know which filter you used with each exposure.

3 Find one or more other subjects to photograph that you think will be improved by a filter. Think carefully about the filter you choose, and try to visualize its effect. Be sure to use a polarizer with at least one of your subjects. Keep notes.

4 Process and mount the slides. Label them with the filter used. Bring four examples (with and without filter) to class for discussion.

DEMONSTRATIONS

The Direction of Light
Light and Texture
Fill-in Light from a Reflector
Adding Light Sources
Exposure with Flash
Electronic Flash Stops Motion
Bounce Flash
Daylight with Fill-in Flash

ASSIGNMENTS

A Portrait in Natural Light
Walk Around a Friend
Use a Photoflood
Using Flash to Stop Motion
Bounce Flash

LIGHT

The true subject matter of photographs is not only the people or objects in front of the camera, but light itself. That light creates the photograph is such an obvious point that it is easy to overlook. But it is the interaction of light with the countless planes, shapes, colors, and textures of the world that provides the richness of our visual experience.

This topic takes up some of the properties of light and the way it reveals and defines the subject. The starting point is a demonstration on natural light, which is our model for all light effects. This is followed by demonstrations on continuous-burning studio lights and flash.

The Direction of Light

Suggested Materials

4 × 5 camera
normal-focal-length lens
tripod
exposure meter
Polaroid Type 52 film
Polaroid 545 film holder
500-watt photoflood in reflector

The most familiar light source, and thus the model we unconsciously use to understand light, is the sun. Because of the sun we expect light to come from overhead and to cast definite shadows. We tend to accept artificial light that meets these conditions, but if we encounter artificial light of another sort—from below the subject, for example—it can be visually unsettling. In addition, the direction from which light comes is important because it affects contrast and the shadows produced either reveal or conceal the shapes of elements in the subject.

This demonstration presents the effects of light direction to help students learn to be more aware of natural lighting and to introduce them to working with artificial light.

Step by Step

1 Set up a tabletop subject. A simple shape like a white egg is useful for revealing the modeling provided by the lighting. You may also want to include a flat surface with texture, like a rug or fabric, to see the effect of light position on it (see Demonstration 8–2). Begin the demonstration with a discussion of light direction as it determines the appearance of the subject. Lower the room lights, and use the photoflood as the primary light source.

2 Photograph the subject with the floodlight positioned to provide each of the following conditions:

Overhead light, with the light above the subject, comparable to sunlight at midday. Shadows will be on the underside of features.

Side lighting, which reveals modeling of features and produces high contrast, with one side of the subject in direct light and the other side in shadow.

Front lighting, which is flat and reduces the modeling of features.

Light from below the subject, which produces shadows above features—a very unusual effect.

3 Process the photographs, and compare the effects of the different positions of the light.

Comments

- The floodlight should be far enough from the subject to provide a fairly directional light. With a reflector of 12–18 inches, keep the light 8–10 feet from the subject, if possible.

- The use of reflector fill-in will be demonstrated later. For this demonstration, position the subject away from light walls that might reflect light into the shadows.

Light and Texture

Suggested Materials

4 × 5 camera
normal-focal-length lens
tripod
exposure meter
Polaroid Type 52 film
Polaroid 545 film holder
500-watt photoflood in reflector
white wall or other large white
 surface for reflecting light

We often take for granted the way light reveals or softens the visual texture of a subject. This is partly a result of the direction of the light falling on the subject. Light from the camera's (or eye's) position flattens texture, while light from the side, or skimming over the surface, emphasizes it. In addition, the nature of the light source is important. A broad, enveloping light source minimizes texture, while a narrow light source (as seen from the subject) casts more pronounced shadows and thus emphasizes texture.

Step by Step

1 Set up the camera and a tabletop or portrait subject.

2 The first factor affecting the visibility of texture is the angle at which the light falls on the surface. Demonstrate this by making two photographs:

• With the light positioned near the camera to minimize texture.

• With the light at nearly a 90° angle from the camera, so it skims the surface of the subject.

3 The second important factor is the apparent size of the light source, as seen from the subject. To show this, make two photographs:

Light near camera position

Light skimming surface of the subject

• With the floodlight at about a 45° angle to the subject. The light should be fairly distant so it works like an acute-angle light source.

• Then repeat this photograph using a much broader light source, which you create by

bouncing the light against a large white card or white wall. Have this reflector direct the light from the same angle as in the previous step.

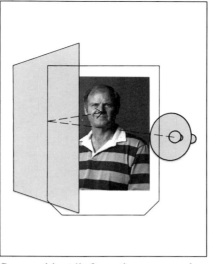

4 Process each photograph as it is made. Compare them in terms of the texture visible on the surfaces of the subject. The texture should be clearly visible in the examples made with the light skimming the surface and with the direct light from the floodlight. Much less texture should be visible in the photographs made with the light source at the camera position and when the light was reflected onto the subject from the wall.

Subject lit with a flood light

Same subject lit from the same angle with a broader light source

Comments

- Some extreme cases can be discussed. A "ringlight" (usually for macrophotography) provides light directly from the camera axis, with no shadows to reveal texture. A "point source" light will show extremely sharp shadows and texture; compare this with tent lighting, which is almost completely without shadows.

- Although this demonstration involves artificial light, there are comparable situations in daylight: direct sunlight (a narrow-angle light source), open shade (blue sky without direct sun, a fairly broad source), an overcast sky (highly diffused). And, of course, the sun can be falling on the subject from the side or from behind, or from behind the camera, providing a range of possible effects on subject texture.

Fill-in Light from a Reflector

Suggested Materials

4 × 5 camera
normal-focal-length lens
tripod
exposure meter
Polaroid Type 52 film
Polaroid 545 film holder
500-watt photoflood in reflector
large white card, reflective
 umbrella, or other surface to
 use as a reflector

A direct, narrow-angle light source, whether it is the sun or artificial light, produces strong textures and shadows and thus high contrast. By adding a simple reflector, these shadow areas can be lightened to bring the contrast into an acceptable range. The reflector can take many forms. Outdoors you can use a large white card or a sheet of metal foil or sometimes you can simply move the subject to take advantage of a nearby white wall, a light-colored rock, or another object that reflects light. In the studio the most common reflectors are a white card or reflective umbrella, or, for large subjects, a large sheet of background paper or a movable partition. Much basic studio photography can be handled with a single light source and a reflector, and experimenting with this combination is an excellent introduction to studio work.

It is important to know ahead of time how much contrast the subject has before attempting to alter it with a reflector. The Zone System provides an excellent way to measure contrast and compare subjects and lighting conditions for classes familiar with it.

Another measure of contrast is a standard devised by portrait photographers called the *lighting ratio,* simply the ratio of the light falling on the bright side of the subject to the light falling on the shadowed side. (For a face or other subject of uniform reflectance, you can determine the lighting ratio by measuring the light reflected from the bright and shadowed sides, rather than measuring the incident light.)

Step by Step

1 Set up a tabletop or portrait subject with the light 10 feet away or more and directed on it at about a 45° angle, from slightly above the camera's level. Be sure the subject is not near any light walls or other surfaces that will reflect light onto it. With a tabletop setup, the subject should have texture and features that will cast shadows. Be sure to use a table with a dark surface.

2 With the room lights turned down or off, photograph the subject under the single light source.

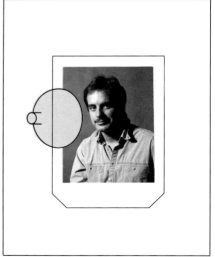

Subject lit with a single light source
— a flood at a 45-degree angle

3 Position the reflector to fill in the shadows with light reflected from the main source. The reflector should be placed close to the camera on the side away from where the floodlight is, and it can be moved toward or away from the subject to get the desired amount of fill. You can judge this by eye and, of course, measure it with a spot meter using the Zone System or the lighting-ratio principle. Make another photograph of the subject.

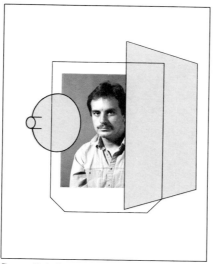

Same lighting with a reflector added as a "fill" to lighten the shadow areas

4 Process and compare the photographs. The reduction in contrast using the reflector should be clearly visible.

Another Example

No "fill"

A silver reflector added as "fill"

A white card added as "fill"

Comments

- It is possible to overcorrect, adding too much fill light in the shadows by using a reflector that is too large, too reflective, or too close to the subject. The fill-in effect will then be obvious and unnatural, causing the subject to look flat and lose its three-dimensional quality.

- Be sure to point out how versatile and flexible this approach can be. It can be used indoors or out with an existing surface as reflector or one provided by the photographer. It should also be clear to students that light-colored walls or a low white ceiling can have a great effect on contrast because they can reflect a great deal of light into the shadows.

Adding Light Sources

A useful way to approach studio photography is to have students "build" the lighting on a subject. This involves starting with a main light and adding reflectors and lights one at a time until the desired effect is achieved. A typical sequence might involve starting with a main light close to and slightly above the camera; adding a broad (diffused) light on the other side of the camera to fill in the shadows; then adding a hair light or other light for accent, plus a light on the background.

For this demonstration, have the class work together to build the lighting for a portrait subject. Make photographs of the subject at each step so the progression can be seen.

Suggested Materials

4 × 5 camera
normal-focal-length lens
tripod
exposure meter
Polaroid Type 52 film
Polaroid 545 film holder
at least two 500-watt
 photofloods in reflectors,
 with dimmers, if available
matte box, umbrella, or
 reflector
small studio spotlight, with
 dimmer, if available

Step by Step

1 Have your portrait subject sit about 4–5 feet in front of a background. Set up the main light to one side of the camera and above it. Dim the room lights.

2 With a spot meter, if possible, measure the ratio of the bright side of the face and the shadowed side. Use the Zone System or express the difference in stops or as a lighting ratio.

3 Photograph the subject, process and label the print, and pin it to the wall.

4 Then add a broad, weaker light source on the other side of the camera from the main light, close to the camera and about level with it. This can be a floodlight in a matte box or a light bounced off a white surface or umbrella. Again, measure the ratio of the lighter side to the shadowed side of the face and adjust the light intensity as needed. For black-and-white portraiture, a range of 1½–2 zones (1½–2 stops), or a ratio of 3:1 or 4:1 is traditionally considered ideal. Make another photograph, process and label it, then pin it up alongside the first.

5 Place a hair light well above and behind the subject. Adjust its intensity and position to provide highlights on the hair, as desired. Again photograph the subject, and pin up the result.

6 If desired, add a light on the background, being careful to point out how it affects the separation of values with the subject's face and hair. Make a final photograph with this light in place.

Main light position just above and to side of camera

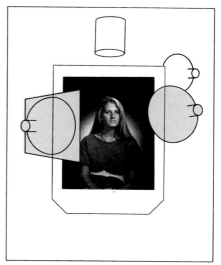
Fill light added from other side of camera

Hair light placed above and behind subject

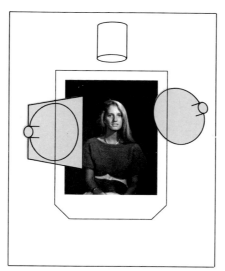
Backlight added behind subject

Photographer: Ralph Ibarra
Instructor: David Litschel, Brooks Institute, Santa Barbara, CA

Comments

- Students should be aware not only of the primary effects of each light in illuminating part of the subject, but also of secondary effects like highlights and shadows. It can be particularly distracting to have conflicting shadows that reveal the use of multiple lights.

- A plain white cube is another useful subject for this demonstration.

Exposure with Flash

Suggested Materials

4 × 5 camera
normal-focal-length lens
tripod
Polaroid Type 52 film
Polaroid 545 film holder
manual flash unit (or automatic
 with manual option)

With flash, aperture and distance—not shutter speed—are used to control the exposure. Of course, automatic flash units change the intensity of the flash to control exposure, so use a manual flash for this demonstration. The flash itself puts out a certain amount of light, and moving it closer to or farther from the subject affects how much light falls on the subject (see the box "Inverse Square Law" on page 121). The aperture, of course, controls how much of the light reflected back to the camera is allowed to reach the film. Thus the usual procedure is to set a shutter speed and then use the distance to the subject to determine the aperture, via the guide number or an exposure calculator dial.

A particular benefit of demonstrating the principles of flash with Polaroid film is that otherwise the effect of the flash cannot be seen until after processing and printing. With other forms of artificial light, the effect can be seen on the subject even before you take the picture.

Step by Step

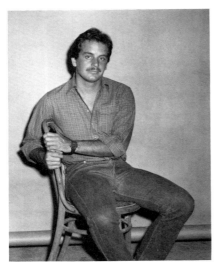

Flash positioned 10 feet from the subject

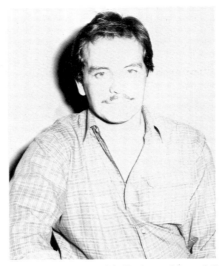

Same exposure with flash positioned 5 feet away

Same distance with exposure recalculated

1 Set up a person as your subject 10 feet away from the camera. Attach the flash to the camera.

2 Choose a shutter speed and determine the guide number or use a flash exposure dial. To determine the aperture, divide the guide number by the distance in feet. Thus if the guide number is 40 and the distance is 10 feet, use f/4. Photograph the subject at whatever exposure is indicated.

3 Move the camera and flash so they are 5 feet from the subject, and make another photograph at the same exposure.

Inverse Square Law

The amount of light falling on a subject depends partly on how far away the light source is. With artificial lights, you can control the intensity of light on the subject by moving the light source closer to or farther from the subject.

You can estimate just how much to move a light source if you are familiar with the *inverse square law*. Similarly with flash; the aperture setting is related to the flash-to-subject distance, which is controlled by the same law.

The inverse square law states that the intensity of light falling on a subject from a light source is inversely proportional to the square of the distance. So, if you double the distance from the light source to the subject, the light falls off one-fourth the original value. If you triple the distance, the light falls off to one-ninth its original value. The light intensity on the subject is inversely proportional to the square of the distance because as the distance gets larger the intensity on the subject gets smaller.

4 Repeat the exposure calculation for the new distance. With the same shutter speed, the guide number will indicate an exposure 2 stops less than the previous one (see the box "Inverse Square Law" shown here). Make another photograph.

5 Pin the photographs to the wall for comparison.

Comments

Some other characteristics of flash can be included in the demonstration or explained:

- With electronic flash and a camera with a focal-plane shutter, there is a maximum speed at which the flash can be synchronized (usually 1/60 second or 1/125 second). A leaf shutter synchronizes at all speeds.

- With electronic flash, changing shutter speed (up to the maximum for synchronization) does not affect exposure. Therefore, it is usually best to set the fastest possible speed to avoid ghost images from the existing light.

- The farther away the background is from the subject, the darker it will appear, even though it may be a white wall. Good practices when using flash include keeping the background fairly close to the subject and avoiding reflections from windows and mirrors. In a very large room or outdoors at night, an increase in exposure will be required, since little light will be reflected from the walls and ceiling onto the subject.

Electronic Flash Stops Motion

Electronic flash is commonly used for sports events and other subjects that require stopping motion. The pulse of light from an electronic flash unit is usually 1/1000 second or less, sometimes as fast as 1/50,000 second. Remind students that even though the flash may last only 1/1000 second, they should avoid slow shutter speeds because they may produce ghost images (unless, of course, they want such an effect).

This demonstration uses electronic flash and a simple moving subject to show how the flash can arrest the motion of the subject on film.

Suggested Materials

4 × 5 camera
normal-focal-length lens
tripod
Polaroid Type 52 film
Polaroid 545 film holder
electronic flash unit

Step by Step

1 Choose a moving subject such as a dancer or a person jumping rope. Position the subject near a light background. Set up the camera and determine the exposure without flash, at a moderate shutter speed. Ask your subject to begin moving and take a photograph.

2 Calculate the exposure for your flash unit or set the automatic flash as needed. Make a second photograph using the flash.

3 Process and compare the photographs.

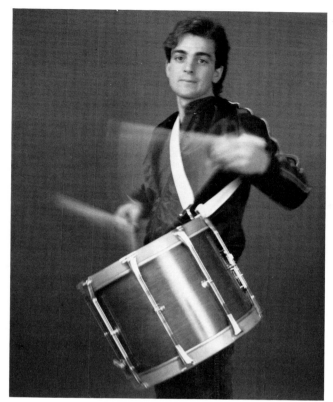

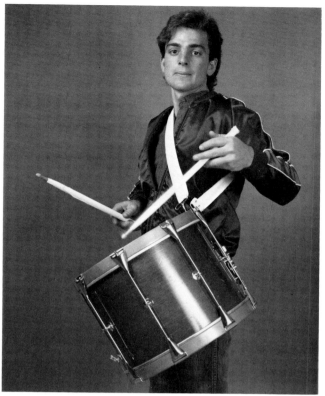

Subject without flash — shutter speed set at 1 second

Same subject with electronic flash stopping the motion

Comments

- Discuss the blurring of motion in the non-flash photograph.

- Point out that using on-camera flash, because it aims directly at the subject, creates flat light and reduces the modeling of features.

Bounce Flash

The sense of "natural" light and the modeling of features can be improved greatly by bouncing the flash from a nearby wall or the ceiling. Using bounce flash is a fairly straightforward process if you use an automatic flash unit that allows you to separate the sensor from the flash head, so you can aim the sensor at the subject while directing the flash itself at the ceiling or wall. These automatic units eliminate the complex and inexact calculation of bounce-flash exposure otherwise required. Calculated manually, the exposure is based on the exposure for the flash-to-reflector-to-subject distance, plus 2 or more stops (depending on how light the reflector is and how far from the subject). This is a situation in which a few test exposures on Polaroid film can be invaluable.

To demonstrate the procedures and effects of bounce flash, use a person or small group of people in a room with a white ceiling and/or walls.

Suggested Materials

4 × 5 camera
normal-focal-length lens
tripod
Polaroid Type 52 film (or Type 57, if very high speed is needed)
Polaroid 545 film holder
electronic flash unit with manual setting

Step by Step

1 Arrange a subject of your choice near a light wall or in a room with a white ceiling of normal height.

2 Make one photograph using direct flash on the subject. Use the manual flash mode and calculate the exposure using the appropriate guide number.

3 For the second photograph, bounce the flash off the wall and/or ceiling so that at least some of the light falls on the subject from overhead. Estimate the exposure, based on the flash-to-subject distance along the path to the reflecting surface; it will be necessary to add 2 or more stops because of the light lost in reflection. Make the photograph using bounce flash.

4 Process and compare the two photographs.

Direct flash

Bounce flash

Comments

- The primary advantage of bounce flash is that it is soft and lends modeling to features, as opposed to the flat and harsh effect of direct flash from the camera. It also helps eliminate the harsh shadows on walls behind the subject often seen with direct flash. Furthermore, it helps avoid "pink eye"—reflections from subjects' eyes that can occur with the flash on the camera.

- To use bounce flash with an automatic flash unit, the light-sensing cell should be pointed at the subject from the position of the camera while the flash is directed at the wall or ceiling. The sensor detects the light actually reaching the camera, so no compensation is required.

- The distance from the reflector to all parts of the subject should be approximately the same or uneven exposure will result. For example, bouncing flash from a low ceiling to photograph a full-length standing figure will result in light visibly falling off from the head downward.

- Bounce flash can be very effective with color film, but you must be careful to avoid reflecting light from colored surfaces, which can lend a color cast to the subject.

Daylight with Fill-in Flash

Suggested Materials

4 × 5 camera
normal-focal-length lens
tripod
exposure meter
Polaroid Type 52 film
Polaroid 545 film holder
electronic flash unit with
 manual setting

Calculating the exposure for combined flash and daylight can be tricky, but the results—reduced contrast and detail in shadow areas—can be rewarding. Fill-in flash relies on daylight or other ambient light as the main source. The flash is kept on or near the camera to avoid secondary shadows and to fill in all shadow areas visible from the camera. As with bounce flash, fill-in flash has now been automated with some camera/flash systems. Note that the function of fill flash—to direct light into shadows and reduce the contrast—is the same as that of the reflector in Demonstration 8–3.

To demonstrate fill-in flash, use a portrait model outdoors in direct sunlight or under strong and directional overhead lighting.

Step by Step

1 Arrange the subject under contrasty overhead lighting—in direct sunlight, if possible. Set up the camera and make one photograph without flash.

2 With the flash on the camera, determine the new exposure as follows. Use the guide number or flash exposure dial to determine the correct aperture for the flash alone. Stop down 2 stops, and set that aperture on the camera. Then determine the shutter speed at the chosen aperture based on a meter reading of the subject under daylight. Make a photograph at this exposure.

3 Make other exposures that bracket the previous one, opening up 1 stop and closing down 1 stop. In each case, change the shutter speed to compensate for the change in aperture, so there is no net change in the daylight part of the exposure.

4 Process and compare the photographs.

Subject photographed without flash

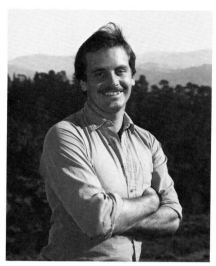

Same subject photographed with flash

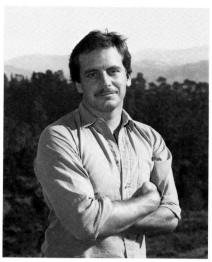

Flash used again with one stop more exposure

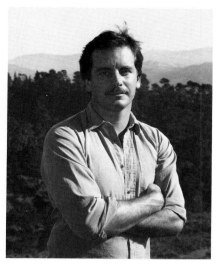

Flash with one stop less exposure

Comments

- This process is easier with a leaf shutter than with a focal-plane shutter, since the leaf shutter synchronizes with electronic flash throughout its entire range of speeds. Students are more likely to use 35mm cameras than 4 × 5, so remind them of this potential problem.

- The optimum amount of fill differs with color and black-and-white film and with different subjects. Too little fill will aggravate the contrast problem and too much will have an obvious and artificial effect. The procedure here calls for the fill-flash exposure to be 2 stops below the ambient light exposure, but this is only a guideline. Students should be encouraged to experiment, and to test with Polaroid film if possible.

A Portrait in Natural Light

Suggested Materials

35mm camera
Polaroid 35mm instant slide
 system
Polaroid Polapan CT film

To the Instructor

Sensitivity to the nuances of light in its interactions with a subject is very important. Beginning students are not always fully aware of light itself, but often see a subject and the light on it as a single entity. Demonstrations 8–1 and 8–2 illustrate some of the effects of a change of the direction or nature of the light on the subject.

This assignment should help students understand some of the possibilities of working with one subject under a variety of natural-light conditions, and may help them appreciate that lighting itself can play an important role in determining what a photograph communicates about a subject.

Instructor: Lorie Novak, University of Massachusetts/Boston, Boston, MA

Michael Amalfi

Points of Discussion

1 How does the nature of the lighting influence the "feeling" of the photographs?

2 Which lighting conditions produced the most and the least satisfactory results for portraiture?

Tony Buccafurri

Tony Buccafurri

ASSIGNMENT 8–1 A Portrait in Natural Light

It is easy to take for granted the variety of natural light effects we see around us every day, but as a photographer you need to be sensitive to them. Light can reveal or obscure details and textures of your subject, lend a mood of harshness or softness, or convey the vibrancy of a high-contrast subject or the calm and quiet of a low-contrast subject.

For this assignment photograph one person in natural light, choosing several lighting conditions that give different visual effects. Some of the effects you might include are direct sunlight, open shade, silhouette, and backlighting. Try to be aware of the lighting as a separate element of your photographs, one that you can control—even if only by turning your subject around or moving him or her to another location.

Step by Step

1 Position your portrait subject in natural light (daylight, whether indoors or outdoors) without adding reflectors, flash, or any extra light sources. Make several photographs at this location.

2 Move to another location where the quality of light is different. Be aware of all the effects of the change in lighting on your subject. Repeat the process. Altogether you should try about six to eight different natural-light situations.

3 Process the film. Mount and bring to class four examples of different light effects. Be prepared to discuss not only the nature of the light itself, but its effect on the mood or feeling generated by the photograph.

Walk Around a Friend

Suggested Materials

35mm camera
Polaroid 35mm instant slide
 system
Polaroid Polapan CT film

Lauren Lantos

To the Instructor

Like the previous assignment, this one asks students to pay close attention to the light falling on their subject. Here they are asked to photograph a person under directional lighting, moving around the subject so the light falls on him or her from different directions. To be effective, the light should be at a fairly low angle—sunlight in early morning or late afternoon is ideal. The resulting conditions range from flat light, nearly on the camera axis, to low grazing light, to backlight. Since both involve photographing a person under natural light, this assignment may be done in place of, or combined with, Assignment 8–1.

Sarah F. Lyle

Sarah F. Lyle

Instructor: Elaine O'Neil, School of
the Museum of Fine Arts, Boston, MA

1 How does the change of lighting affect the portrait?

2 Did the simple act of moving around the subject affect the exposure required?

3 What happens when the camera is pointed toward the light source?

4 What other changes occurred as you moved around your subject (for example, change of background)?

Sarah F. Lyle

ASSIGNMENT 8–2 Walk Around a Friend

There are times when a relatively small change can make a major difference in the visual effect of a subject. When the light is strongly directional, turning your subject or moving to a different side causes a substantial change in the light-and-shadow effects. You can see some of this by simply walking around a person, having him or her turn to face you as you walk, and noting the effect of the differences in direction of light.

For this assignment, photograph a person from several positions as you walk around him or her, so you can see and record the changes caused by light coming from different directions. To be effective, this must be done under directional light of low angle—early morning or late afternoon sunlight is ideal. Try to note and record how the features and textures of your subject change as you go from front lighting to side or skim lighting to backlighting.

Step by Step

1 Position your portrait subject in an open area where you have room to move around him or her. Be sure that the lighting is directional and is falling on your subject from a low angle.

2 Determine exposure and make a photograph of your subject. Be sure to note the effect of the lighting on features and textures.

3 Move around the subject to a new position, having him or her turn to face you. Adjust exposure if necessary and make another photograph.

4 Repeat the process from at least three or four different positions around your subject.

5 Process the film. Mount and bring to class at least three examples.

Use a Photoflood

Suggested Materials

35mm camera
Polaroid 35mm instant slide system
Polaroid Polapan CT film
500-watt photoflood in reflector
large white surface for reflecting light

Photographer: Donald Walker
Instructor: David Litschel, Brooks Institute, Santa Barbara, CA

To the Instructor

Using artificial light builds on what students know from experience with natural light. Being able to control the lighting brings a kind of freedom to photography; at the same time it makes the process more complex. A good introduction is to have students begin with a single light used alone and then add a reflector before they attempt multiple-light setups. The demonstration of studio lighting concepts presented here, though only a brief beginning, can be the basis for a more complete program.

Beginning students rarely use artificial lighting, so this assignment is designed to encourage them to experiment. They are to photograph one subject using a single floodlight, changing the position of the lighting to vary the appearance of the subject.

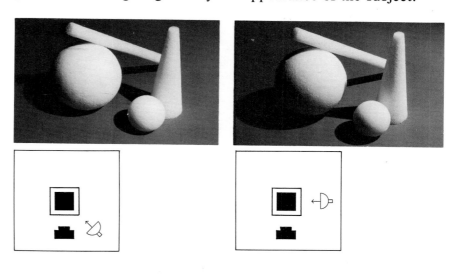

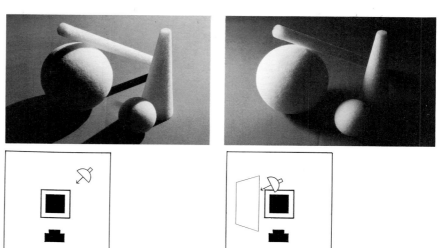

Points of Discussion

1 What different lighting methods did you try? What were the visual effects of each one? Which one produced the most effective lighting for your subject, and why?

2 How does the distance from the light source to the subject affect the nature of the lighting? How does it affect exposure?

Photographer: Donald Walker

ASSIGNMENT 8-3 Use a Photoflood

The effects you have observed with different kinds of natural light apply with artificial light, which can also be flat and can come from in front of a subject, from near the camera position, or from the side, where it causes shadows and reveals texture. It can be acute, producing harsh shadows, or broad and diffuse, producing a much softer result. The main advantage of studio lighting is that you can more fully control the lighting conditions.

Experienced photographers frequently approach a lighting problem step by step, "building" the final lighting by adding one light source or reflector at a time and adjusting it for the desired effect. This approach can help you avoid becoming tangled in multiple lights, with effects that might conflict with one another. To use artificial light effectively, however, you should be fully familiar with all of the possibilities of using a single light. As the next step, you may wish to add a reflector; a main light with a reflector to fill the shadows is a basic lighting setup that can be adapted to many situations.

For this assignment, photograph one subject using a single photoflood. By trying different light positions in relation to your subject, you will see a range of possible lighting effects.

Step by Step

1 Choose a small subject, such as a tabletop still life that contains a variety of shapes and textures. Set up the subject in a room that can be darkened, with the subject far enough away from the walls and ceiling to minimize the effect of reflected light.

2 Photograph the subject using the photoflood directly as the light source. Try three to four positions for the light source, moving it around the subject, and toward and away from the subject. Be sure to make notes, with rough sketches of the lighting arrangement throughout this assignment.

3 Try a few more photographs in which you bounce the floodlight off the white card or reflector. The reflected light becomes the light source.

4 Then use the reflector to fill the shadows. The conventional position is with the light directed onto the subject from slightly above and to one side, and the reflector on the other side of the camera and closer to it. Experiment with different positions of the light and reflector.

5 Shoot at least one roll of Polaroid Polapan CT film with different lighting setups. Process the film and bring to class four photographs that show different uses of light. Try to include one photograph representing each of these approaches: direct light, bounce light, and direct light with reflector.

Using Flash to Stop Motion

Suggested Materials

35mm camera
Polaroid 35mm instant slide system
Polaroid Polapan CT film
manual flash unit (or automatic with manual option)

To the Instructor

One important use of electronic flash is to stop the motion of the image recorded on film—both image motion caused by a moving subject and image motion caused by camera movement. The duration of an electronic flash is very fast—1/1000 second or less—which accounts for its effectiveness in arresting motion.

This assignment works well for students beginning to understand the use of flash to stop motion. Since it requires the use of a manual electronic flash, students will also learn a lot about determining exposure.

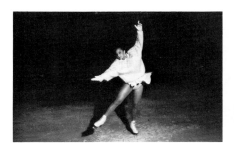 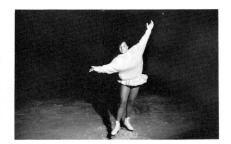

 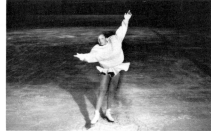 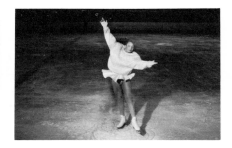

Photographer: Julie A. Serat
Instructor: J. Michael Verbois,
Brooks Institute, Santa Barbara, CA

1 Why is electronic flash good for stopping motion even though the shutter speed used is only 1/60 second?

2 What happens when you use a very slow shutter speed with electronic flash?

3 How did you determine exposure with flash and were you successful in doing so?

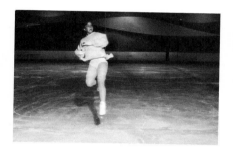

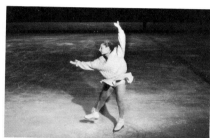

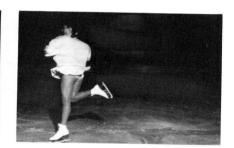

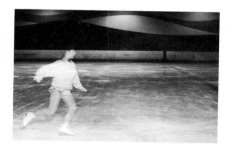

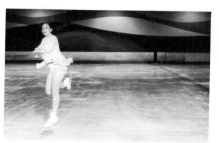

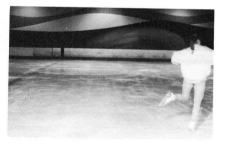

ASSIGNMENT 8–4 Using Flash to Stop Motion

No doubt you have seen sports photographs, such as basketball players in midair, made with electronic flash. You may also have wondered why photographers at some outdoor events, such as outdoor weddings, use flash even though there seems to be plenty of available light. There are two primary reasons for using electronic flash. It ensures that there is enough light, and since the light is in a brief burst (usually 1/1000 second or less) it "freezes" subject motion and prevents lack of sharpness due to motion of the camera.

In this assignment you will have a chance to work with electronic flash to see its ability to arrest motion. Use the flash in manual mode, determining the exposure from the calculator dial on the unit to gain experience determining flash exposure. Experiment also with different ways of using flash. Be sure to keep notes of your exposures, so you can accurately recall what you have done. If you are using a camera with a focal-plane shutter, the shutter speed must be set to 1/60 second or slower (1/125 second on some models).

Step by Step

1 Choose a subject in motion, such as a dancer, swimmer, or runner. The subject chosen should allow you to use flash as the primary light source; it should also permit you to shoot an entire roll under similar circumstances.

2 From your initial camera position, use the flash calculator dial to determine exposure. Using the fastest shutter speed on your camera that will synchronize with electronic flash, make several photographs of the subject from this position.

3 Try several test photographs using slower shutter speeds. In most cases the exposure will not change, since all of the light from the flash is used with a fast or a slow shutter speed. Thus no change of aperture is required unless the available light is very strong. Keep notes on each exposure.

4 Move closer to the subject and repeat the process. That is, determine the new exposure, make a few photographs at the fastest shutter speed for flash, and then make a few test photographs using slower shutter speeds.

5 Process the film and bring four to six examples to class.

Bounce Flash

Suggested Materials

35mm camera
Polaroid 35mm instant slide
 system
Polaroid Polapan CT film
electronic flash unit with
 manual setting

To the Instructor

Bounce flash is especially useful in situations where direct flash will be too flat or harsh. Although you may have demonstrated bounce flash in class (see Demonstration 8–7), you may also wish to have students try out bounce flash for themselves, since it is a technique that requires experience before it can be used with confidence.

This assignment asks students to try bounce flash with one subject in several different environments, to see how it can work and what some of the potential pitfalls are. Depending on how advanced your students are, you might want them to use manual flash only, so that estimating exposure becomes part of the assignment.

Ivar Brynjolffson
Instructor: Jack Fulton, San Francisco Art Institute, San Francisco, CA

1 Did bounce flash provide a natural-looking light on your subject?

2 What problems did you have with bounce flash? Some possible problems include direct light unintentionally spilled onto the subject, uneven light because different parts of the subject are at different distances from the reflector, and, with color film, a color cast caused by light reflected from painted walls.

3 Did you try to bounce flash from surfaces other than a ceiling? How well did they work?

4 Was your flash unit powerful enough to use this way, or are some of your photographs underexposed?

5 If you used manual flash, how well did you estimate exposure?

Instructor: Jack Fulton, San Francisco Art Institute, San Francisco, CA

Claire Kendrick

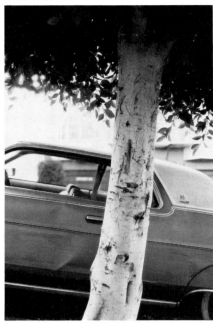
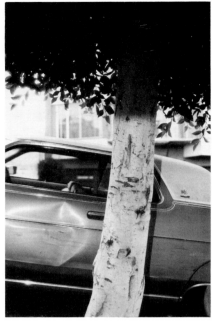

Bounce flash Direct flash

Ivar Brynjolffson

ASSIGNMENT 8-5 Bounce Flash

Flash bounced from a ceiling, walls, or other reflective surfaces can provide far more natural-lighting than direct flash. This is especially true when the ceiling is used as a reflector, since we are accustomed to seeing people and other subjects under overhead lighting, whether outdoors or indoors, and the shadows produced by such lighting look natural

There are two drawbacks to bounce flash. A lot of light is lost in bouncing, so a powerful flash unit is usually required. Also, unless you have one of the automatic flash units that allows you to direct the sensor at the subject while the flash is pointed elsewhere, you will

have to estimate the exposure—an approximate and time-consuming process. But, under the right conditions and with the right equipment, bounce flash can be extremely useful.

For this assignment, take several photographs using bounce flash in a variety of situations. This is a good time to experiment a bit, since there are a number of ways to use bounce lighting. If you are using a manual flash unit, you will have to determine exposure by estimating. However, with Polaroid film you can see your results in time to reshoot a situation if your exposure estimate proves to be wrong.

Step by Step

1 Choose a subject that you can photograph at several locations, or arrange to photograph several different people in different locations.

2 Arrange your subject in a room or location that provides a good surface for bouncing the flash. Be sure the ambient, or existing, light is not strong, so the flash becomes the primary light source.

3 Photograph the subject using bounce flash. With a manual flash unit, estimate the flash-to-reflector-to-subject distance, and open up 2 stops or more from the exposure indicated for that distance. Just how much you need to open up is determined by the general environment and how reflective the surface. A small, bright room will require less additional exposure than a large or dark-walled room.

4 Move to different positions and try other bounce flash photographs. Moving closer to or farther from the subject often has less effect on exposure with bounce flash than it does with direct flash.

5 With the same subject or a different one, repeat these steps at two or more other locations. Be sure to try both the conventional approach, using a fairly low white ceiling for bouncing, and variations like bouncing from a white wall or other light surface to one side of your subject. You may also be able to use a combination of surfaces, directing the flash to the ceiling and a wall.

6 Process the slides and bring four examples to class for discussion.

DEMONSTRATIONS

The Rise, Fall, and Shift Movements
Rear Swings and Tilts
Front Swings and Tilts
Receding Planes
Close-ups

ASSIGNMENTS

Correcting Convergence of Parallel Lines
Photograph a Receding Subject
Erase Your Reflection

VIEW CAMERA

The concepts behind view camera movements are usually confusing to beginning students. They are hard to understand without actually seeing the results, so demonstrating them with Polaroid film, then giving assignments in which the students themselves can work with the movements, is a most direct and effective way of presenting the subject.

Demonstration 9–1 presents the rise, fall, and shift movements—the movements that keep the lensboard and film plane parallel. Demonstration 9–2 presents the rear swings and tilts, which control image shape. This is followed by Demonstration 9–3 of the front swings and tilts, 9–4 on controlling the plane of focus, and finally, Demonstration 9–5 on the issues relating to close-up photography.

The Rise, Fall, and Shift Movements

Suggested Materials

4 × 5 camera
normal-focal-length lens
tripod
exposure meter
Polaroid 545 film holder
Polaroid Type 52 film

The first group of view camera movements to present are those that keep the lensboard and film plane parallel and shift the front or rear laterally. These movements maintain both the geometry, or shape, of the image and the plane of focus, while, in effect, recropping the image area. This is their great value, for turning the camera to the right, instead of shifting the lens to the right, will cause a change in both the plane of focus and the image shape. If the camera is set up parallel to a flat subject—for example, the wall of a building or a smaller flat object like a window frame—the shift movements allow the camera to remain parallel while the image area is shifted.

Step by Step

1 Choose a subject that is rectangular and flat and small enough that the camera can be quite close to it. A book is about right for this demonstration as well as those that follow.

2 Set up the camera to photograph the subject. The camera should be aligned so that the front (the lensboard) and back are parallel to the subject plane, but the subject should be below or to one side. Be sure to include the parallel edges of the subject within the image.

3 Make one photograph of the subject with all movements zeroed, that is, with all the shifts in their "unshifted" position. Choose a large aperture, so the depth of field is minimized.

4 Turn the camera to bring the subject to the center of the frame, and make another photograph. Process this photograph and compare the two. It should be possible to see the loss of sharpness of part of the subject. The convergence of parallel lines should also be visible.

5 Return the camera to its original position and use the appropriate front sliding movement (rising, falling, or sideways shift) to shift the image to the center of the film area. Make another photograph and process it. Point out not only the shifting of the image area, but the fact that the focus is sharp and the rectangular shape of the subject is preserved (parallel lines in the subject remain parallel).

Side View
Camera in zero position

6 These steps may be repeated with another of the shift movements, perhaps one of the rear sliding movements.

Camera moved so subject is in center of frame

Camera front dropped

Comments

- Point out that each front sliding movement is equivalent to the opposite rear sliding movement (this is *not* true with the tilt movements, as demonstrated later).

- If vignetting occurs because the shift exceeds the coverage of your lens, be sure to point this out to students (see the box "Lens Coverage" on page 147).

- If the sliding movements are not sufficient to achieve the required displacement of the lens in relation to the film, show students that turning the camera and then using the tilts to restore the parallel relationship of front and rear has the same effect.

Rear Swings and Tilts

Suggested Materials

4 × 5 camera
normal-focal-length lens
tripod
exposure meter
Polaroid 545 film holder
Polaroid Type 52 film

The rear swings and tilts of the view camera cause a change in the shape of the image. The general rule is that keeping the camera back parallel to the plane of the subject will yield an accurate recording of the shape. Squares will appear square and lines that are parallel in the subject will be parallel in the image. Any movement that changes the relationship of the camera back parallel to the subject plane will change the shape of the image. In the setup of the preceding demonstration, in which the back was originally parallel to the subject, turning the camera altered the rectangular shape of the subject.

The most common use of rear tilt is to correct the geometry of the image so that lines that are parallel in the subject appear parallel in the image. A tall building is the most common example; if you point the camera upward to include the top of a building, the parallel lines of the building facade will converge in the image. For class demonstration, you can use a smaller object such as the book proposed earlier instead of a building.

Step by Step

1 Using the same subject as in Demonstration 9–1, Step 4, set up the camera so that it is positioned slightly higher than the book. All movements should be zeroed.

2 Photograph the subject, without attempting to correct the convergence of the parallel sides of the book. Use a small aperture, if possible, so the tilt introduced in the next step will not cause too much loss of focus.

3 Tilt the camera back to vertical, so it is parallel to the book. Make another photograph.

Side View

Camera in zero position pointing down at the subject

Camera back tilted to be parallel to subject

4 Process and compare the photographs.

Lens Coverage

The coverage of each view camera lens determines how much it can be shifted to the side or tilted and still produce a complete image over the entire film plane. Once the limit of lens coverage is reached, the corners and an edge of the film will not be exposed, and the resulting dark area is said to be *vignetted*. Students should think of the light from the lens as a cone shape, much like the light from a slide projector or even a flashlight. Any camera movement that causes the cone of light to move in relation to the film may cause vignetting. Thus, shifting the front and rear or tilting the lens may cause vignetting, but tilting the film plane usually will not. Vignetting can be very hard to see on the ground glass.

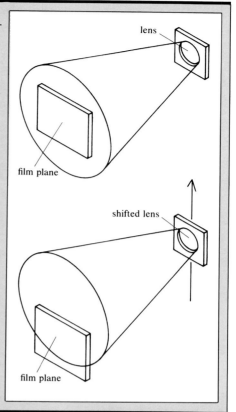

Comments

- Eliminating convergence is probably the most common reason to use the rear swings and tilts. However, you can also use them to deliberately cause or exaggerate convergence.

- The rear swings and tilts are sometimes used together with the front swings and tilts to control image focus. Usually the front swing or tilt is used to the limit of lens coverage, and then rear tilt is added as needed. Some change in the image shape must be accepted as a result of these movements. This can be shown as part of the next demonstration.

- Students should be made aware of the loss of focus across the plane of the subject. The next demonstration shows how to correct it.

- Vignetting is not likely to occur with these movements, since the rear swings and tilts do not significantly alter the position of the film within the cone of light projected by the lens.

Front Swings and Tilts

Suggested Materials

4 × 5 camera
normal-focal-length lens
tripod
exposure meter
Polaroid 545 film holder
Polaroid Type 52 film

Front swings and tilts are useful for their effect on the plane of focus. As long as the front and back are parallel, you can focus the camera on a plane in the subject that is parallel to these planes. If the subject plane that needs to be in focus is not parallel to the film plane, however, tilting the lens can help, usually in combination with a small aperture to extend the depth of field.

For this demonstration, use the same book-sized subject, photographed from above as in the preceding demonstration. With the camera pointed down, adjust the back to produce a "squared-up" image, and swing the lens to get the entire surface in sharp focus.

Step by Step

1 Set up your camera and a subject, such as a book, with the camera above the book and pointed down so the subject is centered in the image area.

2 Make one photograph with the camera movements zeroed. Process it and pin it to the wall.

3 Use the rear tilt to bring the camera back parallel with the book (that is, vertical). Readjust the focus until the end of the book close to the camera is sharp. Make a photograph at a large aperture, process it, and compare the results with the first photograph.

4 Tilt the lensboard to a vertical position so it is aligned with the camera back and the subject. Check the focus, and make another photograph without changing the aperture.

5 Process and compare the photographs.

Side View

Camera in zero position pointing down at the subject

Camera back tilted to be parallel to subject

Lensboard tilted to be aligned with camera back and subject

Comments

- This demonstration combined with the previous ones shows how to handle the problem of parallel planes. The general principle is if the plane where you want optimum focus in the subject is parallel to both the lens and the film planes, the image shape will be accurately rendered and the entire subject will be in sharp focus. To photograph a tall building from ground level, you must use the rising front (or an equivalent), while keeping the camera back and lens plane vertical, to avoid convergence and keep the entire building facade in focus.

- The final camera configuration, once the camera has been pointed down and the back and lensboard returned to vertical, is the same as if you had used rising/falling movements of the front or back (or both, in opposite directions). A possible, and actually easier, alternative is to level the camera and then use the falling front, plus rising back, if needed, to center the image of the book. If these sliding movements prove inadequate, then it would be necessary to point the camera down and use front and rear tilts to return the lens and film planes to vertical.

- Vignetting may occur when the lens is tilted, depending on the amount of tilt and the coverage of the lens used.

Receding Planes

Suggested Materials

4 × 5 camera
normal-focal-length lens
tripod
exposure meter
Polaroid 545 film holder
Polaroid Type 52 film

Swings or tilts of both the front and back of the camera are usually needed when the plane of the subject is not viewed from straight on but recedes, so that part of it is closer to the camera than other parts. In this situation convergence of parallel lines in the subject cannot be avoided—in fact, the convergence is needed as a clue of perspective—and so the matter of shape distortion is usually not critical. The convergence can be exaggerated if steep perspective is desired, or minimized to make the subject appear flatter. Corresponding degrees of lens tilt will help keep the receding plane in focus; a small aperture for increased depth of field also helps. The principle controlling how the lens tilt and film plane tilt are related is called the Scheimpflüg principle (see the box "How Much Should I Tilt the Lens?" on the next page), and understanding it can be helpful, even if you use it only to make an "eyeball" first guess at the right camera setup.

Step by Step

1 Choose a subject that is flat and can be photographed from about 4 feet away, receding from the camera. Some possibilities include a desktop, bulletin board, or an area of the floor.

2 Start with the camera back and lens plane perpendicular to the plane of the subject (they will be vertical if a floor or tabletop is the subject). Then turn the camera toward the subject plane to bring it into view on the ground glass.

3 Focus on a marked point in the subject, about one-third of the way into the subject area. Make a photograph at a fairly large aperture—say, f/5.6 —so the depth of field does not fully cover the subject area.

4 Tilt the lens plane toward the subject plane slightly. Refocus on the same point as before and make a photograph.

5 Tilt the camera back away from the subject slightly. Refocus on the same point and make another photograph.

6 Compare the three photographs in terms of focus on the entire subject plane. Also examine the changes in shape of the subject that occur when the camera back is tilted.

Camera in zero position perpendicular to the plane of the subject

Lensboard tilted toward the subject plane

How Much Should I Tilt the Lens?

There is a rule that describes the relationship of the lens plane to the film plane when they are focused on a particular subject plane: *All three planes must be parallel, or they must all meet at one point.* This is a fairly simple concept that can be surprisingly helpful, despite its imposing name—the Scheimpflüg principle.

Suppose you are photographing a receding subject, for example, the surface of a street you are standing on that extends into the distance. You can estimate how much to tilt the lens (and the film plane, if you are using the rear tilt) by standing away from the camera and looking at the relationship of the lens plane (the lensboard), film plane, and subject plane (the street). Or suppose you are photographing a wall. You can actually look along the top of the camera back to see where that line would touch the wall, and then look along the camera's front standard to see if that line meets the wall at the same point. If so, you know that the alignment is right for focusing on the plane of the wall.

Note that more than one camera configuration meets the requirements of the Scheimpflüg principle. When you are photographing the wall, for example, almost any lens tilt can be matched with a corresponding rear tilt so that lines through both planes meet at the same point on the wall, thus theoretically providing good focus. The factors that determine the best practical configuration are the coverage of the lens, which will limit the amount of lens tilt, and the degree of shape distortion that is acceptable—controlled, of course, by the tilt of the film plane.

Comments

Camera back tilted away from the subject

- Depending on the subject, altering its shape by using the rear tilt may or may not be a problem. Landscape subjects, for example, can tolerate more shape distortion than subjects that are rectilinear. With rectilinear subjects, the rear tilt can be used in conjunction with the front tilt to control the plane of focus as described. The usual procedure is to use the front tilt first, since it is limited by the coverage of the lens, and then add the complementary rear tilt for optimum focus. However, when the rendering of shape is critical, adjust the back first to obtain the desired image, and then tilt the front to control focus.

- Once the right combination of tilts is established, it is possible to make minor image adjustments using the rising, falling and sliding movements without changing the focus plane. However, watch for vignetting.

Close-ups

Suggested Materials

4 × 5 camera
normal-focal-length lens
tripod
exposure meter
Polaroid 545 film holder
Polaroid Type 52 film

A view camera is the ideal tool to demonstrate the lens extension needed to make close-up photographs, since the focusing movements are relatively large and obvious and it provides an easy way to measure the lensboard-to-film distance for determining the bellows factor. In addition, the lack of depth of field that occurs with close-ups will be obvious. You can then point out to students how the 4 × 5 compares to a 35mm camera used either with extension rings (or bellows) or with a macro lens, which has a long helical focusing mount that permits focusing on close subjects.

The bellows factor is found by measuring the lens-to-film distance, or bellows extension, with the camera focused on a close subject. The factor is then equal to:

$$\frac{(\text{Bellows extension})^2}{(\text{Lens focal length})^2}$$

Since this is a factor, it can be multiplied directly by the exposure time or converted to f-stops to correct the aperture (a factor of 2 equals 1 stop, and so on).

This rule of thumb may help your students:

Whenever the distance from the lens to the *subject* (not the *film*) is less than 8 × the focal length, the bellows factor is significant—1/3 stop or more—and should be calculated and used.

This demonstration will be most effective if you choose a subject that lends itself well to being photographed both at a distance (approximately 10 feet) and close up. A still life or a portrait subject should work well.

Step by Step

1 Set up the camera to photograph your subject from a normal distance (far enough away that no bellows factor is needed). Make one photograph, properly exposed, and process it.

2 Move the camera close to the subject, focus, and make a second photograph using the same exposure as the first. Process it and compare with the first; it should be underexposed.

3 Measure the distance from lensboard to film plane to determine the bellows factor. Show students how to determine the corrected exposure using the bellows factor.

4 Make a photograph using the corrected exposure. Process it, and compare it with the first two.

Camera at a normal distance from subject

Camera close up to the subject using same exposure

Camera close up to the subject correcting for bellows extension

Comments

- The exposure correction made necessary by the lens extension often complicates the making of close-up photographs. The photographer may have to use a long exposure time, which then may require additional correction because of reciprocity failure. And opening the aperture to correct the exposure will only aggravate the depth-of-field problem. For subjects that allow it, use very strong light and/or very fast film.

- Be sure to point out the lack of depth of field inherent in close-up photographs.

- Explain that 35mm cameras with behind-lens metering usually provide automatic correction for lens extension since they measure the light that actually falls on the film plane.

Correcting Convergence of Parallel Lines

Suggested Materials

4 × 5 camera
normal-focal-length lens
tripod
exposure meter
Polaroid 545 film holder
Polaroid Type 52 film

To the Instructor

Students can approach this assignment at any level of sophistication. For example, beginners may need time to simply try out the view camera. However, correcting convergence is one of the fundamental view camera capabilities, and since it rarely requires lens or film plane tilts, this assignment is a good way for them to start learning some of the benefits of using a view camera.

Kelly Walker

Ray Laub

Instructor: Pirkle Jones, with assistance from Jock Sturges, San Francisco Art Institute, San Francisco, CA

1 Were you successful in correcting the convergence of parallel lines?

2 What problems did you have?

3 What effect does lens coverage have on the ability to correct convergence? What effect does the distance to the subject have?

4 Can you detect any loss of sharpness near the edge of your photographs?

5 Can you think of a situation in which you might want to emphasize convergence rather than eliminate it?

John W. White

ASSIGNMENT 9-1 Correcting Convergence of Parallel Lines

A primary use of the view camera is to keep parallel lines in the subject parallel in the image. When you turn the camera upward to include the top of a building, for example, the sides of the building converge because the camera back is no longer aligned with the building facade. If you use the rising front movement instead of pointing the camera up, the camera back remains parallel with the front of the building, thus preserving the parallel edges. Since the plane of the lensboard is also parallel, you can maintain focus over the entire front of the building.

There are numerous other situations that involve the same problem, and they can be handled in much the same way. Just remember that you must keep the camera back parallel to the plane of the subject that you want accurately reproduced.

For this assignment, photograph a subject that includes parallel lines. Make one photograph with no camera movements to see how the lines converge, and then make another using the camera movements to keep the lines parallel, maintaining good focus over the entire plane.

Step by Step

1 Find a subject with prominent horizontal or vertical parallel lines. Position the camera in such a way that you would have to turn it, either up or to one side, to include the parallel lines.

2 Make an exposure with the camera turned up or to the side, showing the convergence of the lines that are parallel in the subject.

3 Then set up the camera again in the same position but keeping the camera back and front aligned with the principal subject plane. Use the rising, falling, or sliding movements to control the location of the edges of the image.

4 Make a second photograph and examine it for accurate alignment of the subject's parallel lines. If the lines are not parallel, adjust your camera setup and make another photograph.

ASSIGNMENT 9–2

Photograph a Receding Subject

Suggested Materials

4 × 5 camera
normal-focal-length lens
tripod
light meter
Polaroid 545 film holder
Polaroid Type 52 film

To the Instructor

This assignment follows up on the points made in Demonstration 9–4, which introduced some of the problems of representing a subject plane that extends toward and away from the camera. Students will photograph an appropriate subject, whether a small-scale tabletop or a landscape, and use the camera movements to control the focus. They should apply the Scheimpflüg principle to determine the degree and direction of tilt of the lens and film planes.

Angela Clark

Instructor: Sean Wilkinson, The University of Dayton, Dayton, OH

1 How did you determine which camera movements to use and how much to use them?

2 Did you encounter vignetting of the image? If so, how did you, or how could you, correct it?

3 Did the shape of your subject become distorted because of the camera movements?

Angela Clark

Instructor: Sean Wilkinson, The University of Dayton, Dayton, OH

Assignment 9–2 Photograph a Receding Subject

From class demonstrations and reading, you should have a good idea of how to maintain focus on a subject that recedes—that is, a subject whose principal plane extends toward and away from the camera. A view camera is the ideal tool to tackle this problem, and this assignment gives you a chance to do that.

Find a subject in which the major plane—the plane that must be in sharp focus—is not parallel to the camera back, but recedes from the camera. Inevitably in such a situation parallel lines in the subject plane will converge in the image. In fact, this convergence of lines is one of the classic visual clues of perspective, which helps us judge distance and spatial relationships. The rear tilt of the view camera gives you control of how steep the perspective appears to be, and thus control over the sense of space in your photograph.

The other major issue you will work with in this assignment is the plane of focus. If you are photographing a receding plane with a 35mm camera, you would need to use a small aperture for maximum depth of field. Tilting the lens in a view camera gives you much greater control of the focus, allowing you to focus on a plane from very near the camera to infinity, well beyond the range of the aperture. Usually you would both tilt the lens (or the back, provided the shape distortion didn't bother you) to control the plane of focus, and stop down to a small aperture for maximum depth of field.

Step by Step

1 Choose a subject with an important receding plane. This might be the ground, perhaps a sidewalk or beach, or a smaller surface like a wall or tabletop.

2 Set up the view camera with all movements zeroed. Compose the image, focus, and make one exposure without using any of the movements.

3 Then use the swings or tilts of the lens plane and camera back to control the focus and perspective. Remember that, in general, the lens swings are used to control focus and the back swings to control shape or perspective; however, the back swings also affect focus. Try to position the front and rear standard using the Scheimpflüg principle.

4 Bring to class the original uncorrected photograph as well as the corrected one.

Erase Your Reflection

Suggested Materials

4 × 5 camera
normal-focal-length lens
tripod
exposure meter
Polaroid 545 film holder
Polaroid Type 52 film

To the Instructor

This assignment makes use of the sliding or shifting movements of the view camera to create a squared-up image of a reflective subject such as a mirror. The purpose is to produce a photograph in which the mirror appears to have been photographed from directly in front, but with no reflection of the camera. It can be applied in other situations, such as photographing a storefront without having the camera reflected in the window glass.

Points of Discussion

1 What factors limit how far you can move to one side of the subject and still use the shift movements to center the image?

2 When you compare the straight-on image with the one made from one side, what visual clues indicate that the camera was not directly in front of the reflective surface?

3 How do distance from the subject and size of the subject affect your ability to create this effect?

Patricia J. Cousins

Instructor: William E. Parker, University of Connecticut, Storrs, CT

ASSIGNMENT 9–3 Erase Your Reflection

Here's an interesting and sometimes useful feat you can perform only with a camera with movements. It involves photographing a mirror or reflective window straight on, with no reflection of you or the camera. The secret is that instead of being in front of the reflective surface, you move to one side and use the camera movements to "square up" the image.

Step by Step

1 Set up your camera directly in front of a rectangular mirror or window so that your reflection shows. The parallel edges of the subject should appear parallel in the image. Make one photograph in which your reflection is visible.

2 Then move just far enough to one side that you can no longer see your reflection. Set up the camera pointing straight at the wall so the lensboard and film plane are parallel to it.

3 Then use the sliding/ shifting movements to frame the photograph as before. All the parallel lines should once again be parallel, but with no reflection. Make a second photograph.

4 Process and bring the two photographs to class.

Introduction

A little while ago we sent a mailing to photography teachers asking them to share their personal assignments with us. Hundreds of teachers responded. From these, we've selected the 37 projects that make up the second part of this book.

The idea was to find assignments that had been developed and used by a variety of teachers. Some of the assignments chosen are technical in nature, but most deal with creative or picture-making issues.

Many of the assignments submitted were similar to those in the first part of the book, so we decided not to include them in Part Two. When we received duplicate assignments, we chose either the ones most clearly expressed or those with the best illustrations. In some cases, when they were different enough to merit it, we included more than one related assignment.

The use of Polaroid 35mm materials is recommended for most of these projects, because students generally feel comfortable with, and have access to, 35mm equipment.

The illustrations for all the topics were provided by the teachers from their students' work. In some cases, the teachers' own work is included.

TOPIC 1

ICEBREAKER

Group Icebreaker

Instructor: Alida Fish
Philadelphia College of Art
Philadelphia, Pennsylvania

The goal of this assignment is to use instant materials to create a class portrait during a two-hour class meeting. Every member of the group should be represented at least once in the final presentation.

"This project helps greatly in breaking the ice on the first day of class. It generates an activity and enthusiasm that adds to the momentum of the class overall. The results are always unpredictable and exciting."—Alida Fish

Suggested Materials

4 × 5 camera
normal-focal-length lens
tripod
exposure meter
Polaroid 545 film holder
Polaroid Type 52 film
simple studio lighting, if
 needed

Step by Step

1 Before starting, discuss with students the spontaneity possible with instant materials, for example, the ability to make instant critical judgments, the ease of including one photograph within the next photograph, and the possibilities of reworking prints and rephotographing and collaging them. The final presentation is important, so make suggestions concerning the form it can take, such as a book, a mural, or a three-dimensional object.

2 You, the instructor, can assist students with the camera and lights. Let the students collaborate on the positioning, posing, as well as the direction of models, the framing of the image, and the presentation of the picture or pictures.

Four different students appear in this collage.

In this sequence, one or more members of the class were added for each shot. The pictures were displayed in an accordion-bound book.

Icebreaker

Instructor: John Schulze
University of Iowa, Iowa City, Iowa

Suggested Materials

Polaroid SX-70 or Type 600
 camera
Polaroid Time Zero or Type
 600 film

One way to get students to relax and participate in class is to take Polaroid photographs of them at the first meeting. As a variation, you could get students to photograph each other.

"This creates a relaxed atmosphere, we all get better acquainted, they sign their names under their image, and I have a record of their names linked to their faces. I have found this simple act more helpful to the learning situation than any other introductory idea I have ever used."—John Schulze

John Schulze

Taking photographs of students on the first day of class is an easy way to get to know them and for them to meet each other.

Lloyd Dunn

TOPIC 2

FIND A PICTURE

Where's the Picture in This Picture?

Instructor: Lisl Dennis
Travel Photography Workshop in Santa Fe,
Santa Fe, New Mexico

Seeing a picture, extracting it from the clutter of its surrounding environment, is often more difficult than composing the picture itself. This assignment helps students learn how to visualize images that are part of an overall scene.

Suggested Materials

35mm camera
Polaroid 35mm instant slide
 system
Polaroid Polapan CT or
 Polachrome CS film

Step by Step

1 Make one overall shot to record the context, or the general situation, in which you are working.

2 Then visualize, compose, and expose one or more images that you extract from the context situation. These images can deal with specific themes such as light, balance, color, and texture.

Lisl Dennis

Walking down a street in Tunisia, Lisl Dennis liked the look of the striped fabric she saw against the blue wall of a street stall. She knelt down to try to get a better angle on the stall, even though she thought that the fabric and blue wall by themselves did not seem to be enough. Only when she had gotten to a lower angle did she notice the blue window in the background.

Lisl Dennis

At a Buddhist temple in northern
Thailand, saffron-colored monks'
robes were hanging up to dry. Dennis
felt that she wanted more than just a
picture of the robes. A black water
pot that was nearby provided a cen-
tral point of emphasis for the picture.
Dennis moved the pot to the railing
and draped the cloth around it.

Postscript

"The process of recognizing elements that could be composed as
a strong visual statement perplexes many students. 'I just don't
see it,' they say. Making photographs is a process of unfold-
ment. We may just see a portion of something when we begin to
look at a scene. The rest appears as we get involved."
—Lisl Dennis

Finding Pictures

Instructor: Robert Sheppard
Hennepin Tech Centers, Eden Prairie, Minnesota

Asking students to find something to photograph in a restricted, apparently unspectacular area is a good exercise to do early during a field trip. It gets students looking for photographs rather than for dramatic subjects. This version was designed for a nature photography class, but the idea can be used with any subject matter.

Suggested Materials

35mm camera with lens suitable for close-ups
Polaroid 35mm instant slide system
Polaroid Polapan CT film
OR
Polaroid SX-70 or Type 600 cameras and film

Robert Sheppard

Finding photographs within a limited area shows students that they do not need a dramatic subject to make an interesting image.

Step by Step

1 Define a small area suitable for nature photography. 30 × 30 feet is more than enough for 10 to 15 people. Choose one that does not have any dramatic or unusual features but that does have a variety of plant life.

2 Have the class spend half an hour photographing only within that area. Students will have the greatest success with this assignment if they have cameras with close-up capabilities.

3 At the end of the half hour, bring the group together to discuss and compare what people found to photograph and how they approached their subjects.

Postscript

The assignment can be adapted to an urban area. Have students photograph in any restricted area, either indoors or out.

SCAVENGER HUNTS

Scavenger Hunt

Instructor: Henry Horenstein
Rhode Island School of Design
Providence, Rhode Island

In this photographic scavenger hunt, students make photographs to illustrate the items on an assigned list. This is a good assignment for introductory students early in the semester, but it could be used at any time, including at a workshop. Quantity is emphasized, rather than quality, in an attempt to get students working as soon as possible.

Suggested Materials

35mm camera
Polaroid 35mm instant slide
 system
Polaroid Polapan CT film

A Scavenger Hunt

action
blue
couple in love
couple not in love
fear
gross
hatred
intellectual
joy
lobby of a hotel (specify the
 hotel)
long-haired dog
pride
punk
sunny day
three dimensions
wealth

Step by Step

1 Make a separate photograph for each item on the list (see the sample list).

2 The photographs must be "found," rather than set up or constructed. Try to photograph people you don't know or to photograph in unfamiliar surroundings.

3 The photographs should illustrate the categories on the list, but should be interpretive rather than literal. Feel free to experiment.

Peter O'Brien: punk

Barbara Aldrich: couple in love

Joen Van Oppen: fear

Barbara Aldrich: long-haired dog

Lynn Riddle: sunny day

175

Heather Ann Pafka: fear

Barbara Aldrich: punk

Postscript

Class discussion of the results is an important part of this assignment. As a starting point, students can try to guess what category the photograph is supposed to illustrate. Have students compare photographs taken by different people of the same location or illustrating the same subject; the results are often surprisingly different.

Have people talk about the experiences they had while they were out photographing as a way of having them learn more about how to photograph in a public place, how to handle unfamiliar situations, how to approach strangers, and so on. The difference in experiences of males and females is one subject that's sure to come up.

Opportunities arise for pointing out technical issues, such as backlighting, although this is not primarily a technical assignment.

"I teach in an art school and have students who think mostly in terms of personal expression. However, a photographer's job is sometimes more editorial. You find things and edit from them and must place things within the frame. This assignment tests and develops resourcefulness, the ability to find a picture. It gets students photographing subject matter that they wouldn't necessarily deal with, and gets them to confront people they don't know."—Henry Horenstein

PROJECT 6

Geographic Scavenger Hunt

Instructor: Frank Rehak
Loyola High School, Towson, Maryland

Beginning photography students often resist making photographs except in their usual surroundings or of things or people they already know. This project encourages students to expand their horizons, see how other students photograph, and share experiences.

Suggested Materials

Polaroid SX-70 or 600 series camera

Polaroid Time Zero or Type 600 film

At least six numbered index cards for each student. Cards should contain directions to places in the community such as monuments, landscapes, industrial sites, and stores. Destinations should not be mentioned by name (see samples illustrated here).

Step by Step

1 Each of you has been given six index cards containing directions that will take you to a specific location. Follow the directions exactly, and you will arrive at your picture site.

2 Upon arrival, study the location. Walk around it, observe what is happening, notice what is visually interesting. Then make one photograph that you find technically and aesthetically satisfactory.

3 Number this photo on the back with the number of the direction card that took you there.

4 Repeat steps 1, 2, and 3 with the next card. Continue until you have used at least five of the cards. If you want to, you can swap one of the cards for another student's card.

5 Bring all the cards and photographs to the next class meeting.

Card #3
Head south on St. Paul St. until it turns into Light St. - follow Light past the Harbor, continue south three blocks, you will see a market on your right, enter the market and proceed to the West end of the market, you will see your subject fast at work with his special knife!

Clue: Shucks!

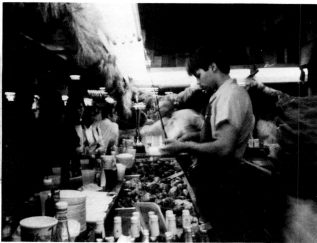

Cesar Castillo

Card #4

Go to Towson, park anywhere, walk to the York
Rd. entrance of Hutzler's dept. store,
standing near the War Memorial, you should
see both your subject and perhaps yourself!

Clue: You should "reflect" upon your subject

Artemio Cuevas

✓ Card #11

Head south on St. Paul St. until it turns
into Light St. by the harbor, pass the harbor
and turn off of Light onto Key Highway,
follow Key Hwy approx. 1/2 mile until you
see a large abandoned industrial area on
your left. Park where you can, explore this
waterside area, make your photograph.

Clue: men of iron, ships of steel

Michael Simon

✓ Card # 13

Leaving school, head north on Charles St.,
make a right turn in the very next driveway,
ascend the hill, park your car- historic
and beautiful!

Clue: Balto County learning

Michael Simon

In Class

1 Have students lay all the photographs out on long tables and organize comparisons of the same locations or sequences, series, or storytelling groups of photographs.

2 Encourage students to verbalize the experiences they had while taking the photographs and their reactions to other students' photographs.

3 Some classes will benefit from having each student make a brief written summary of the concepts learned and ideas exchanged with other students.

Photographing the Same Object

Instructor: Larry Kilgore
Longmont Junior High School, Longmont, Colorado

Many beginning students think that they must own the latest camera technology in order to make good pictures. This assignment reinforces the idea that it is the photographer who is important, not the equipment that is used. For example, choose an animal skull, a part of a mannequin, an old milk can, an old wagon wheel, a football helmet, a large piece of brightly colored cloth. Each student photographs the same object.

Suggested Materials

Polaroid SX-70 or 600 series camera
Polaroid Time Zero or Type 600 film

Step by Step

1 Take the camera and the object out of the classroom. You have 10 minutes to make one photograph and return to class.

2 Use the object as the central theme of the photograph.

3 Carefully choose a location, the object's placement, its background, and your point of view. You are not restricted to an eye-level view; consider shooting from above or below the object.

4 Take only one picture. Return the camera and object to class. Turn in your photograph with your name on the front.

5 Don't share any information with classmates at this time.

The variety of results that students produce when all use the same equipment to photograph the same object shows that it is the photographer and not special equipment that creates an interesting picture.

David Kleen

Conan Bliss

Kelly Robl

Photographer Unknown

Postscript

"After the last student returns to class, we display all prints on one board. The display spurs many comments and leads directly to a discussion of the photographer's role in the picture-making process."—Larry Kilgore

TOPIC 4

VERBAL-TO-VISUAL COMMUNICATION

Verbal-to-Visual Telephone

Instructor: Rik Sferra
Minneapolis College of Art and Design
Minneapolis, Minnesota

Suggested Materials

Polaroid SX-70 or 600 series
 camera
Polaroid Time Zero or Type
 600 film
index cards

This project is a variation of the telephone game that children play in which a message is whispered to one child, who whispers it to the next child, and so on, until the message is received by the last child. Often the last version of the message bears little resemblance to the original.

"The objective is to demonstrate the differences between a verbal message and a photographic message. This is to help the student to understand how we read and interpret photographs, and to increase awareness of the photographer's accountability for whatever formal and conceptual decisions are made in creating a photograph."—Rik Sferra

Step by Step

1 Divide the class into even-numbered teams of four to six students. Designate half of the students in each group as image makers, the other half as verbal message writers.

2 Give the first image maker of each team the same simple verbal message written on an index card. Try a single active verb (such as *throw*) or a simple sentence (such as *The woman is sitting*). The image makers can be informed of the type of message ("verb" or "sentence"), but not its contents.

3 Give the first image maker 3–5 minutes to make an image illustrating the message. Team members must work independently of one another and pass on only what they make or write.

4 The first image maker hands their finished Polaroid print to the first verbal message writer in the team, who, not knowing the original message, has 3–5 minutes to write a simple message that describes the photograph.

5 This verbal message is passed on to the next image maker, and so on, until the last member of the team, a verbal message maker, is finished. The whole process should not take more than 15–20 minutes.

6 The original message is then compared to the final verbal message and the whole "telephone line" is examined to determine where the breakdowns, if any, occurred. With several teams, compare how each team interpreted the common message.

THROW	throw	GIVE

THROW	ANGER	PAINTING STUDIO

Students should have little trouble when told they are working from a single active verb or common noun. Notice how the execution of the second photograph causes the breakdown of the message. From examples like this, students can learn that what they want to convey can differ significantly from what viewers will see in an image. Notice how clear the interpretation of the word *give* is in the third photograph.

The transition from the first photograph, which shows an intense throwing gesture and expression, to the word *anger,* and then to the abstract image in the second photograph, demonstrates how we stereotype the portrayal of emotions.

Personal Vision

Instructor: Bob Gauvreau
Modesto Junior College, Modesto, California

Each of us is unique and has many experiences, memories, and interests that we draw upon when making visual decisions in photography. This assignment demonstrates how individuals perceive an environment. Although two people look at basically the same subject, each brings something a little different to the expression of that scene in a photograph.

Suggested Materials

Polaroid SX-70 or 600 series camera
Polaroid Time Zero or Type 600 film

Instructions for Students

1 Each of you will be assigned a partner. The first part of this assignment, however, is done without your partner.

- Find a nearby subject to photograph.

- Before you make a picture, make a mental note of the way you want the scene to appear in the print, for example, its structure, feeling, or arrangement.

- Make the photograph. Don't look at the print. Put it away as soon as it emerges from the camera.

2 Return to the class meeting point and find your partner. Take your partner to the general vicinity in which you photographed, and give him or her a verbal description of the picture you just made. Do not look at your picture or show it to your partner.

3 Your partner should then explore the area and make an image based on your verbal description. Again, neither you nor your partner should look at the print; put it away as soon as it emerges.

4 Reverse roles, so that your partner makes a picture first and describes it to you, then you make a picture based on that description.

When each student has made his or her own image plus one described by a partner, the class meets to compare the results. Each student describes the scene, shows the first photograph, then the partner displays the second photograph. Students do not see the photographs until after the verbal description has been given, so results can be surprising. The images may be exactly what the class expects, or they may be quite different. Such variations let class members experience many different approaches. It helps them to conceive of ideas and images in their own way.

Todd Rushing

Suzanne Young

When Todd Rushing took his partner to the location in which he had just photographed, he described the image he had made there as "circle and field." Notice how the more specific the description was, the more the photographs matched each other.

Postscript

It is generally best for the instructor to pick the partners. Try to pair people who do not know each other well or who have different approaches to photography. This makes for more unpredictable or original results.

"A positive attitude and success are built into the assignment; there are no 'bad' photographs made. Rather, students are given an opportunity to communicate to their partner and the group what they saw and how they chose to photograph it. Students are encouraged to perceive and express ideas in their own way."—Bob Gauvreau

Ron Jackson

Ron Jackson's description to his partner was "a commonplace scene, that people walk over or around every day."

Jean Hackamack

Jean Hackamack

Jean Hackamack's description was "happy faces."

Ron Jackson

TOPIC 5

MULTIPLE IMAGES

PROJECT 10

Photographs Arranged Like a Tile Wall

Instructor: Margaret Braiden
Cate School, Carpinteria, California

To encourage her high school students to go beyond the snapshot photographs they tended to take, Margaret Braiden asked them to photograph around the school, but to concentrate on color rather than to just record whatever activity was taking place. Pictures by everyone in the class were put on display in a grid pattern, arranged like a tile wall.

Suggested Materials

Polaroid SX-70 or 600 series camera
Polaroid Time Zero or Type 600 film

Step by Step

1 Photograph one or more events of school life, concentrating on the colors of the scene rather than simply making a snapshot of the event.

2 You may wish to take several pictures that tell a story about a person or place or that give an in-depth look at them.

3 The pictures will be mounted and displayed like a tile wall, so give some thought to their sequencing and arrangement.

**Photographs: Nicole Blatt,
Tracy S. Brown, Wendy Meyer,
and Brian Yager**

High school students at the Cate School made photographs of school activities, concentrating on the colors in each scene. Photographs from an entire year were displayed in a grid-like arrangement, resembling a tile wall: "The Colors of Cate School." Shown is a portion of the display.

Making a Photographic Book

Instructor: Peter E. Charuk
Nepean College of Advanced Education, Kingswood, Australia

Peter Charuk combines bookbinding with his photographic teaching in an assignment to produce an extended sequence or series of photographs.

Suggested Materials

any Polaroid print or a Polaroid negative or slide used to produce a print
bookbinding materials, as needed
examples of photographers' works to show class

Step by Step

1 Show the class work by photographers who have done extended sequences or series, such as Robert Frank's *The Americans* or any work by Duane Michals.

2 Discuss with the class ways in which a photographic book can be organized, such as a single motif or a negative sequence. Discuss ways in which text can be used in relation to images (see the box "Suggestions for a Book" on page 192).

3 Ask students to select a working topic such as a journey, a dream, or some specific topic or text. Have them plot the photographs they want to make and begin to make them.

4 At this point, give students some individual help in making decisions such as how the images will be sequenced, how the text (if used) will relate to the pictures, and which bookbinding methods to use (see the box "Some Ways to Bind a Book" on the next page).

Some hand-bound, student-produced books.

Peter E. Charuk

The cover and opening page of *Preludes,* a book by Roger Griffin. This book was based on writings by T. S. Eliot and uses photographs of his environment.

Images are preceded by partially transparent pages on which the text is typed, so a combination of text and image can be seen before the image is fully revealed.

Roger Griffin

Postscript

One problem you may encounter with this assignment is the tendency to tell a trite story. If this happens, encourage students to rethink the idea or to come up with an unusual presentation.

Some Ways to Bind a Book

Single-section binding, Japanese binding, and family-album binding are shown here. Accordion binding is another possibility; the right edge of one page is attached to the left edge of the next page, then all pages are folded into a stack. More information can be found in any book about bookbinding; see particularly Pauline Johnson, *Creative Bookbinding* (Seattle: University of Washington Press, 1973) or Keith A. Smith, *Structure of the Visual Book* (Rochester, New York: Visual Studies Workshop Press, 1984).

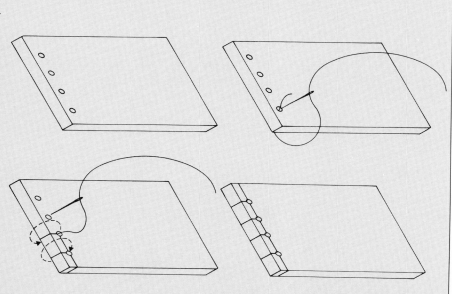

Suggestions for a Book

by Barbara London

A story told in pictures with some words. Duane Michals, *Take One and See Mt. Fujiyama*, Rochester, N.Y.: Light Impressions/Stephan Mihal, 1976. (Was it a dream?)

Mostly pictures, amplified by some words. Abigail Heyman, *Growing Up Female*, New York: Holt, Rinehart and Winston, 1974. (Females of various ages, in various relationships.)

Mostly writing, illustrated with some pictures. Elsa Dorfman, *Elsa's Housebook*, Boston: David R. Godine, 1974. (Mainly about people who came to her house one year.)

A question posed in words and pictures. Shirley Burden, *I Wonder Why . . .*, Garden City, N.Y.: Doubleday & Co., 1963. (The last picture answers the question.)

A comic book using photos instead of drawn pictures. Elizabeth Crawford, *Click—The Photocomic for Romance*, Brooklyn, N.Y.: Click, 1984. (Part 2 of *Stupid Girl* gives "The Thrilling Conclusion!")

The documentation of an event. Mason Williams, Edward Ruscha, and Patrick Blackwell, *Royal Road Test*, Los Angeles, 1967. (They throw a typewriter out of the window of a speeding car and record the consequences.)

A collection of images related by subject matter. Garry Winogrand, *The Animals*, New York: Museum of Modern Art, 1969. (What you see at the zoo, if you are Garry Winogrand.)

A sequential collection. Kenneth Josephson, *The Bread Book*, 1973. (Pictures of each side of every slice of a loaf of bread, assembled in the order in which they were sliced.)

Images that relate graphically to one another. Janet Maher, *The Dance*, 1983. (Graffiti squiggle and dance from one page to the next.)

Images plus overlays. Hans Breder, *Portrait of Rosa*, New York: Chicago Books, 1983. (Words and images are printed on transparent and translucent pages that overlay the photograph; words are also printed directly on some of the photographs.)

A flip book. Like a sequence of frames from a movie; flip the edges of the pages and see an image appear to move. George Griffin, *Face Phases*, 1976. (The man yawns, etc.)

Oversize or undersize. Catherine Jansen, *Cloth Book*. (Pieces of cloth, 5 × 6 feet, were coated with blueprint or brownprint photo emulsion, exposed with negatives, objects, and sometimes people laid on top of the cloth, processed and dried, hand-colored, stitched, backed with another piece of cloth, and stuffed. The collection of "pages," 2 ft. thick, was held together by grommets along one side. Just the thing if you like to crawl into bed with a book.)

Consider also page cutouts, embossing, combinations with other processes or media, use of found imagery from magazines, and so on. Feel free to experiment.

Camera Blending

Instructor: John Warren Oakes
Western Kentucky University
Bowling Green, Kentucky

Camera blending is a method of double exposure using a mask to cover part of the lens, thereby exposing only part of the image. This lets you take part of a picture at one time and the other part at a later time or of a different subject.

Suggested Materials

any camera and film with which you can make more than one exposure without advancing the film, such as:

35mm camera with Polaroid Polapan CT film

4 × 5 view camera and tripod with Polaroid 545 film holder and film

Polaroid Series 100 through 400 pack film cameras

Polaroid EE 100 camera

mask (construction explained on page 194)

holder for mask (A mask fitted into a holder for a series filter is shown in the illustration on page 194.)

Step by Step

1 Make an exposure of the first image with the mask in place so that only half of the film or print is exposed.

2 Recock the shutter without removing or advancing the film.

3 Rotate the mask 180° and make the second exposure.

4 Process the film (if using sheet or pack film) or advance to the next frame (if using 35mm film).

John Warren Oakes

Postscript

It can be helpful to make a simple sketch of the shapes of the subjects to be combined to determine the best size relationships and composition. With a view camera, you can make a more exact sketch by attaching a piece of tracing paper to the ground-glass viewing screen.

The blend occurs where the two exposures overlap. A larger lens aperture creates a wider blend line; a smaller aperture creates a narrower blend line.

You can cut a mask into unequal pieces to blend a smaller area into a larger one.

Filters can be used selectively on parts of an image at the same time as the blend. For example, you can expose the top half through a red filter to darken a sky, while exposing the bottom half through a green filter to lighten grass and trees.

John Warren Oakes

Unmasked and masked images of a building and a toy horse. The camera-blended image of the two images is on the preceding page.

Constructing a Mask and Holder

As a holder for the mask, you can use a series filter holder that attaches to the taking lens. To make the mask, cut a piece of black cardboard into a semicircle that fits into the filter holder. (See illustration **A**.) You can use white cardboard if you cover the side that faces the lens with black ink.

If a filter holder ring is not available for your lens, you can construct your own holder from heavy paper such as construction paper. Cut a strip of paper long enough to go around the lens and wide enough to extend from the camera body to slightly past the lens. Tape the strip of paper into a tube. (See illustration **B**.)

For the mask, cut a semicircle bigger than the end of the tube. Cut and bend the overlapping

A.

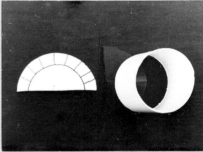

B.

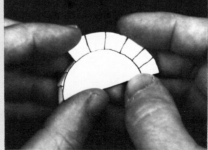

C. Score ½ inch from inside edge.

area so the mask can be taped to the tube. (See illustrations **B–D**.)

The inside of the tube and the side of the mask facing the lens

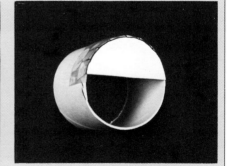

D. Mask and holder in place on a camera.

should be black. You can construct the tube and mask out of either black paper or white paper covered with black ink.

COMPOSITION/ PERSPECTIVE

PROJECT 13

Form and Content

Instructor: Richard D. Merritt
University of New Hampshire
Durham, New Hampshire

Form and content are inseparable, but dealing with them as separate elements helps students to clarify their perceptions of them. Many beginning photography students have no prior experience in art, so the assignment sharpens their awareness of how design elements can strengthen an image.

Before giving the assignment, introduce or review examples of design concepts such as line, shape, pattern, texture, balance, perspective, tone, and emphasis, as well as those that relate specifically to photographic technique, such as sharpness, contrast, and color balance.

Suggested Materials

35mm camera
Polaroid 35mm instant slide
 system
Polaroid Polapan CT film

Step by Step

1 Formal elements dominate. Make a photograph in which the subject is abstracted to the point where design elements (such as line, shape, and pattern) are the main force of the image, and content, although possibly present, is of lesser significance. You do not need to abstract the subject to the point where it is unrecognizable, but try to make form, rather than a particular subject, the most important part of the picture.

2 Content dominates. Make a photograph in which the content is paramount. The image should trigger some emotional or intellectual response in the viewer. Do not disregard design elements, but use them to enhance the content or message of the picture, rather than allowing them to dominate the image.

A rhythmic array of the vertical lines of a fence—thick and thin, light and dark—is broken by a random pattern of shadowy forms from nature. Some intellectual content is present in the concept of an interplay between human constructions and the natural environment, but the main interest of the photograph is in the rigid pattern of the fence against the looser shapes of the shadows.

Anne Meda

The print is divided into two halves. On the right is a regimental array of white clotheslines and laundry hanging to dry. On the left, a more chaotic arrangement of curving rope and carelessly discarded children's playthings. The contrast between the formal qualities symbolically contrasts an adult world of work and the freedom and abandon of youth. The content or meaning of the photograph is the most important part of the picture, while the formal elements strengthen its meaning.

Stewart Landry

Texture and Pattern

Instructor: Charles Borman
California State University, Los Angeles, California

In this assignment students are asked to create images in which texture or pattern are strong elements. Pattern is defined here as a repetitive design with the same shapes appearing again and again. Texture also repeats, but generally with variation or irregularity. Texture often evokes our sense of touch, while pattern provides a design that is appealing to the eye.

Suggested Materials

35mm camera
Polaroid 35mm instant slide system
Polaroid Polapan CT film

Step by Step

1 Select a textural surface or repetitive pattern to photograph. Objects such as stacked lumber, pebbles, pipes, or bricks can create strong patterns. Weathered surfaces such as wood or metal can be distinctively textured.

2 Examine the scene through the viewfinder of your camera or on its ground glass. How can you arrange or frame the image so that it is a strong composition and not just a simple documentation of the particular texture or pattern? What kind of lighting will enhance the photograph? Textures are often brought out by lighting that strikes the object at an oblique angle to the texture. Some patterns are more evident in diffused light in which dark shadows do not intrude on the underlying pattern. In other scenes, shadows themselves create the pattern.

3 Make one or more exposures when you are satisfied that you have an interesting image as well as one that shows texture or pattern.

Roland Percey

Side lighting created dark shadows that brought out the texture of the peeling paint in this photograph. The image is framed so that the forms radiate from the center of the photograph to the sides.

Curved horizontals and straight verticals make an interplay of texture and pattern in this rock wall.

Roland Percey

Postscript

Variations of this assignment could be to photograph other design concepts such as line, contrast of light and dark, or illusion of depth, with the goal of making a strong photograph as well as using the particular concept.

Size/Space Ambiguities

Instructor: Ron Geibert
Wright State University, Dayton, Ohio

This assignment draws students' attention to how the three-dimensional world is abstracted and altered when converted to a two-dimensional photograph. Black-and-white materials are suggested because they make the change from "reality" to a photographic print more obvious. Students also get hands-on experience with a view camera and increase their awareness of the effects of lighting.

Suggested Materials

4 × 5 camera
normal-focal-length lens
tripod
exposure meter
Polaroid 545 film holder
Polaroid Type 52 film
photofloods

Step by Step

1 The goal is to construct a tabletop still life in which the actual space and/or size of the objects is ambiguous or even deceptive when photographed.

2 Select objects for the still life and make a preliminary arrangement of them. Consider what type of objects or placement of them lends itself to ambiguity. For example, objects of similar tonality can be in a different space but appear to merge. Exaggerated perspective or hand-constructed items of unknown size can cause objects of different sizes to appear the same size, or objects of the same size to appear different.

3 Set up the view camera and examine the scene on the ground glass. Make any necessary changes in camera placement, lighting, or the arrangement of the objects.

4 Make one exposure and compare the resulting print to the scene. Are there additional changes that could enhance the ambiguity in the print? If so, make them, then make another exposure.

The rims of the glasses and the checkerboard pattern behind them create illusions of space and form that do not match the actual position of the objects in the scene.

M. Susan Kuntz

Postscript

"The most common error made by students is not moving the camera in close enough. I purposely allow them to frame the first exposure on their own without comment or suggestions. Most are disappointed with the first picture because it just looks like a table with stuff on it. In subsequent exposures and discussion, they see the need of careful framing, become aware of how objects interrelate and are changed by being juxtaposed, and how the use of highlights and shadows can change the image."
—Ron Geibert

Up Against the Edge

Instructor: Gregory Spaid
Kenyon College, Gambier, Ohio

Photographic composition differs in some significant ways from composition in painting or drawing. The camera tends to fragment reality and show only a slice of something we know to be much larger. Sometimes that slice seems particularly meaningful or abrupt. This assignment explores the function of the edge or frame of a photograph.

Suggested Materials

35mm camera
Polaroid 35mm instant slide system
Polaroid Polapan CT film

How do the edges of a photograph—its frame—affect an image? These photographs explore the use of the frame as a compositional device.

Step by Step

1 Experiment with compositions that use the edge of the photograph in some deliberate way—perhaps meaningful, humorous, poetic, horrifying, scandalous, or beautiful. The edge should pull attention away from the center of the image.

2 Look at how other photographers have used the frame of the image. See, for example, work by Richard Avedon, Imogen Cunningham, Lee Friedlander, Ralph Gibson, Eva Rubinstein, Edward Weston, or Garry Winogrand.

Susan Hillenbrand

Elizabeth Wood

Postscript

"Every time we look at a photograph, we are aware, however slightly, of the photographer selecting that sight from an infinity of other possible sights."—John Berger, *Ways of Seeing* (New York: The Viking Press, 1973)

Workshop: "Close-up" as a Visual Concept

Suggested Materials

35mm camera (use the same lens for all photographs)

Polaroid 35mm instant slide system

Polaroid Polapan CT, Polaroid Polachrome CS, or other film

OR

Polaroid SX-70 or 600 series camera

Polaroid Time Zero or Type 600 film

Instructor: Barbara Crane
School of the Art Institute of Chicago
Chicago, Illinois

The instant feedback of Polaroid film materials makes them very useful at workshops, where time is usually limited. There are many ways in which Polaroid film materials can be used for workshop demonstrations and assignments. The following is an assignment for a one-day workshop that combines photographing with viewing and critiquing that day's work. The goal is to explore the visual effects of photographing close to a subject.

In past workshops Barbara Crane has had students use Polaroid print film and cameras that were supplied to them, but for this workshop she had them use their own 35mm cameras with Polachrome CS or Polapan CT instant slide film. When students are able to use their own cameras, workshop ideas are more easily applicable to their ongoing work.

Step by Step

1 Use the first half of the roll (18 exposures) to make photographs only of inanimate objects photographed at a distance of 3 feet or less.

2 Use the last half of the roll (18 exposures) to make photographs of people from a distance of 3 feet or less.

Susan Fowler

3 Return to the meeting place within two hours.

4 After the film is processed, the slides are mounted and edited by each participant for group viewing and discussion.

Lynn Bahannon

Lee Mondale

Carol Siegel

Postscript

Allowing two hours for picture-taking gives time for the instructor to get to know participants and their portfolios on a more personal level than can be done just during group meetings.

It is often easier for students to work up close if they use the first half of the roll only for inanimates, rather than approaching people right away.

Using the same lens for all photographs, Crane believes, reduces the number of decisions that do not relate directly to the assignment. This encourages clarity of thought and concentrates attention on picture-making rather than hardware.

"I am interested in helping people find the visual relationship between pictures. I seek connections based upon form, texture, hue, and content. There could even be a sequence of overexposed shots. Many people have been taught to explain things verbally, to translate their ideas into words. They try to put pictures together because of a story, a verbal relationship. I try to help them make visual connections."—Barbara Crane

PROJECTS

Photographing, Critique, Rephotographing

Keeping a Comp Book

Imitate an Advertising Photograph

CRITIQUING

Photographing, Critique, Rephotographing

Instructor: Stuart Nudelman
The Ogunquit Photography School, Ogunquit, Maine

Critiques are an ongoing process in many classes and workshops. In this project, the entire group participates in making suggestions for improving a photograph. The photograph is then remade, incorporating the suggestions. The sooner the original picture can be critiqued and remade, the more the student is likely to benefit from the experience.

Suggested Materials

35mm camera
Polaroid 35mm instant slide system
Polaroid Polapan CT film

OR

Polaroid SX-70 or 600 series camera
Polaroid Time Zero or Type 600 film

Step by Step

1 Have students photograph a scene that they will be able to reshoot at a later time.

2 Setting the tone of a group critique is important. Ask for constructive and specific analysis and suggestions.

3 Have students remake their original photographs, incorporating ideas, suggestions, and modifications resulting from the group discussion.

 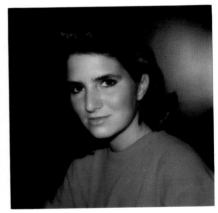

Linda J. Bromberg

Students felt that the subject in the first portrait did not seem comfortable. Technically, they observed that there was a lack of tonal separation between the subject and the background, and decided that the subject should occupy more of the frame.

In this remade version, the model is more relaxed; eye contact has also improved the feeling. The subject has been separated more from the background and framing is tighter.

Keeping a Comp Book

Instructor: J. Michael Verbois
Brooks Institute, Santa Barbara, California

A comp book is a detailed, illustrated notebook for the photography student and is meant to be used the same way a scientist keeps a lab book or a writer keeps a diary. Students at Brooks Institute use comp books to keep a comprehensive record of every aspect of making a photograph or doing other class work. If a student has a problem with a particular assignment, and all the steps taken have been documented and illustrated, it is far easier for the instructor to retrace each step with the student, find problem areas, and suggest alternate approaches. The book becomes a valuable reference for technical and logistical information, and many graduates report that they continue to refer to their books.

Suggested Materials

notebook large enough to keep detailed notes, to sketch setups, and to mount sample pictures.

Step by Step

Use your comp book from the beginning to the end of an assignment. Following are typical items to include.

Preproduction
The goal or purpose of the work
Thumbnail sketches of preliminary ideas
Potential problems and their solutions
Equipment and supplies needed, including rental items
Logistical considerations—places, people to contact, props, locations, models

Technical information
Sketch of setup
Light source
Exposure
Filtration
Camera and lens
Film
Processing

Preliminary and final photographs of project

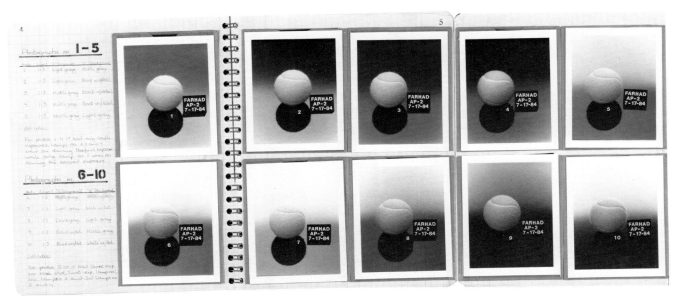

Shukri Farhad

Illustrations from Shukri Farhad's comp book

Postscript

Student reaction to the idea of a comp book is often initially negative—it seems like unnecessary work. But students quickly become enthusiastic when they see what a valuable resource their comp books can be.

"The book makes students think and plan logically, helping them to separate the components of the overall problem and tackle them individually. . . . It makes students more literate—able to express their assignment goals verbally as well as visually."
—Vern Miller, Chairman of
Industrial/Scientific Department at Brooks Institute,
who introduced the idea of a comp book to the school

PROJECT 20

Imitate an Advertising Photograph

Instructor: David M. Wagner
Bowling Green State University
Bowling Green, Ohio

By imitating an advertising photograph as closely as possible, students will become familiar with view-camera controls, increase their ability to analyze and manipulate lighting and backgrounds, and learn to apply a systematic approach to studio photography.

Suggested Materials

4 × 5 camera
normal-focal-length lens
tripod
exposure meter
Polaroid 545 film holder
Polaroid Type 55 P/N film
props and studio lighting, as
 needed

Easy going taste in a low tar.
Regular and Menthol
Kings and 100's

Reprinted by permission of Philip Morris, Inc.

Photograph reproduced in advertisement.

Step by Step

1 Review several magazines and select an advertisement you wish to imitate. Analyze the picture for such elements as composition, lighting, subject position and its relation to camera position, and background. If you plan to shoot in color, examine the color balance of individual parts of the picture and of the advertisement overall. You may, if you wish, reproduce in black and white an advertisement that originally appeared in color, but if you do so, make sure that it has adequate contrast to render well in black and white.

David M. Wagner

2 Set up the camera and scene and make your first exposure, attempting to imitate the advertisement as closely as possible.

Keith A. Fazio

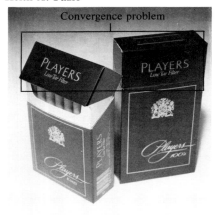

Foreground area too light

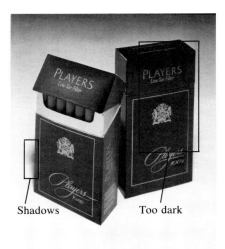

Shadows Too dark

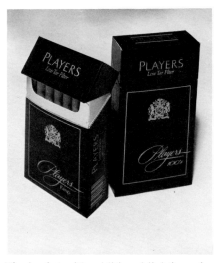

Student's first shot, view camera in neutral position.

Second print shows view camera corrections and lighting changes.

Final print with additional lighting adjustments.

3 Evaluate the print, and analyze what you will need to do to make your photograph more closely resemble the one in the advertisement. This process is likely to require several trials. Reshoot the scene as needed.

4 As you make each photograph, indicate lighting, camera, and composition improvements that you made directly on the print or on a tracing paper overlay. Draw a lighting diagram, showing subject, camera, and lights.

Postscript

If the advertisement defies imitation, it may be that the original picture was retouched or airbrushed. Also, some color advertisements do not reproduce well in black and white. Consult with your instructor if you experience unusual difficulties.

TOPIC 8

PAINTING WITH LIGHT

Painting with Light

Instructors: Mike Hatchimonji
Los Angeles Trade Technical College
Los Angeles, California

William Noyes
Paier College of Art, Hamden, Connecticut

Suggested Materials

4 × 5 camera
normal-focal-length lens
tripod
exposure meter
Polaroid 545 film holder
Polaroid Type 52 or Type 55
 P/N film
10- or 12-inch photoflood
 reflector with a 75-watt or
 stronger bulb

Painting with light involves moving a light source up, down, around, across, or even below or behind the object to "paint" on the light while the shutter is open. The technique is often used by industrial photographers to illuminate objects that for one reason or another cannot be brought into the studio; with this method, a photographer does not have to bring many lights on location and is not restricted to a single lighting position. The method can be used in the studio as an alternative to tenting an object when you want soft, shadowless lighting. The light can be directed into deep recesses and spread evenly from front to back.

Step by Step

1 Select a desktop-size object to photograph that has complex, hard-to-light surfaces, for example, a typewriter, a television with its outer shell removed, or a multiangled sculpture.

2 Place the object on a large, white background.

3 Focus, then close down the lens aperture to its smallest opening. Close the shutter and set it on T (see the box "How to Keep the Camera Shutter Open" on page 216). Insert the loaded Polaroid film holder.

4 Plan the general way in which you will move the lamp.

5 Ambient light (the overall room light) should be relatively dim; bright ambient light can affect the results even at a small aperture.

6 Light the lamp and open the camera's shutter. Keeping the light in constant motion, sweep it smoothly over and around the object. Try a 10–30 second exposure, depending on the wattage of the bulb, the size of the object, and whether you're using any bellows extension.

7 Close the shutter and process the film.

8 Evaluate the photograph. Is the exposure about right overall? Should you give less or more exposure to specific parts of the object? Has the light cast any shadows that should be eliminated? Do you want to paint more light onto the background to make it lighter or even totally white? If ambient light interferes and cannot be dimmed, try a 2- or 3-stop neutral-density filter on the lens and a stronger lamp in the reflector. The ND filter will reduce the effect of the ambient light, whereas the stronger lamp will offset the loss while you are painting.

A sculpture of a bull made of metal screening and wire was painted with light to eliminate shadows that might cause confusion in the subject's shape and textures.

William Noyes

Mike Hatchimonji

Painting this old typewriter with light created soft, shadowless lighting. Extra light was directed from above onto the type levers to bring out detail in them.

Mike Hatchimonji

Move the light smoothly and constantly when painting with light.

Postscript

Painting can be done with a portable electronic flash unit by giving an object multiple flashes from different positions.

How to Keep the Camera Shutter Open

The camera shutter must be kept open for an extended period if you want to paint with light (pages 214–215). Different cameras vary in their ability to keep the shutter open. Experiment with the operation of your camera before beginning one of these assignments.

A view camera will probably have a lens with a T setting. This is easy to use. The first time you press the shutter release, the lens opens; the second time you press it, the lens closes.

A 35mm or medium-format camera may have a B setting. At this setting the lens stays open as long as the shutter release is held down. To keep the shutter open without having to keep your hand on the release, use a cable release that can be locked down. Some cameras have a built-in lock that will hold the shutter open.

Polaroid cameras. The shutter on a Polaroid SX-70 or Type 600 camera can be kept open in the following manner. With room lights off, press the shutter release; the shutter will open. Quickly press the yellow bar on the side of the camera to open the film door; the shutter stays open as long as the film door is open. When exposure is complete, close the film door and press the shutter release again to eject the film.

If the room is totally dark, the camera will take about 20 seconds to eject the film. You can speed up the ejection process by letting light strike the electric eye (on a One Step or SX-70, this is the small window on the opposite side of the camera from the shutter button). First, cover the lens to prevent unwanted light from striking the film; then, turn on the room lights or flash a penlight at the electric eye.

You can make the shutter stay open on some Polaroid cameras by placing black tape over the electric eye. Cover the lens, then remove the tape and expose the electric eye to light to close the shutter.

A pinhole camera usually has no shutter. Simply uncover the pinhole opening during the exposure and cover it again when the exposure is complete.

Painting a Large Room with Light

Instructor: R. T. Clark
Utah State University, Logan, Utah

Painting with light (see page 214) can illuminate large interior locations where the available light is not bright enough for an ordinary exposure. One person can do this assignment, but it is more efficiently done with two people, one at the camera and one using the light. This is an excellent assignment for teaching view-camera movements.

Suggested Materials

4 × 5 camera
normal-focal-length lens
tripod
exposure meter
Polaroid 545 film holder
Polaroid Type 52 or Type 55
 P/N film
photoflood reflector with 250-
 watt or stronger bulb

Step by Step

1 Select a large interior that can be darkened, such as an auditorium or chapel. Focus and compose the photograph.

2 Plan the general pattern for moving the light. Position the light so that it more or less covers about a 10-foot square area at one time. Plan on keeping the light in motion, sweeping it smoothly over the scene. To prevent light flares, always keep the light turned away from the camera. To prevent ghost images of the person holding the light, keep light away from feet or other parts of the body. Keep extension cords behind the light, not in front of it.

3 To calculate the exposure, shine the light on the wall and make an exposure reading. Adjust the distance of the light so that the exposure for each area is about 5 or 6 seconds at the lens aperture that you want to use. High ceilings or other areas far from the camera require a longer exposure.

4 Set the lens aperture. Close the shutter and set it on T (see "How to Keep the Camera Shutter Open" on the previous page). Insert the loaded Polaroid film holder.

5 Open the camera's shutter and paint the first area with light. If necessary, close or cap the lens or hold a black card in front of it when the person operating the light moves to another area. Repeat until the entire scene visible in the photograph has been lit.

6 Close the shutter and process the film.

7 Evaluate the photograph. Is the exposure about right overall? Should specific parts of the scene have less or more exposure? Has the light cast any shadows that should be eliminated?

Only a single photoflood was used to photograph this stage set. The set was about 65 feet long, 15 feet high, with the theater wall at right about 100 feet from the camera. To build up the overall exposure, the scene was divided into 9 areas, each exposed for 8 seconds, using a single photoflood reflector.

R. T. Clark

Painting a Fantasy Image with Light

Instructor: Lorran Meares
Virginia Intermont College, Bristol, Virginia

When you paint with light (pages 214–215), you don't have to record a subject realistically. In this assignment, the shutter remains open while the photographer works in front of the camera, lighting and manipulating the subject as desired. (Before selecting a camera to use, see the box "How to Keep the Camera Shutter Open" on page 216. Some cameras are easier to operate than others.) The person or persons making the image can be part of the image if they are illuminated by the light being used. Focus can be adjusted so that near and distant objects can be placed in or out of focus selectively. The environment can be made to appear either realistic or fantastic.

"Painting with light offers almost limitless opportunities to anyone who enjoys creative play with highly flexible materials and a fluid imagination."—Lorran Meares

Suggested Materials

4 × 5 or 35mm camera
tripod
Polaroid Type 52 or 55 P/N film or Polaroid Polapan CT
any source of continuous light that can be hand held and that has an on-off switch, such as a photoflood in a reflector, flashlight, penlight, or battery-powered camping light
neutral-density filter for lens (optional)
an electronic flash (optional) as an addition to the continuous light source if you want to freeze a moving subject at some point during the exposure
a completely or nearly dark working environment—outdoors at night or in any room that can be darkened

Step by Step

1 Set up the camera with the scene in room light or other ambient light.

2 Compose and focus your image. If you wish, you can refocus the camera in the interval between painting any two objects. You may want both a close and a distant object in focus. Or perhaps you want one object in focus, while another object next to it is out of focus.

3 Plan the way in which you will move the light source during the exposure. See step 6 and Variations, below.

4 Exposure is affected by several factors: the brightness of the light, its distance from the subject, the reflectivity of the subject, the lens aperture, and the length of time light falls on the subject. You can calculate the exposure by shining the light on part of the scene and reading that area. Or simply make a trial exposure: follow steps 5, 6, and 7 below, giving about 5 seconds of illumination to each area. If the resulting picture is too light, decrease the amount of time or the intensity of the illumination; if it is too dark, increase the amount of time or the intensity. If you find that you have to move the light very quickly to avoid overexposing

the film, you can put a neutral-density filter over the lens; this will decrease the amount of light reaching the film and so increase your working time.

5 Turn off the room lights or, if outdoors, the light you have been using for focusing. Open the shutter.

6 Paint your subject with light. In most cases, the light should face away from the camera so that the bulb is not visible in the image and no light spills onto the lens. Keep the light in constant motion, sweeping it smoothly over the object being lit. The film will record only objects that you illuminate, and the light can be switched on or off as desired. Thus, you can record repeated images of the same object by turning off the light, moving the object, and repainting it wherever you want it to be seen.

7 Close the shutter and process the film.

8 Evaluate the photograph. Is the exposure about right overall? Should you give less or more exposure to specific parts of the subject? Has the light cast any shadows that should be eliminated? Feel free to experiment. You may begin with a preconceived image, then find that you want to alter it when you see the picture.

Using a pinhole stereo camera, the photographer selectively illuminated the woman and part of the surrounding area. (See pages 235–240 for information on stereo photography with Polaroid materials.)

Lorran Meares

Wanda Levin and Simone Little

The woman in the doorway was painted with light, first completely clothed, then again after removing her dress. Colored gels and moving fabric created the misty effects.

Melissa Smith

The photographer had a single statue of a flamingo, which she illuminated with a flashlight several times, moving the bird forward a few feet each time. She drew in the legs and feet by outlining them with a penlight pointed toward the lens.

Variations

- You can blur or freeze objects in motion. Illuminating a moving object during the exposure will cause it to blur and, if blurred enough, will show illuminated objects that are behind it. A burst of light from electronic flash used with the continuous light will create a blurred image combined with a sharp one.

- Diaphanous materials such as gauze, silk, or plastic can be lit from front or back while in motion to produce a vaporous or misty effect.

- You can use colored filters over the lens or over the light source.

- See related assignments "Streaking Light" on the next page and "Multiple Flash Exposures" on page 260.

Streaking Light

Instructor: William Sipe
Susquehanna Township High School
Harrisburg, Pennsylvania

This assignment uses a penlight to outline a subject with light.

Suggested Materials

4 × 5 or 35mm camera
normal-focal-length lens
tripod
exposure meter
Polaroid Type 52 or 55 P/N
 film or Polaroid Polapan CT
penlight

Step by Step

1 Set up the camera in room light. Focus and compose your shot. Plan the way in which you will move the penlight. You will need to keep the light pointing toward the camera to get the broadest lines of light; the lines will get thinner if the light angles away from the camera.

2 Turn off the room lights or darken the room by covering the windows. The only light striking the film should be from the penlight, so the darker the room, the better the results are likely to be.

3 Open the camera's shutter.

4 Now make your way to the subject (move carefully, in total darkness) and trace its outline or other details with the penlight.

5 When your outlining is complete, close the shutter and process the film.

6 Evaluate the photograph. Are parts of the subject itself exposed? The ambient light may be too bright, or you may have let light from the penlight fall on parts of the subject seen by the camera lens. Do you want to change the outlining in any way?

Left: Moving a penlight around a subject outlines it with light.

Right: Jennifer Hunter's setup for her photograph, just before turning off the room light. Make sure you have enough room to maneuver around the subject you are outlining.

Jennifer L. Hunter

William Sipe

Postscript

See "Painting a Fantasy Image with Light" on page 219.

William Sipe

With the television off, objects were outlined and streaks from the screen were drawn. Then the television was turned on for less than 1 second.

Jennifer L. Hunter and William Sipe

A burning sparkler was held out of camera range and allowed to drop streaking sparkles onto the setup. All the illumination comes from the sparkler.

Variations with Streaked Light

Use colored gels over the lens or over the light to create colored lines.

Tape several penlights together for multiple lights.

After outlining a subject, shine the light on part of the subject that will be seen by the lens. Shining the light on a person's face, for example, will produce a face with a glowing outline.

After outlining a subject, turn the room lights on and off to produce a normally exposed scene with a glowing outline of the subject. Results will vary depending on the brightness of the light and the length of the overall exposure.

After outlining a subject, move the subject a step or two to one side. Then add overall illumination. The result will be an empty outline with the subject next to it.

After outlining, remove the subject from the scene, then add overall illumination. The result will be an outline in an otherwise normal scene.

PINHOLE PHOTOGRAPHY

Constructing a 4 × 5 Pinhole Camera

Instructors: William C. Higgins
MacCormac Junior College, Chicago, Illinois

Norman Sanders
Cooper Union, New York, New York

Building a pinhole camera out of inexpensive and readily available materials is easy. The project can be used to introduce students to many basic principles of photography, such as angle of view, the relationship of aperture to shutter speed, the effect of film speed on exposure, and reciprocity effect with long exposures. Wide-angle distortion and limitless depth of field are not only easily achieved with a pinhole camera, they are often the main reasons for making a pinhole image. The following are Polaroid instructions for building a pinhole camera that accepts a Polaroid 545 film holder.

Suggested Materials

Polaroid 545 film holder
Polaroid Type 57 film
black cardboard and gray cardboard, one piece of each, 3 × 20 inches (for wide-angle camera); 6 × 20 inches (for normal-focal-length camera); 12 × 20 inches (for telephoto camera)
black cardboard and gray cardboard, 5 × 6 inches, one piece of each
two 1 × 4-inch strips and two 1 × 5½-inch strips black cardboard
opaque black plastic, one 1 × 20-inch strip and four 1 × 3-inch strips (substitute four 1 × 6-inch strips for a normal-focal-length camera, four 1 × 12-inch strips for a telephoto camera)
black velvet, one 1 × 20-inch strip
black electrical tape, 1-inch piece and 20-inch piece
aluminum pie plate or aluminum beverage can

#10 sewing needle, .018-inch diameter (not a sewing machine needle)
ruler
utility knife
scissors
glue
pencil with eraser
pliers
fine sandpaper or emery board
flat black paint and brush
large rubber bands

Assembling the Camera

The measurements below are for a wide-angle camera. (Measurements, other than width, are the same for all cameras. Width measurements are as follows: 3 inches for wide angle, 6 inches for normal, 12 inches for telephoto.)

1 Place the 3 × 20-inch black cardboard black side down. Draw lines on the back to mark each side of camera. Using a utility knife, score along the dotted lines; do not cut all the way through. There will be slightly less than an inch of excess length; do not cut it off yet.

2 Fold the cardboard with the black side facing in. Now cut off the excess length so that the two ends fit squarely together.

3 To lightproof the camera, glue black plastic strips on the outside of the camera around the corners and along the top edge. Let the plastic around the top edge stick up $\frac{1}{2}$ inch past the edge. Later this will be folded down over the front of the camera.

4 Place the 3 × 20-inch gray cardboard gray side up. Draw lines to mark each side of the camera. This piece of cardboard will be glued around the outside of the first box, so it has to be slightly larger than the first box. Using the utility knife, score along the dotted lines; do not cut all the way through. Do not cut off the excess length yet.

5 Fold the cardboard with the gray side facing out. Now cut off the excess length so that the ends fit squarely together. Glue it around the outside of the first box.

6 Glue the 1-inch black cardboard strips around the inside front edge (where the extra plastic sticks up), then glue the strips $\frac{1}{16}$ inch below the top edge of the inner box. These strips provide the edge on which the front of the camera will rest.

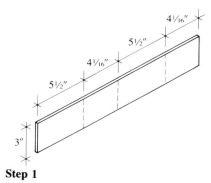

Step 1

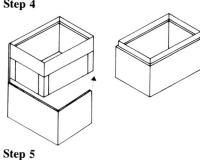

Steps 2, 3

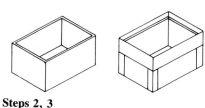

Step 4

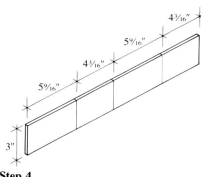

Step 5

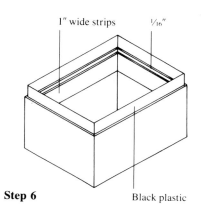

Step 6

1" wide strips $\frac{1}{16}$"

Black plastic

7 Cut down the 5 × 6-inch black cardboard rectangle for the front of the camera. It will fit inside the camera resting on the 1-inch strips just installed. Measure for a tight fit (about $5\frac{1}{2} \times 4\frac{1}{16}$ inches). The exact dimensions will vary with the accuracy of your box construction. Don't glue it in place yet.

8 Draw diagonal lines to find the center of the rectangle. Cut a $\frac{1}{2}$-inch square at the center.

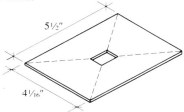

Steps 7, 8

9 Make a drill for the pinhole by inserting the needle in the pencil eraser with the point out. It is easier to drill the pinhole holding the pencil than holding just the needle. Use pliers to assist in inserting the needle.

Step 9

10 Cut a 2-inch square from the aluminum pie plate or can. Place it on a resilient surface, such as a cardboard scrap, and drill a small hole in the center with the needle. Don't make the hole too large; insert the needle only along its tapered part, not all the way to the thickest part of the shaft.

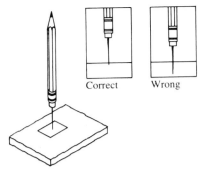

Step 10

Steps 11, 12, 13, 14

Steps 15, 16, 17

Steps 18, 19

11 Sand both sides of the hole until smooth. The more perfectly round the hole, the sharper the images will be. Paint one side of the aluminum square black, being careful not to clog the pinhole.

Note: You can buy precision-drilled pinholes from The Pinhole Camera Company, P.O. Box 19128, Cincinnati, Ohio 45219.

12 Glue the black rectangle to the inside front of the camera (where the 1-inch strips are glued) with the black side facing in. This is the camera front.

13 Glue the black plastic that is sticking up to the camera front.

14 Glue the pinhole with its black side facing in to the center of the opening in the camera front.

15 Cut down the 5 × 6-inch gray cardboard rectangle to finish the camera front (about $5\frac{9}{16} \times 4\frac{1}{16}$ inches). Place the gray side down and draw diagonal lines to find the center. Cut a hole 1 inch square in the center.

16 Glue the gray rectangle to the camera front with the gray side out.

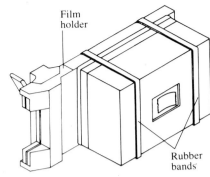

Finished Camera

17 Place the open side of the camera over the front of the 4 × 5 film holder. Make sure that the camera is square with the film holder edges. Mark the camera where it touches the raised ridge of the film holder. Remove the camera and cut small notches to accommodate the ridge.

18 Fold the black velvet strip (fuzzy side out) along the bottom edge of the camera, gluing it to the camera's inside and outside. This prevents light leaks where the film holder and camera meet. For neatness, you can put a strip of black electrical tape over the outside of the velvet to get a straight line.

19 Put the 1-inch piece of black electrical tape over the pinhole to use as a "shutter."

1 Place the open side of the camera over the 4 × 5 film holder. Attach with rubber bands.

2 Place the camera in front of the subject and load the film into the holder.

3 For exposure, remove the piece of black tape that is over the pinhole. When the exposure is complete, replace the tape over the pinhole (see the box "Pinhole Exposure Times" on page 230). For maximum sharpness, keep the camera perfectly still during exposure.

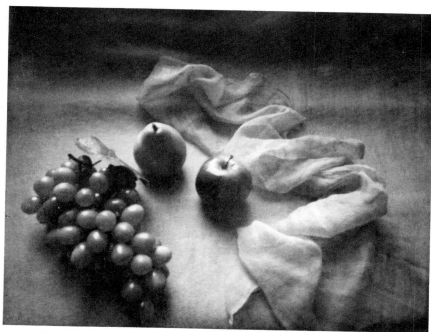

Jan L. Smith

A photograph made with a 3-inch-focal-length pinhole camera, f/166 pinhole.

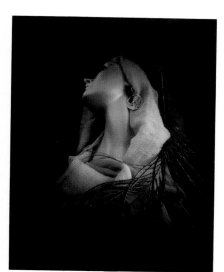

Karen Rees

A photograph made with a 1½-inch-focal-length pinhole camera, f/166 pinhole.

Pinhole Exposure Times

Suggested Exposure Times

The following times are suggested as starting points for experimentation. Different pinholes will vary in diameter, and so will let in less light or more (just as different aperture settings on an ordinary camera let in different amounts of light). Thus, the length of required exposure time will vary.

	Bright Sunlight	**Cloudy/Overcast**
ISO 3000/36°	$\frac{1}{15}$ sec.	2–4 sec.
ISO 400/27°	$\frac{1}{2}$ sec.	15 sec.–1 min.
ISO 50/18°	6 sec.	1–4 min.

With color Polaroid films, exposures of 1 minute or longer must be increased to correct for reciprocity effect. To do this, multiply the exposure time in the chart by about 5. Although reciprocity failure creates a color shift with Polachrome CS, it should also be considered with black-and-white Polaroid films.

Using a Light Meter to Determine Pinhole Exposures

1. Meter the scene and select a combination of f-stop and shutter speed.

2. To find the pinhole f-stop, divide the focal length of the camera (distance from film to pinhole) by the diameter of the pinhole. For a 3-inch focal length and a .018-inch pinhole (the size made by a #10 needle), the formula is:

$$\text{F-stop} = \frac{\text{Focal length}}{\text{Pinhole diameter}} = \frac{3}{.018} = \text{f}/166$$

3. Use the charts below to determine how many stops smaller your pinhole f-stop is than the metered f-stop you selected. Give that many more stops of exposure time.

Suppose that the light meter indicated an exposure of f/16 at $\frac{1}{250}$ seconds and your pinhole f-stop is f/166. F-166 is about 7 stops smaller than f/16, so you would need a corresponding exposure time that is 7 stops longer, or $\frac{1}{2}$ second.

Reciprocity Effect
When exposures are longer than about $\frac{1}{2}$ second, the indicated exposure has to be increased to allow for the reciprocity effect, the tendency of any film to fail to respond as predicted at very long exposure times. The color response of color film also shifts during very long exposures. (See the information sheet provided with your film.)

F-stop progression for pinhole range of apertures (each number is one stop smaller than the following number):

Smaller apertures (less exposure) . . . Larger apertures (more exposure)
f/512 350 250 180 128 90 64 45 32 22 16 11 8

Shutter speed progression in seconds (each speed gives 1 stop more exposure than the preceding speed):

Faster speeds (less exposure) . . . Slower speeds (more exposure)
$\frac{1}{500}$ $\frac{1}{250}$ $\frac{1}{125}$ $\frac{1}{60}$ $\frac{1}{30}$ $\frac{1}{15}$ $\frac{1}{8}$ $\frac{1}{4}$ $\frac{1}{2}$ 1 2 4 8, etc.
(double the seconds to increase the exposure by 1 stop)

Variation

Norman Sanders suggests an extremely simple way to convert a 4 × 5 view camera for pinhole use.

Suggested Materials

4 × 5 camera
normal-focal-length lens
tripod
exposure meter
Polaroid 545 film holder
Polaroid Type 52 film
opaque black paper
black tape
needle

Step by Step

1　Remove the camera's regular lensboard. Tape a piece of black paper across the open front of the camera.

2　Put a pinhole in the paper. Hinge a piece of tape over the hole to act as the shutter.

3　Compress the bellows to reduce exposure time and create a wide angle of view.

4　Insert the loaded Polaroid holder and film at the back. Try a 2–3 minute exposure in ordinary classroom light. The entire class can be the subject if you warn them in advance of the length of the exposure time.

Norman Sanders

10 minutes

40 minutes

Constructing an SX-70 Pinhole Camera

Instructor: Stephen M. Perfect
Saint Francis College, Fort Wayne, Indiana

This simple project produces a pinhole camera that accepts Time Zero film. Exposures will be relatively long, which can be turned to advantage to create blurred or ghost images.

Suggested Materials

Polaroid SX-70 camera (The camera is used to break the chemical pods in the film after the pinhole exposure is made.)

Polaroid Time Zero film

2-inch-square piece of thin metal (such as from an aluminum pie plate)

needle

fine sandpaper

4 × 5 sheet film box

cardboard strips

glue

black tape, 1-inch piece

darkroom or changing bag

Step by Step

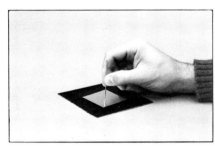

1 Place the piece of metal on a scrap of cardboard. Carefully pierce the metal with just the tip of the needle.

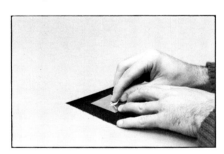

2 Sand both sides of the metal very lightly to expand the hole and smooth rough edges. Use a magnifying glass to make sure the hole is round and clean.

3 Make the camera body from the bottom and middle sections of a 4 × 5 sheet film box. A 10-sheet box will show a wider-angle image than a 100-sheet box.

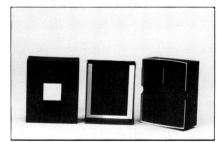

4 Cut a 1½-inch opening in the bottom of the box. Glue the piece of metal inside the bottom, centering the pinhole within the opening.

5 Glue cardboard strips inside the middle section of the box to form a slot to hold a piece of Time Zero film.

1 In the darkroom or in-side a changing bag, remove a piece of Time Zero film from the film pack. (Protect the next piece of film in the pack from being exposed to light either by replacing the piece of card-board that originally covered the film or by putting the pack into a light-tight container.)

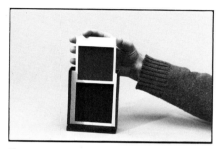

2 Still in the dark, insert the piece of film into the slot formed by the cardboard strips in the middle section of the camera.

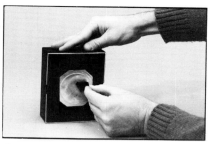

3 Make an exposure by re-moving the black tape from the pinhole. Polaroid Time Zero film is rated at ISO 150/23°. With the 10-sheet film box, try an exposure of 5 seconds for a scene in bright sun, 30 seconds for a scene in ordinary room light.

4 In the darkroom or changing bag, take the exposed film from the camera and put it into an empty Time Zero film pack.

5 Still in the dark, insert the film pack into an SX-70 camera. Close the film loading door to the camera to eject the film. This will break the chemi-cal pods in the film and pro-cess it.

Stephen M. Perfect

During a 20-second exposure, hands
were inserted in the camera's angle of
view at different distances from the
camera and for different lengths of
time.

Stephen M. Perfect

A pinhole does not focus an image as
sharply as a lens does at any single
point, but if the pinhole is small
enough, the image will be acceptably
sharp overall.

TOPIC 10

STEREO PHOTOGRAPHY

Constructing an Instant Stereo Camera

Instructor: Lorran Meares
Virginia Intermont College, Bristol, Virginia

Stereo photography consists of taking two pictures side by side of the same subject. This approximates the two slightly different viewpoints seen by human eyes. When the pair of pictures (a *stereograph*) is shown through a special viewer (a *stereoscope*) that presents one view to each eye, the brain fuses the two slightly different images into a single image that appears to have three dimensions.

You can produce the two stereograph images in several ways. At the simplest level, you can use an ordinary camera, take one picture, move the camera a few inches to one side, then take a second picture. You can buy a commercially manufactured stereo camera that has two lenses mounted side by side and that produces two pictures. Or you can adapt two cameras to make your own stereo camera (see below).

Suggested Materials

two identical Polaroid instant
 cameras
two identical lenses or pinholes

Step by Step

1 If you want to replace the cameras' original lenses, you will need to cut off the front of each camera. To do so, first remove the camera's rollers. Use a table saw or band saw to cut off the front lens-supporting part of each camera. Be sure to protect your eyes with suitable safety glasses. Cut exactly parallel to the film plane at the same point on each camera. Sand all rough edges, then remove all plastic dust from the cameras.

2 Mount the new lenses or pinholes. To hold the new lenses or pinholes in place, you will need to construct new fronts for the cameras. Using the bottom of a 4 × 5 film box is one possibility. You will also need to provide an adjustable bellows arrangement if you want to change lens focus for different scenes or if you want to change the angle of view of pinholes. Glue or tape the lens systems to the cameras so that each is at the same distance from the film plane. Tape open edges with black tape to prevent light leaks that can fog the film with unwanted exposure.

To match normal human binocular vision, the distance between the two lenses should match the distance between an average pair of human eyes, about $2\frac{1}{2}$ inches from the center of one lens to the center of the other. However, the cameras will only butt so close together, about $4\frac{1}{2}$ inches from lens center to center. The difference is not significant with normal or long focal lengths; simply position the lenses (or

pinholes) so that each forms its image circle on the center of the film.

If you are using pinholes, they should be of identical diameters. Pages 226–229 tell how to make your own pinholes, or you can buy precision drilled ones from The Pinhole Camera Company, P.O. Box 19128, Cincinnati, Ohio 45219.

Pinholes require no focusing, but the closer the hole is to the film, the wider the angle of view—and the more pronounced the stereo effect—it will produce. Mounting a pinhole 35mm from the film plane produces a super-wide angle of view, 100mm away is wide angle, even further away produces a normal angle of view.

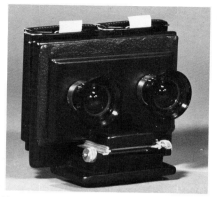

Lorran Meares

A stereo camera utilizing Polaroid film pack adapters.

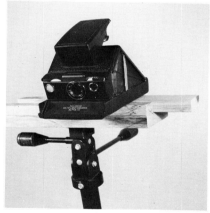

Lorran Meares

You can make stereo pictures with any camera if you shift the camera slightly to the side between exposures. Here an SX-70 is mounted on a sliding bar, which is attached to a tripod. After the first exposure, the bar and camera are shifted to the other side, and the second exposure is made.

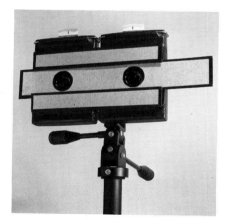

Lorran Meares

A stereo pinhole camera made from two Polaroid Square Shooter cameras. The plastic camera bodies were cut off at the front and the lenses replaced with two pinholes. A slide-bar shutter produces simultaneous exposure of the two images.

3 Construct a shutter system. The shutters must open and close simultaneously if your subjects will be moving even slightly during the exposure. If you have mounted two view-camera lenses with shutters, they can be fired simultaneously with a double cable release. For two SX-70 or 600 series cameras, you can wire together two cable releases. A slide-bar shutter or revolving disk shutter is another way to provide simultaneous exposures.

4 Attach the cameras to a supporting base. Gluing the cameras to a simple wooden base will do, if you don't plan to use the cameras for any other purpose. Make sure the film planes are aligned with each other exactly.

To make a tripod screw attachment for a supporting base, drill a $\frac{5}{16}$-inch hole in the bottom of the base and insert a $\frac{3}{8}$-inch T-nut with $\frac{1}{4}$-inch \times 20 tapped threads (available at a hardware store; take your tripod to the store to make sure of the fit).

A commercially made, two-headed tripod attachment is available that can be used if the cameras already have tripod sockets.

Step 1

Choose cameras with plastic bodies if you decide to cut them apart to replace the lens systems.

You can use the lenses that are in the cameras or cut the cameras apart and substitute a pair of view-camera lenses with shutters, barrel-mounted lenses without shutters, or pinholes. Shorter-focal-length lenses produce a more pronounced stereo effect than do longer lenses.

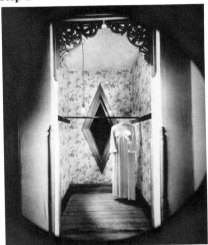

Step 2

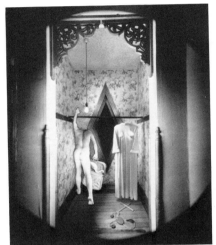

Step 3

Step 4

This series utilizes Polaroid Type 665 P/N film showing progressive creation of the image. This is an example of the "in process" creative visualization mentioned in the text.

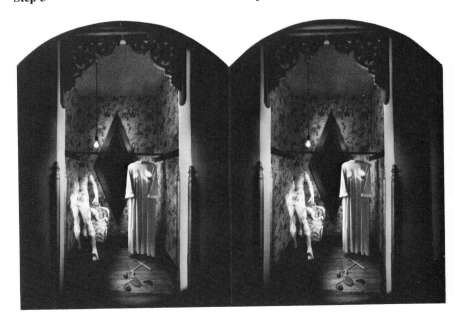

Lorran Meares and Simone Little

"The Painful Passage"

238

Mounting and Viewing Stereo Pictures

Instructor: Lorran Meares
Virginia Intermont College, Bristol, Virginia

In order to see a pair of stereo images as three-dimensional, the left eye needs to see only the image taken by the left camera, while the right eye sees the image taken by the right camera. The traditional viewing device for prints is the Holmes stereoscope (see illustration on page 240). You can find these vintage devices at flea markets, antique stores, and sometimes in a relative's attic. Sources for viewers, books, and other stereo items include Stereo Photography Unlimited, 8211 27 Avenue North, St. Petersburg, Florida 33710 and Reel 3-D Enterprises, P.O. Box 35, Duarte, California 91010.

If you want to make your own stereoscope, you can get lenses (+5 diopter stereoscope lens set #725-183) from Keystone-Mast, 2212 E. 12 Street, Davenport, Iowa 52803, a company that makes stereoscopes for ophthalmic testing.

Suggested Materials

stereoscope
heavy card stock
mounting adhesive
mat knife and straight-edge or
 precision trimmer

Step by Step

1 Trim the photographs, if necessary, to fit the stereo card format, $3\frac{1}{2} \times 7$ inches (see illustration on page 240). To get the closest butting together of two images, apply the adhesive to the back of the print prior to trimming, then trim the white borders as needed.

SX-70 stereo pairs butted together side by side measure 7 inches across and do not need to be trimmed. Mount them on heavy card stock for support.

2 Before mounting prints make sure that the left-camera image is on the left side, the right-camera image on the right side. You will be able to see a little more of the left side of the scene in the left-camera image.

The Holmes stereoscope is the standard viewer for stereographic prints. Illustration courtesy of *Points of View: The Stereograph in America—A Cultural History,* edited by Edward W. Earle (Rochester, N.Y., Visual Studies Workshop Press, 1979).

Near-point distance
3″ separation

7″

3½″

C&C′

B&B′

Bottom edge of pictures

Wanda Levin and Simone Little

"Illuminated Woman"

The stereo card format for a Holmes viewer typically measures 3½ × 7 inches. Basic rules are: Position the prints such that the distance between a point at the center of each picture (A, A′) is 3 inches. Corresponding points A, A′, B, B′, C, C′ should be equal distances from the bottom edges in both left and right prints.

TOPIC 11

AND SOME OTHERS

PROJECT 29

Self-Portrait

Instructor: Richard Margolis
State University of New York at Brockport
Brockport, New York

A self-portrait can be more than just a picture of the photographer. It can be a reflection in a mirror, a shadow of yourself, or a picture of something that represents you, such as the tree that you might be if you were a tree.

Suggested Materials

35mm camera
Polaroid 35mm instant slide system
Polaroid Polapan CT film

Francisco Borrayo

Instructions for Students

1 Beginning with your next roll of film, make pictures of yourself. Make several exposures on every roll of film that you shoot. It takes time to allow for growth and improvement, so keep shooting and be prepared to reshoot those that express an idea you like but that can be improved.

2 Shoot under different conditions, at different times of day, and in different places. Try sometimes to record a scene realistically and at other times to create some fiction about yourself. Part of this assignment involves discovering new definitions of self-portraiture in, for instance, photograph reflections, shadows, footprints, traces, reactions, or equivalents. Hold your camera at arm's length and aim it at yourself. Try using a self-timer. Photograph your desk or closet; they reveal a lot about you. Photograph a house, car, tree, or animal that could be you if you were such a thing.

3 Think about how you will present your self-portrait to others. Do you want it to be a straight, full-scale slide or print? What happens when you deliberately scratch the slide or negative and then print it? Or cut out parts of several images, reassemble them, and make new images? Or draw on or color parts of the image? Use this assignment to explore a variety of possibilities.

Jerome C. Dixon

Jerome C. Dixon

Carol Kuszelewicz

PROJECT 30

Two Kinds of Light

Instructor: Gregory Spaid
Kenyon College, Gambier, Ohio

Light is the fundamental element of any photograph. Photographs record the light that is reflected off the objects in a scene, and that light can significantly change the way that objects appear. This assignment helps students learn to see a subject in these terms.

Suggested Materials

35mm camera
Polaroid 35mm instant slide system
Polaroid Polapan CT film

Step by Step

1 Create two very different photographs of the same subject from the same viewpoint. The difference should be the result of light changing the appearance of the subject. Try to make both photographs equally satisfying as individual images, but make them as different as possible, only by using light differently.

2 Go back to your subject at different times of the day and in different lighting conditions: early morning, morning, midday, dusk, or evening. Look at the subject in contrasty light, such as direct sunlight, or in soft light, as on an overcast day. Consider illuminating your subject with available or artificial light.

Sarah Corvene

Gordon Campbell

Sensitivity to light and how it creates form, space, tone, and emotion is as essential to photography as sensitivity to line is to drawing. These photographs differ only in the light on the subject.

Break a Personal Rule

Instructor: Sandi Fellman
Rutgers University
New Brunswick, New Jersey

All photographers have structures within which they work, even if they are not aware that they do. This assignment has two goals: first, to get students to be aware of the limits and values they unconsciously set up in their work and then to get them to stretch themselves and try something new.

"As teachers we often allow and even encourage students to settle into a style or approach to their work very early in their photographic careers. Consequently, it often takes an act of courage on a student's part to try something new. The plus with this assignment is that it requires that students produce that 'something new' in a personalized and self-examining way."
—Sandi Fellman

Suggested Materials

consider using a camera or film format different from the one you normally use

Step by Step

1 Take a look at your photographs. What patterns or rules do you tend to follow? Rules can be related to ideas, values, techniques, materials, and so on. Do you photograph people, but only from a distance? Do you arrange and rearrange a scene, never working fast and intuitively?

2 Choose some personal photographic rule that you tend to follow, then make some photographs that break it. Are all your photographs sharp from near to far? If so, you might try some blurred motion or very shallow depth of field. Do you photograph rather randomly, shooting whatever happens to catch your eye? If so, you could plan the layout of an image in advance of shooting it.

Sandi Fellman

Sandi Fellman shows this example of breaking her own personal rules. Typically, her work is highly detailed and textured. To break her own stylistic and technical patterns, she made an image that *felt* like hers but that didn't follow her typical structure. Rather than her usual strobe lights, which freeze motion, she used tungsten lights and 10–30 second exposures. The model's moving body blurred the detail of the image, reducing it to color and gesture.

Making SX-70 Pictures Without a Camera

Instructor: Stephen M. Perfect
Saint Francis College, Fort Wayne, Indiana

Time Zero or Type 600 film can be used creatively without a camera. The film can also be manipulated after a scene has been photographed with a camera. This assignment gives students an opportunity to work with patterns of shape and color that they might not explore if they were making conventional pictures.

Suggested Materials

Polaroid SX-70 or 600 series camera

Polaroid Time Zero or Type 600 film

cigarette lighter or other heat source

darkroom with yellow and red safelights

pointed tool

Step by Step

1 In a darkroom remove a piece of Time Zero or Type 600 film from its pack. Cover the remaining film to protect it from light.

Press on the slightly bulging areas at the bottom of the film to break the chemical pods and spread them into the picture area.

2 The slightly slicker and shinier side of the film faces up in the pack and is the light-sensitive side. Briefly hold that side of the film close to a red or yellow safelight. Then, with your fingers, break the chemical pods at the bottom of the film and push the chemicals into the image area.

3 Heat and/or additional pressure can be used to manipulate the image under room light.

Hold a lighter under the back of the film to create heat bursts. Do not hold it too close or for too long or the backing will melt and curl.

A pointed tool can be used to draw on the image.

Stephen M. Perfect

The film was exposed to a red safelight before the pods were broken.

Steven Pfefferkorn

The blue color is produced by breaking the pods, then exposing the film to a safelight.

Steven Pfefferkorn

Exposures of one second or longer to white light will produce pale, muted colors. The brown color is an area that chemicals from the pods did not reach.

Clare Barton

Heating the back of the film produces bursts of color.

Steven Pfefferkorn

Try pressing with a pointed tool to draw on an image made either with a camera or without one.

249

Portraits in the Style of Hill and Adamson

Instructor: Michael Simon
Beloit College, Beloit, Wisconsin

This version of the assignment is done in class. Students are shown reproductions of the work of the 19th-century photographers, D. O. Hill and Robert Adamson. One student selects a picture, then poses one or more other students in a way that simulates the picture.

"The assignment aims to illustrate how difficult it is to copy the most evident photographic style. Through this understanding, students comprehend the photographer's primacy in the photographic picture-making process."—Michael Simon

Suggested Materials

4 × 5 camera
normal-focal-length lens
tripod
exposure meter
Polaroid 545 film holder
Polaroid Type 52 film
slide projector
slides of Hill and Adamson
 photographs

Step by Step

1 Show students slides of portraits by D. O. Hill and Robert Adamson. It will help students unfamiliar with their work to know that Hill and Adamson made these pictures in the mid-1840s, soon after the invention of photography, and that they employed the poses used in the portrait painting of the period.

2 Ask for a student to volunteer to select a slide and to choose other students to use as models. Keep the selected slide on the screen while the student arranges the models to match the slide.

3 So the student can concentrate on the style of the picture rather than its technical aspects, you, the instructor, can handle the focusing, exposure, and processing. Let the student handle the positioning, posing, and direction of models as well as direct the framing of the image.

4 If class size permits, have each student make a photograph. With large classes, comparison of even three or four photographs will demonstrate the role that the photographer plays in selecting and shaping the style of an image.

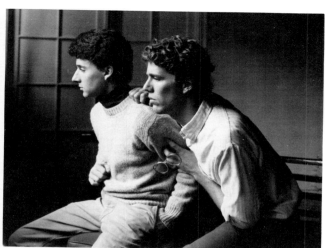

Erika Dennis

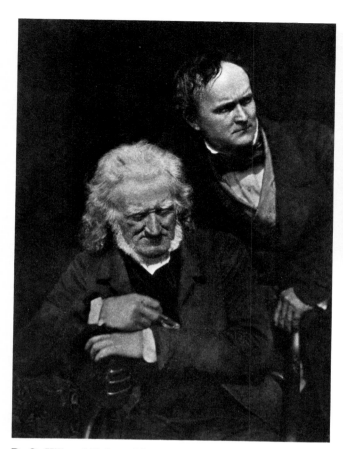

D. O. Hill and Robert Adamson

Portrait of John Henning and Alexander Handiside Ritchie. Courtesy of the International Museum of Photography at George Eastman House

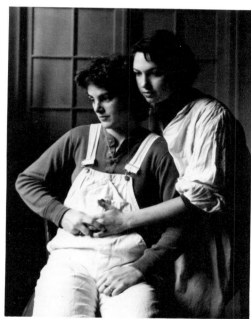

Lincoln Wilson

Having students attempt to duplicate the style of another photographer, here the 19th-century photographers Hill and Adamson, demonstrates the control that a photographer has over the style of an image.

How to Match Hill and Adamson Lighting

The lighting in most Hill and Adamson portraits can be simulated either by a broad source coming from the side and above (such as light from a window) or by an overhead source (such as a single ceiling fixture). Reverse the slide in the projector if side lighting in a room comes from the wrong side.

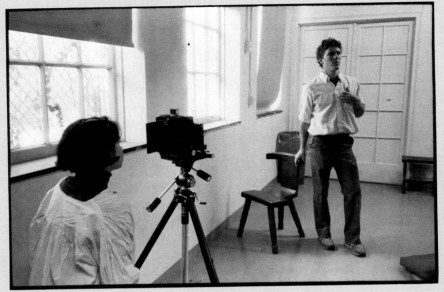

Michael Simon

Postscript

Variations
Have advanced students shoot Type 55 P/N film and use the negative to produce final prints on their own, so that they are responsible not only for the organization of the image, but also its technical completion.

Have students select and reproduce the work of other photographers, such as a portrait by Diane Arbus or Julia Margaret Cameron or a close-up of a vegetable by Edward Weston.

Strip Photography

Instructor: Andrew Davidhazy
Rochester Institute of Technology
Rochester, New York

A common way to photograph a moving subject when you want to blur the background—but not the subject—is to pan the camera, move it during the exposure in the same direction that the subject is moving. Panning keeps a moving subject's image relatively stationary with respect to the film during the exposure. Thus a sharp image is recorded even with a relatively long exposure time.

In strip photography a similar effect is produced by keeping the camera stationary while moving the film during the exposure. If the film is moved so that the image of a moving subject is stationary with respect to the film, a sharp image can be recorded that looks much like a panned image. A simple method of strip photography, which uses the rewind knob on a 35mm camera to move the film during the exposure, is described below.

Suggested Materials

35mm camera
Polaroid 35mm instant slide system
Polaroid Polapan CT film

Step by Step

1 People walking by are ideal beginning subjects. Place the camera on a tripod, focus and compose the scene. Keep in mind that the moving film will record only whatever moves across the position of the slit in the mask that you have installed in the camera. If the slit is at the center of the film frame, you can use the focusing circle at the center of the viewfinder as a guide.

2 As you look through the viewfinder, time the number of seconds that it takes the subject to go from one side of the viewfinder to the other. (If you are using a slit in front of the lens of a single-lens-reflex camera, remove the mask so you can see the entire viewfinder image.) Also time your rewind rate; make one complete turn of the rewind knob in about $1\frac{1}{2}$ times the number of seconds that it takes the subject to pass.

3 Exposure time is controlled by the rate at which you turn the rewind knob, which is affected by the speed of the subject moving across the viewfinder. Exposure time is the total time it takes a particular point on the film to cross the width of the slit. To find the equivalent "shutter speed," multiply the slit width (in millimeters) by the time (in seconds) required for your subject to cross the viewfinder, then divide by 36. If the slit width is 1mm and it takes 5 seconds for the subject to

cross the viewfinder, then:

$$\frac{1 \times 5}{36} = \frac{5}{36} = \frac{1}{7}$$

or about ⅛-second shutter speed. Meter the light and set the aperture to the setting required for this shutter speed for the film you are using.

4 Load the camera with film. Attach the lens cap to the lens, then advance all the film to the take-up side.

5 Set the shutter on B and lock it open with a locking cable release. Some cameras have a built-in camera lock that will hold the shutter open.

6 Remove the film cap when you are ready to begin the exposure. As people walk past the camera in the opposite direction from that in which the film will be moving, slowly rewind the film past the open slit back into the supply cham-

ber. The image recorded will move forward on the film. (This is easier to understand if you open the back of an unloaded 35mm camera and turn the rewind knob while you visualize the motion of people and film.) Recap the lens after the exposure.

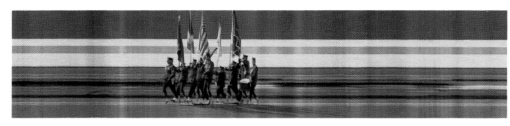

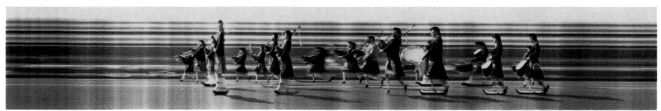

Andrew Davidhazy

Photographs made by rewinding 35mm film during the exposure.

Postscript

When people walk past the camera at just the right speed, their image will appear normal. When they move slower than the film, their image will appear stretched. When they move faster than the film, their image will appear compressed.

It is possible to make strip photographs without modifying the camera in any way, but the changes described in the box "Modifying a 35mm Camera for Strip Photography," on the next page, are recommended, particularly masking the image to a narrow strip.

"In any case, each roll of film will contain images that are by normal standards quite unusual. It is exciting just to scan the developed film for that unique image."—Andrew Davidhazy

To get more details on strip photography, such as how to make panoramas and how to motorize the film transport, send a self-addressed, stamped envelope to Andrew Davidhazy, School of Photographic Arts and Sciences, Rochester Institute of Technology, One Lomb Memorial Drive, Rochester, New York 14623.

Modifying a 35mm Camera for Strip Photography

The principal requirement for strip photography is that the camera be capable of moving the film while the exposure is being made. This can easily be done by using the rewind knob of a 35mm camera. You can use the knob without modification or, for easier use, you can attach an oversized lever to the knob.

Andrew Davidhazy

To avoid overexposing the film and to increase sharpness, you should install a mask inside the camera so that the normal 24 × 36mm gate is narrowed to a 24 × 1mm or 24 × 2mm gate. The mask can be made out of any thin, opaque material, such as exposed and developed Kodalith sheet film. Cut the mask to fit between the focal-plane rails of the camera so that it does not intrude on the normal path of the film. Tape the mask temporarily in place, so that it can be removed readily when you want to resume normal shooting.

An alternative to installing the slit inside the camera is to make an oversized lens shade covered by an opaque mask into which you cut a 1mm-wide slit. This location is safer as far as the camera is concerned, but not as optically efficient or predictable. For best results use a wide-angle lens set to a small aperture such as f/11 or f/16. This type of exterior mask cuts the amount of light reaching the lens by a stop or two, so bracket your estimated exposure with a stop or two more exposure.

With an exterior mask, the size of the slit relative to the film will vary with the f-stop and focal length of the lens. If you have a single-lens-reflex camera, you can estimate the effective width of the slit by looking through the viewfinder with the mask in place. The width of an unmasked viewfinder is equivalent to 36mm.

PROJECT 35

Homage to a Square

Instructor: Richard D. Zakia
Rochester Institute of Technology
Rochester, New York

In this assignment the student uses an SX-70 or 600 series camera and film to produce photographic versions of artist Josef Albers's famous series of works, Homage to the Square. The process provides numerous insights into color photography and human perception. This assignment provides an opportunity through experimentation and discovery for learning some fundamental photographic principles about the color response of film versus that of the eye, the use of color and neutral-density filters, the effect of exposure changes, and so on.

Suggested Materials

Polaroid SX-70 or 600 series camera

Polaroid Time Zero or Type 600 film

tripod or copy stand

gray and white paper (see details with diagram of test target)

dry-mount tissue or glue

colored filters, such as CC filters, polycontrast filters, lens filters, or colored cellophane

3 strips of 0.30 neutral-density filter

Step by Step

1 Construct a test target as follows:

Use four different neutral shades (gray or white) of paper.

Outermost square	12 × 12 inches	Zone V or Munsell 5 (18% gray)
Next square	10 × 10 inches	Zone VI or Munsell 6
Next square	8 × 8 inches	Zone VII or Munsell 7
Innermost square	6 × 6 inches	Zone VIII or IX or Munsell 8 or 9 (white)

The size of the target is important because it must completely fill the SX-70 format at a camera distance of no less than 1 foot. Arrange the squares as in one of Albers's works. Dry mount or glue one on top of the other to avoid any edge shadows.

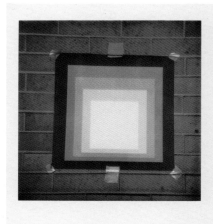

2 Place the target and camera on a copy stand, or position the target on a wall with the camera on a tripod. Align the target so it is parallel to the front of the camera and exactly fills the SX-70's square format.

Richard D. Zakia

3 Make three prints without using a colored filter: one with normal exposure, one with increased exposure, and one with decreased exposure. To increase or decrease the exposure, use the lighten/darken control on the camera.

4 Compare the prints to the test target and to each other. The prints will not be neutral in color unless you are photographing outdoors on a sunny day. They will have a bluish cast if photographed in the shade and a yellowish cast if photographed with tungsten illumination.

5 To obtain different colored images, use colored filters over the lens of the camera. Then add neutral-density filters over the camera's electric eye to increase the exposure and compensate for the colored filter over the lens. (The electric eye is the small window on the opposite side of the camera front from the shutter button.) Putting a 0.30 ND filter over the electric eye will increase the exposure by 1 stop, 0.60 filtration will increase it by 2 stops, 0.90 by 3 stops.

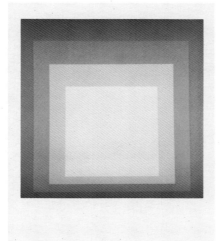

No filter

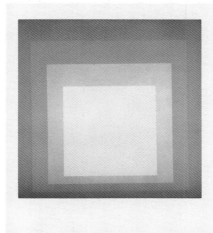

Magenta Edmund Scientific #828 filter over the lens, 0.90 neutral-density filter over the electric eye.

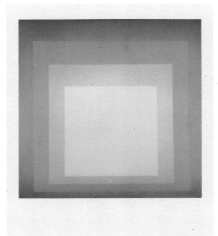

Green Edmund Scientific #871 over the lens, 0.90 neutral-density filter over the electric eye.

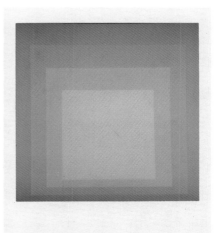

Blue Edmund Scientific #856 filter over the lens, 0.90 neutral-density filter over the electric eye.

Postscript

"In the words of Josef Albers, 'Good teaching is more a giving of right questions than a giving of right answers.' Paraphrased, this could read, 'Good teaching is providing the students with hands-on exercises that will raise a number of fundamental questions.' Answers to such questions should lead to an understanding of basic principles that can be generalized to embrace other situations."—Richard D. Zakia

See also Leslie Strobel, Hollis Todd, and Richard Zakia, *Visual Concepts for Photographers* (London: Butterworth/Focal Press, 1980).

Making Separation Negatives

Instructor: Elaine O'Neil
School of the Museum of Fine Arts
Boston, Massachusetts

This project uses Polaroid Type 55 P/N film (which produces a high quality negative as well as a print) to make direct color separation negatives. The negatives can then be used in tri-color printing with processes such as Kwik-Print or gum bichromate printing. A three-hour class session is long enough to demonstrate how to expose the negatives and make a Kwik-Print image. Kwik-Print materials are available from: Light Impressions, P.O. Box 940, Rochester, N.Y. 14603.

Suggested Materials

4 × 5 camera
normal-focal-length lens
tripod and cable release
exposure meter
Polaroid 545 film holder
Polaroid Type 55 P/N film
Kodak Separation Guide (color control patches) and Gray Scale
filters for lens: #47B blue, #58 green, and #25 red
sodium sulfite (anhydrous or desiccated) for clearing the negative

Step by Step

1 Set up a still life or select a scene that will not change between exposures. Include color control patches and a gray scale to help determine the correct exposure and to aid in adjusting color balance when printing. For a class demonstration, you can leave the patches and gray scale in the middle of the scene, as shown in the pictures here. For a print that is not simply a demonstration, you may be able to position the patches and gray scale at the edge of the film format, so that you can later trim them off. Or you can make two sets of negatives, one with and one without the patches and gray scale.

2 Determine a basic exposure for the scene and expose a sheet of film accordingly. Evaluate the exposure as you would for any negative. Examine the gray scale shown in the negative; it should have good

Elaine O'Neil

Unfiltered black-and-white print of the scene with color control patches and gray scale in place.

Blue-filtered negative used to print yellow in the final image.

separation in both shadows and highlights. Adjust the exposure, if necessary.

3　Make three additional exposures, increasing the basic exposure as indicated if the illumination is from daylight or electronic flash.

Through #47B blue filter: +2⅔ stops
Through #58 green filter: +3 stops
Through #25 red filter: +3 stops

With tungsten illumination, which is richer in red light, increase the red filter exposure only 2 stops.

4　As soon as you peel the film from the negative, clip the corners of the negatives so that you can identify them after clearing.

Blue: clip one corner
Green: clip two corners
Red: clip three corners

Evaluate the exposure of the negatives by examining only the middle value (18% gray card or Zone V) on the gray scale. It should be the same density in all three negatives. If the value is not the same on all negatives, adjust the exposure and reshoot. The color areas in the scene will change in density depending on the color of the filter, so they cannot be used to judge exposure.

5　Clear the negatives as instructed on the information sheet packed with the film. With tri-color processes such as Kwik-Print, the blue-filtered negative will be used to print the yellow emulsion layer, the green-filtered negative will print the magenta layer, and the red-filtered negative the cyan layer. The unfiltered negative is used only to check exposure.

Green-filtered negative used to print magenta in the final image.

Red-filtered negative used to print cyan in the final image.

Final Kwik-Print image of the scene.

Multiple Flash Exposures

Instructor: Richard L. Ware
Ball State University, Muncie, Indiana

The goal of this assignment is to produce a multiple exposure using electronic flash or a combination of flash and continuous light.

Suggested Materials

35mm camera
tripod
electronic flash
Polaroid 35mm instant slide system
Polaroid Polapan CT or other film
a long synch cord and/or a long cable release (useful if you want to move away from the camera)
a continuous light source (optional)

Step by Step

1 Set up the camera in room light. Focus and compose your shot. A subject in white or light-colored clothing against a black background works best in most instances. Footprints will show if the subject is on black background paper, so have your subject wipe the soles of his or her shoes before stepping on the paper.

2 Position the electronic flash. Cross lighting or backlighting usually works best. No light should show on the background. Indoors, you may have to block the illumination from the flash with a piece of cardboard on the background side. Outdoors, the background is usually too far away to reflect any light back to the camera.

3 Exposure is determined by the flash-to-subject distance, as in an ordinary flash exposure. However, superimposed images will be lighter than single ones, so you may want to adjust the exposure after seeing the first picture. You can also arrange your subject's positions so there is no overlap.

4 The room or outdoor area should be dark enough so that ambient light will not add unwanted exposure to the picture. You can make a reading of the ambient light level or simply evaluate it after the first exposure.

5 Make the exposures and after the shutter is closed for the last time, process the film.

6 Evaluate the photograph. Is the exposure about right overall? Do specific areas need less or more light? What changes would improve the image?

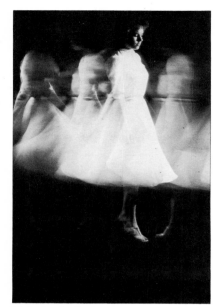

Nicholas L. Parks

Electronic flash plus continuous light superimposed a sharp image on a blurred one.

Postscript

The shutter must be open for each burst of light, so select a camera with a shutter that can be recocked without changing film position. Or you can use one that has a shutter that can be left open for an extended period of time (see the box "How to Keep the Camera Shutter Open" on page 216).

Variations

Use a continuous light source along with the flash if you want a blur plus the frozen image from the flash. The faster the motion of the subject across the film plane, the greater the intensity of light needed to record it. A slow-moving subject may require only a 50-watt lamp; a fast-moving subject, such as a gymnast in action, may require a 500-watt lamp. Position or shield the continuous source so it does not strike the background; it is easier to do this with a spotlight than with a broad source like a floodlight.

Try adding trace lighting from a flashlight, candle, lighted baton, or if outdoors, from a fire baton or sparkler.

See "Streaking Light" on page 222 and "Painting a Fantasy Image with Light" on page 219.

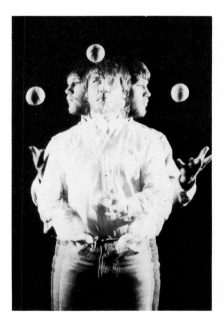

Andy Johnston

A student juggling tennis balls was recorded sharply with three electronic flash exposures.

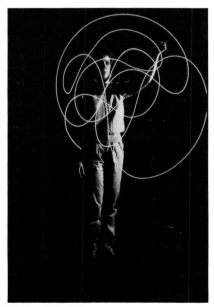

Richard L. Ware

The lights were positioned to sidelight and backlight the subject.